©MARCOS MAEU 2016

Copy Editors: Melissa Kent, Scott Robertson, Heather Dennis
Graphic Design: Marcos Mateu-Mestre,
 Alyssa Homan,
 Christopher J. De La Rosa

Published by Design Studio Press
Website: www.designstudiopress.com
E-mail: info@designstudiopress.com
Printed in China | First Edition, September 2016

10 9 8 7 6 5 4 3 2 1

Library of Congress Control Number 2016949361
ISBN: 978-162465032-1

MARCOS MATEU-MESTRE
FRAMED PERSPECTIVE VOL. 2

TECHNICAL DRAWING FOR SHADOWS, VOLUME AND CHARACTERS

designstudio|PRESS

To Alfie and Arianna

Special thanks to:

Joan Mateu

Margalida Mestre

Carme Mateu

Thanks to models:

Toni Czechorosky

Jonathan Footman

Ronald Velasquez

TABLE OF CONTENTS

FOREWORD

Building on the wonderful instruction Marcos shared with us in *Framed Perspective Vol. 1*, we are all ready to be inspired and educated once again with *Framed Perspective Vol. 2*. This book came about as we were working with Marcos on the *Framed Perspective* title and it became apparent that he had simply too much great information to limit to just one book. After reviewing the complete content in detail and observing the special expertise Marcos brings to drawing figures so well in perspective, we determined this difficult subject (along with shadows and rendering volumes) would best be communicated in a second book.

As you have learned in *Vol. 1*, everything you observe in the natural world is seen in perspective. The more abstract perspective construction techniques of cast shadows are integral to acquire to add to your perspective drawings. Mastering these skills is one of the most important elements to add to your work to make the volumes feel more realistic. Just as perspective drawing can become a large asset and second nature, so too can the ability to implement cast shadows add value to your work.

Marcos excels at such a beautiful, skillful application of value to his drawings that I can't help but want to do the same with my own drawings each time I read this book. I hope you feel the same way and find many years of inspiration and education to improve your own work forevermore. Finally, I'd like to offer a huge thanks to Marcos for the time and effort he has relentlessly put into the completion of *Framed Perspective Vol. 2* for us all to enjoy.

Scott Robertson.

Author of *How To Draw, How To Render*
Founder of Design Studio Press

Los Angeles
August 2016

INTRODUCTION

One of the wonderful things about visual storytelling is the potential integration of everything and anything ever imaginable in the course of a story, from everyday life in any given part of the planet to the most outlandish (literally) science fiction story. An essential part of this process, in most cases, are the characters. To have the kind of control over the technique that will allow us to tell stories effectively, we will need to know how to work with them from any point of view and how to integrate them in the environments in which the action develops. It is also a fact that besides the spatial relationship between the two, a common lighting and the deriving shadows will tighten the net that will make our image or succession of images the credible fabric we need.

Framed Perspective 2 is targeting all these aspects so that it can offer a solid base to the visual storyteller on which to build his or her work. These are basic elements that, in my case and thanks to my art-oriented family, I became acquainted with since a very early age. From here my eternal gratitude to them.

— Marcos Mateu
3-2016

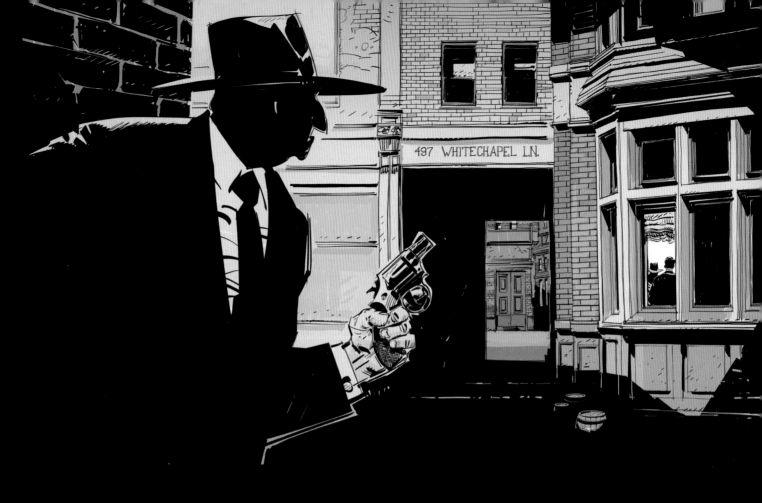

1

SHADOWS ON OBJECTS

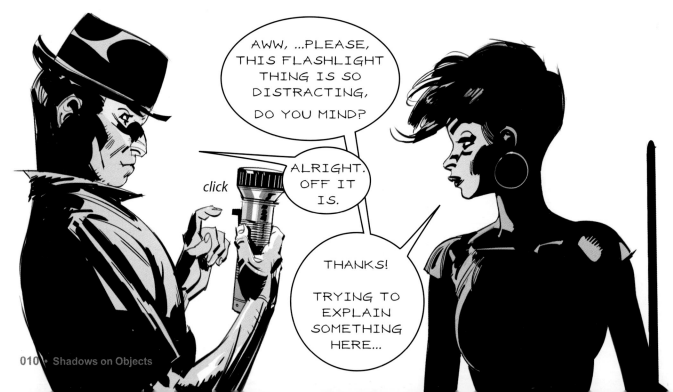

To work with shadows, three things are needed: 1 – a **light source**, 2 – an **object** totally or partially exposed to the light, and 3 – the **surface** on which the shadow of the object is projected.

Regarding **light sources**, usually it is either a *local* one, in most cases positioned a reasonable distance from the object exposed to its light, like a light bulb or a lit candle, or *the sun itself*, some 150,000,000 kilometers (a little over 93,000,000 miles) away.

The way to work with these two cases is a bit different, but right now let's start with a local source. Ready?

Fig. 1.1: Here are the three necessary elements: a streetlight, a stick exposed to its light, and a ground plane.

Draw a straight line from point A to B (that is, the points of contact with the ground of both the streetlight and the stick) and keep drawing past the base of the stick. Note: if instead of a streetlight the light source was a lamp hanging from the ceiling, just project the point of the light source straight down to the ground plane to find point A.

Line A–B indicates the direction in which to draw the shadow. The question is where should this shadow line end?

The answer comes from drawing a line from the light source to the top of the stick and beyond, until such line (representing a ray of light) crosses the directional line, in this case, at point 3.

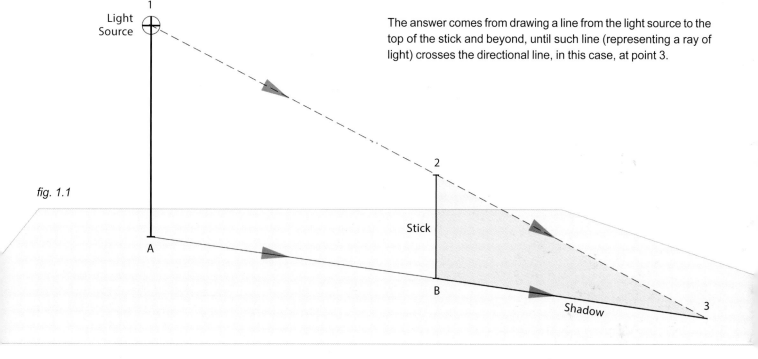

fig. 1.1

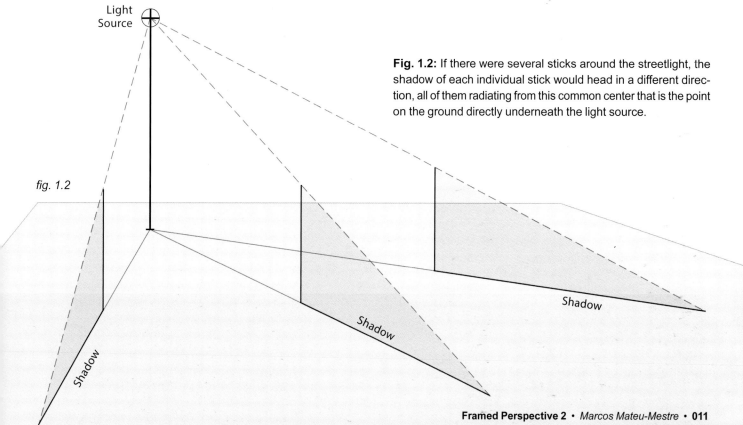

fig. 1.2

Fig. 1.2: If there were several sticks around the streetlight, the shadow of each individual stick would head in a different direction, all of them radiating from this common center that is the point on the ground directly underneath the light source.

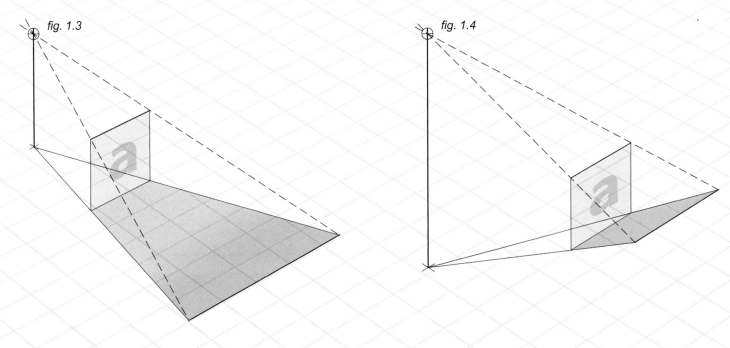

Figs. 1.3–1.7: Here are 5 identical cards on a flat perspective grid. In each case, the light source has been positioned differently to appreciate that the mechanics always work as explained on the previous page.

Observe a phenomenon that no matter where the light is coming from, the top edge of the card and its projected shadow on the ground plane are always parallel to each other. Go ahead and try this at home by moving a light around a solid object with straight sides.

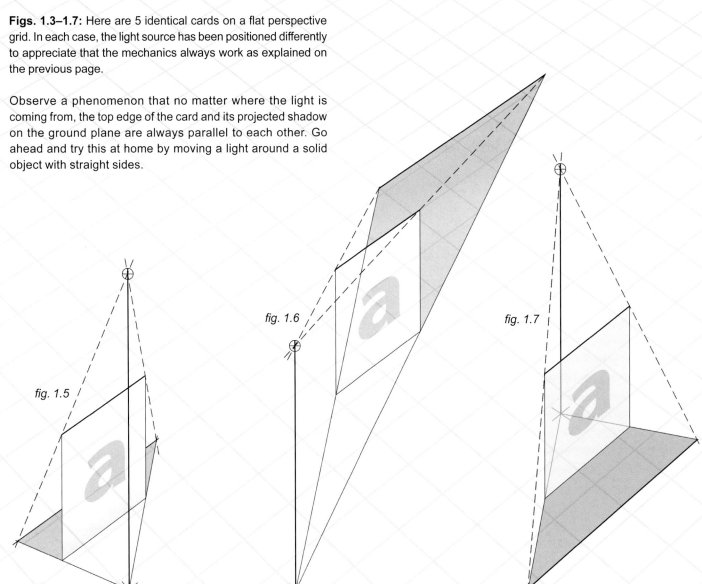

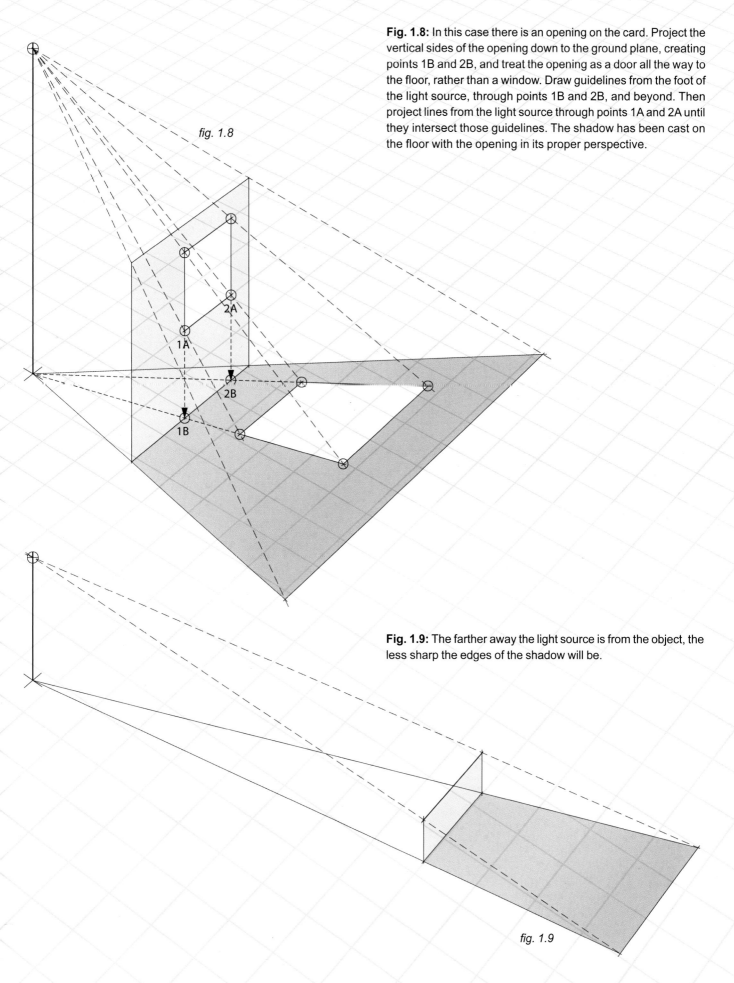

Fig. 1.8: In this case there is an opening on the card. Project the vertical sides of the opening down to the ground plane, creating points 1B and 2B, and treat the opening as a door all the way to the floor, rather than a window. Draw guidelines from the foot of the light source, through points 1B and 2B, and beyond. Then project lines from the light source through points 1A and 2A until they intersect those guidelines. The shadow has been cast on the floor with the opening in its proper perspective.

fig. 1.8

Fig. 1.9: The farther away the light source is from the object, the less sharp the edges of the shadow will be.

fig. 1.9

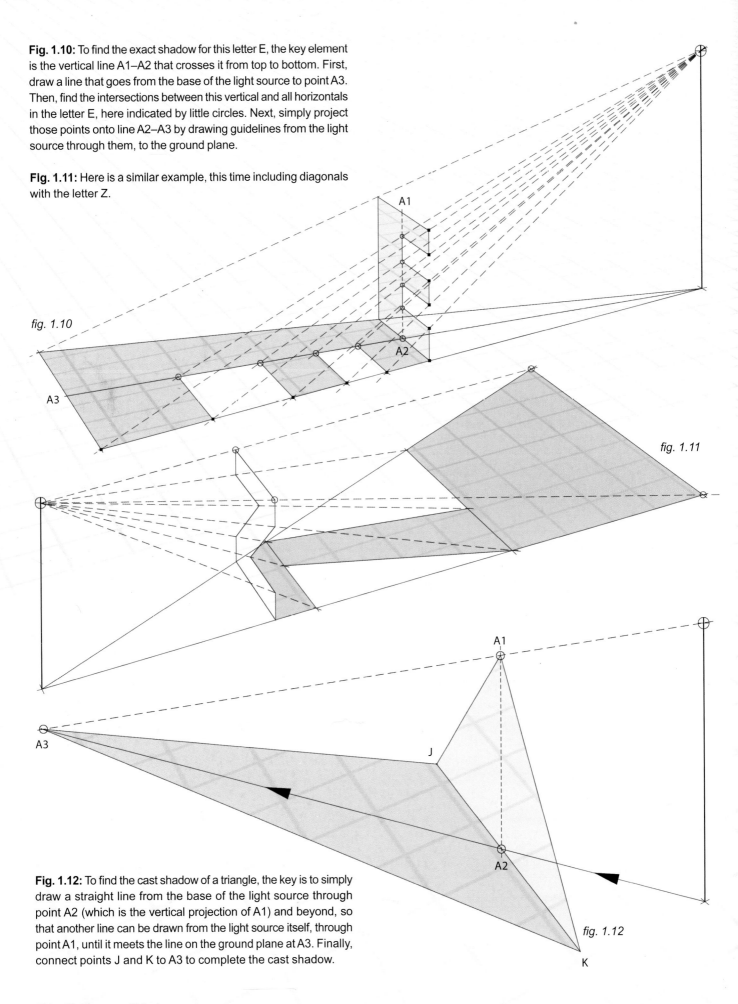

Fig. 1.10: To find the exact shadow for this letter E, the key element is the vertical line A1–A2 that crosses it from top to bottom. First, draw a line that goes from the base of the light source to point A3. Then, find the intersections between this vertical and all horizontals in the letter E, here indicated by little circles. Next, simply project those points onto line A2–A3 by drawing guidelines from the light source through them, to the ground plane.

Fig. 1.11: Here is a similar example, this time including diagonals with the letter Z.

fig. 1.10

A1

A2

A3

fig. 1.11

A1

J

A2

A3

K

Fig. 1.12: To find the cast shadow of a triangle, the key is to simply draw a straight line from the base of the light source through point A2 (which is the vertical projection of A1) and beyond, so that another line can be drawn from the light source itself, through point A1, until it meets the line on the ground plane at A3. Finally, connect points J and K to A3 to complete the cast shadow.

fig. 1.12

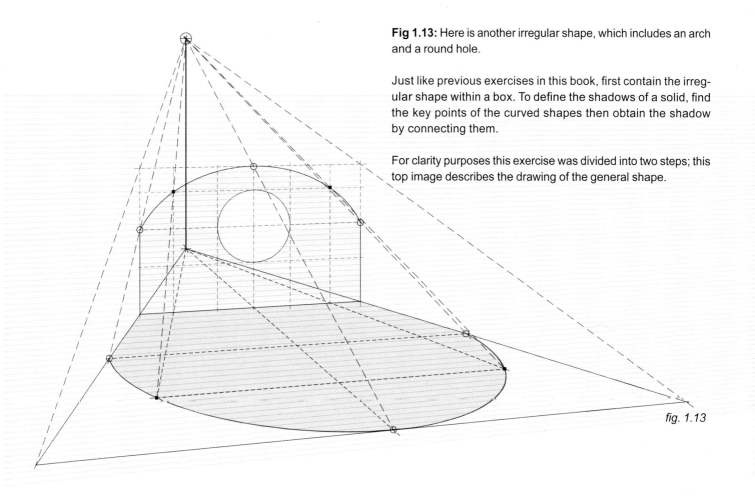

Fig 1.13: Here is another irregular shape, which includes an arch and a round hole.

Just like previous exercises in this book, first contain the irregular shape within a box. To define the shadows of a solid, find the key points of the curved shapes then obtain the shadow by connecting them.

For clarity purposes this exercise was divided into two steps; this top image describes the drawing of the general shape.

fig. 1.13

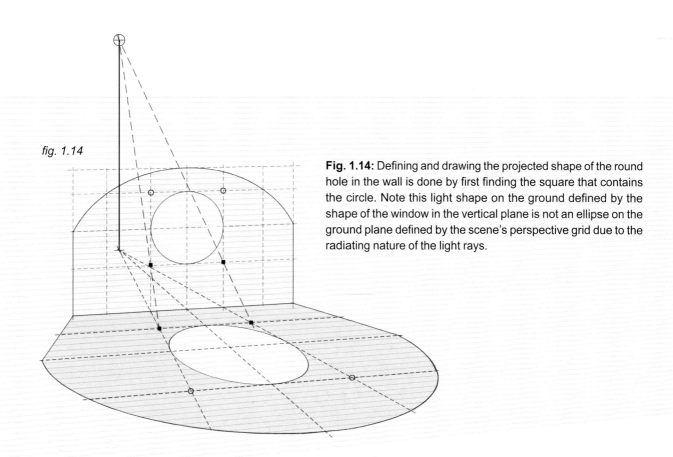

fig. 1.14

Fig. 1.14: Defining and drawing the projected shape of the round hole in the wall is done by first finding the square that contains the circle. Note this light shape on the ground defined by the shape of the window in the vertical plane is not an ellipse on the ground plane defined by the scene's perspective grid due to the radiating nature of the light rays.

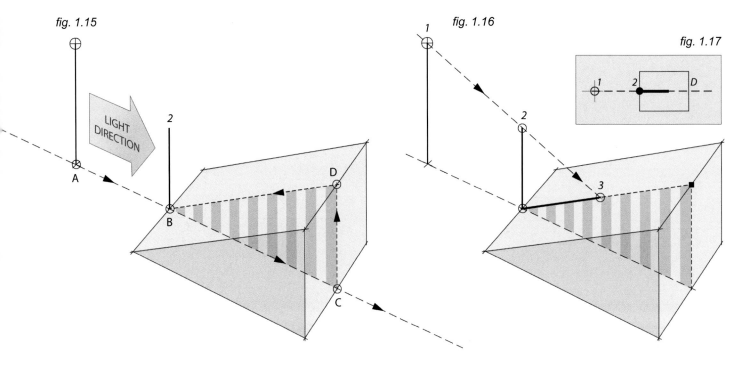

What about casting shadows on inclined planes?

Fig. 1.15: Here is a ramp with a vertical stick (2–B) right at its base. Now imagine there is no ramp. Draw a line from the foot of the light source to the base of the'stick (dotted line A–B) and extend it beyond the end of the ramp, creating point C. Project point C vertically upward to create point D. Then draw a line connecting points D and B. On this line B–D is where the stick's shadow will fall. Basically the section in stripes represents the actual shadow, if it was cutting the ramp vertically.

Fig. 1.16: To find the end of the shadow, draw a line from the light source to the top of the stick until it touches line B–D on the inclined plane. Job done.

Fig. 1.17: Interestingly, if observed from above, the shadow direction looks exactly the same with or without the ramp.

Fig. 1.18–1.19: The same procedure applies even when moving the light source around.

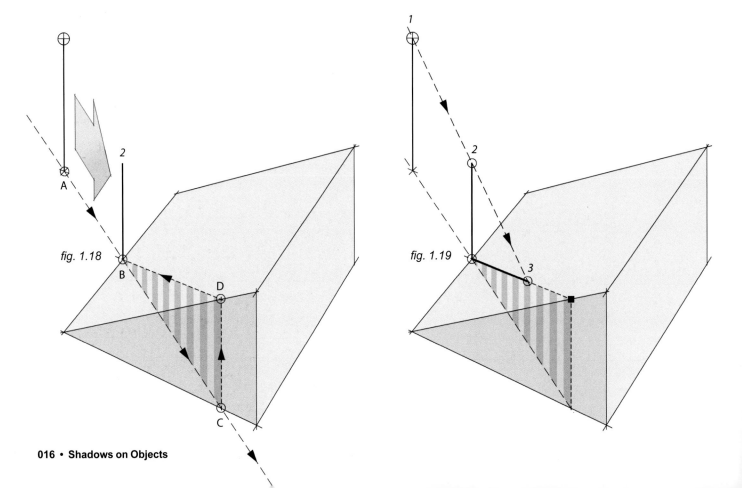

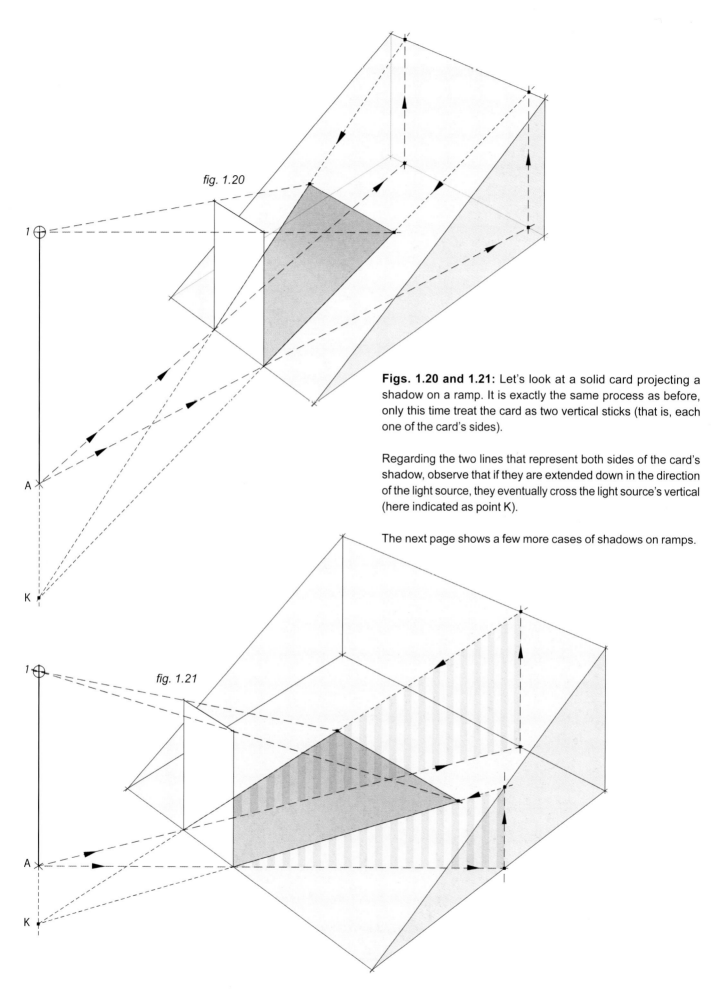

fig. 1.20

Figs. 1.20 and 1.21: Let's look at a solid card projecting a shadow on a ramp. It is exactly the same process as before, only this time treat the card as two vertical sticks (that is, each one of the card's sides).

Regarding the two lines that represent both sides of the card's shadow, observe that if they are extended down in the direction of the light source, they eventually cross the light source's vertical (here indicated as point K).

The next page shows a few more cases of shadows on ramps.

fig. 1.21

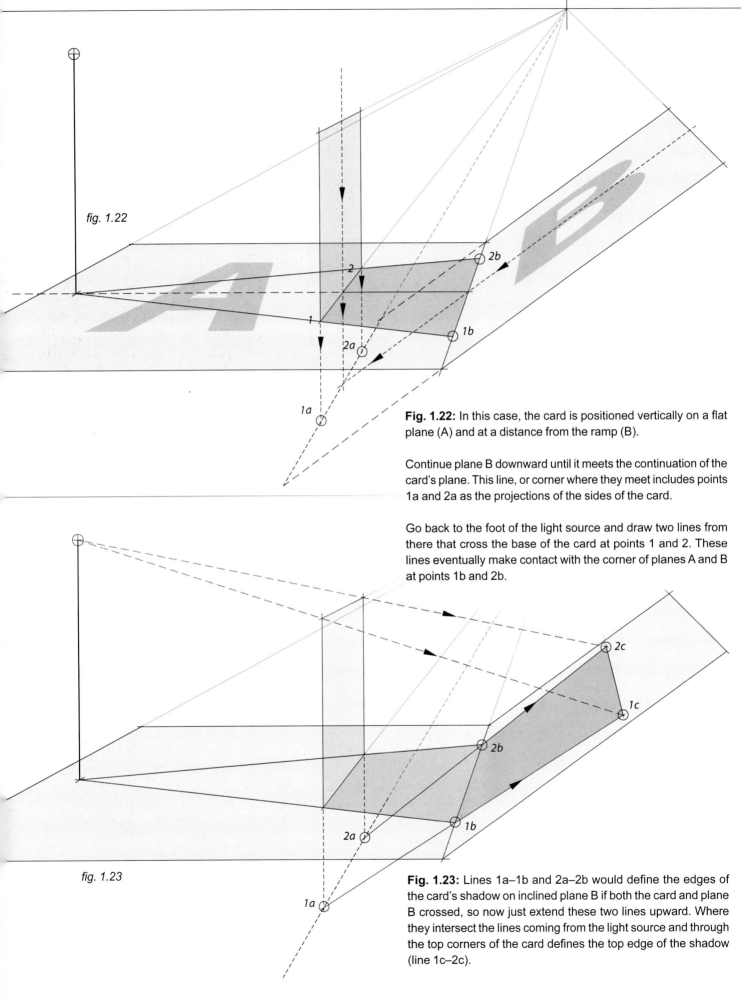

fig. 1.22

Fig. 1.22: In this case, the card is positioned vertically on a flat plane (A) and at a distance from the ramp (B).

Continue plane B downward until it meets the continuation of the card's plane. This line, or corner where they meet includes points 1a and 2a as the projections of the sides of the card.

Go back to the foot of the light source and draw two lines from there that cross the base of the card at points 1 and 2. These lines eventually make contact with the corner of planes A and B at points 1b and 2b.

fig. 1.23

Fig. 1.23: Lines 1a–1b and 2a–2b would define the edges of the card's shadow on inclined plane B if both the card and plane B crossed, so now just extend these two lines upward. Where they intersect the lines coming from the light source and through the top corners of the card defines the top edge of the shadow (line 1c–2c).

Fig. 1.24: Again, here is a shadow interrupted by an inclined surface before it can reach the ground plane.

In this case, the shadow is cast by an object located to the side of the ramp and it is tackled the same way as it was on the previous pages 017–018. This is done by bringing the two sides of the object (or house-shaped card) down to the ground plane and then using those two points of contact (circled) and the base of the light source (a) to create the lines that literally wrap around the ramp (see the arrows), going all the way back to the points of contact of the house-shaped card with the ramp.

As expected, the two resulting lines on the ramp's surface converge to point K on the vertical projection of the light source.

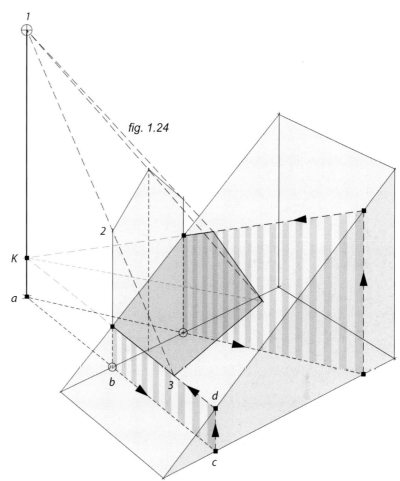

Fig. 1.25: Here is another example of light coming through a gap in a wall, and how it is projected onto another vertical wall (A) and the ground plane (B).

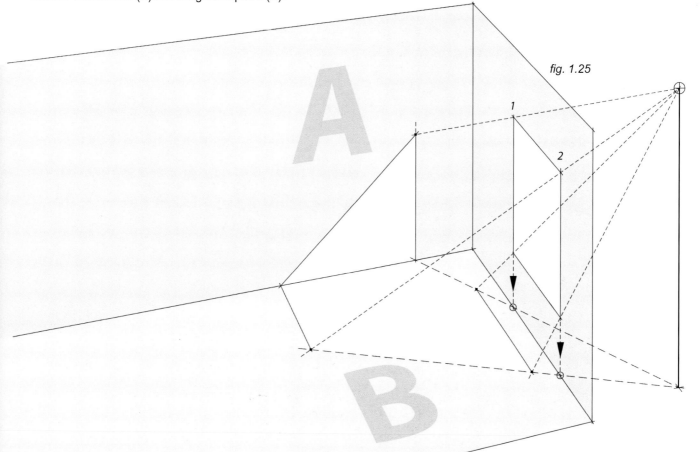

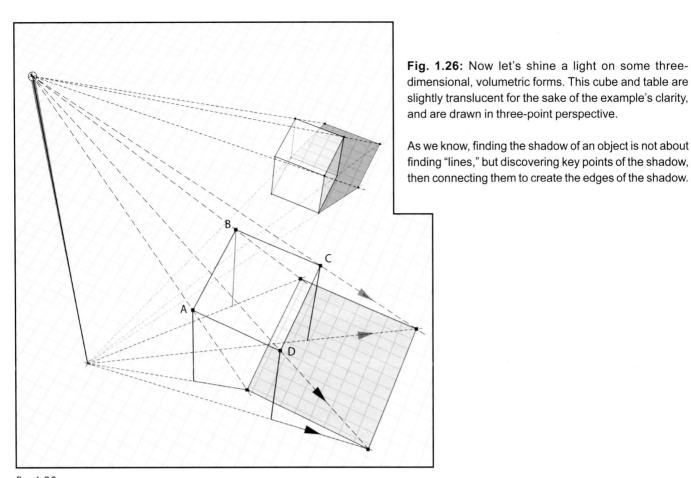

fig. 1.26

Fig. 1.26: Now let's shine a light on some three-dimensional, volumetric forms. This cube and table are slightly translucent for the sake of the example's clarity, and are drawn in three-point perspective.

As we know, finding the shadow of an object is not about finding "lines," but discovering key points of the shadow, then connecting them to create the edges of the shadow.

Observe that the only table legs with visible shadows are the two in front (A and D); B is hidden underneath the table and C is contained within the shadow of the tabletop.

Fig. 1.27: Lighting pyramids essentially follows the same process as lighting a flat triangle, as seen on page 014, fig. 1.12.

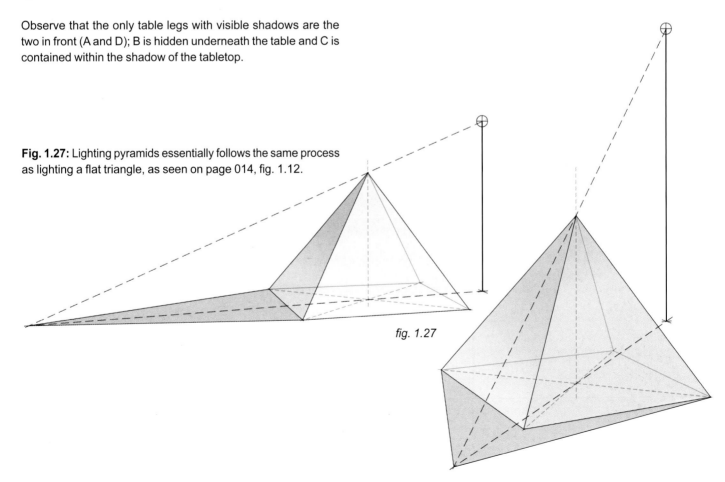

fig. 1.27

Fig. 1.28: This next exercise could be applied to a doorway, a window or a fireplace. As usual, draw a guideline from the base of the light source, through point 1, and from the light source itself through point 2. They intersect at point 3.

When drawing the projected shadow of the top of the fireplace, at some point the right wall is hit. From there, connect it to the frame's top-right corner.

Fig. 1.29: Here is yet another curved object casting a shadow. For this fountain-like piece it is done in two steps, starting with the base. Draw as many verticals as needed to properly represent the area of the cylinder on the shadow side. Find the shadow points of each of these "sticks" and then connect them to obtain the desired shadow.

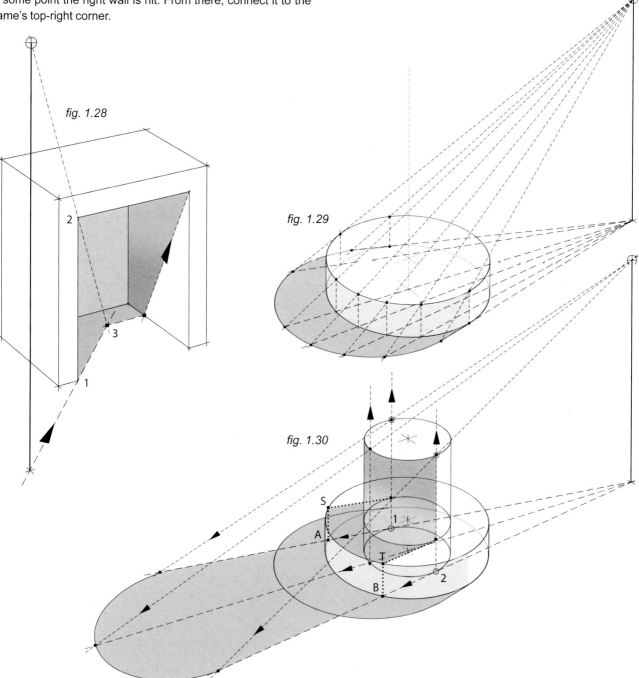

fig. 1.28

fig. 1.29

fig. 1.30

Fig. 1.30: After completing the base, move on to the top cylinder. Make sure to draw the cylinder all the way to the ground and then draw the shadow as if the bigger, wider base does not exist. Draw guidelines from the base of the light source tangent to either side of the ellipse (on the ground plane), creating points 1 and 2 (circled).

Project points 1 and 2 upward. Where those lines intersect the top of the cylinder, draw guidelines from the light source through them, all the way to the ground plane.

Finally draw verticals from points A and B upward, until they reach the top of the base at points S and T, then draw tangent lines to the bottom of the visible part of the thinner cylinder (see dotted lines).

Fig. 1.31: Let's project the shadow of an inclined plane (P) onto another inclined plane (Q), like the shadow of a rooftop onto another rooftop.

Same drill as the previous inclined planes: Extend the ramp on which the shadow will fall, down to the ground plane (points 1 and 2).

Next, draw a line from the base of the light source (point A) through the base of the vertical whose shadow is to be cast (point B) all the way to the base of the distant vertical wall (point

D). "Wrap the line" around the object by heading vertically to point E and then back down to point C which is on the original line A–D so that line C–E is the representation of C–D on the surface of the inclined plane where the shadow is needed.

Point F, the intersection of line E–C and the line coming straight from the light source, is the key point for the shadow to be drawn.

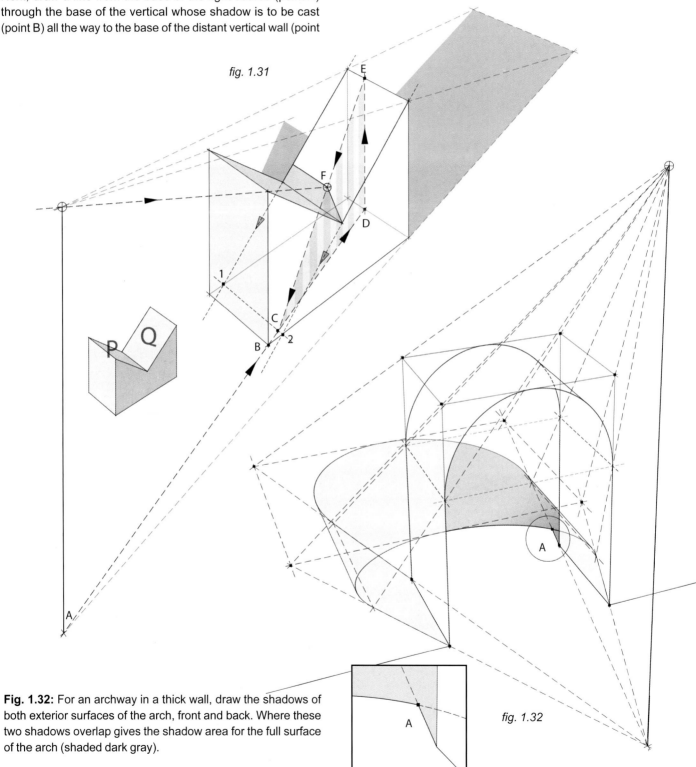

fig. 1.31

fig. 1.32

Fig. 1.32: For an archway in a thick wall, draw the shadows of both exterior surfaces of the arch, front and back. Where these two shadows overlap gives the shadow area for the full surface of the arch (shaded dark gray).

Inset: Notice the way these two shadows overlap in that particular crossing creates not a smooth curve but actually an angle.

What about the shadow projected on the inner wall of the arch?

Fig. 1.33 (right): It is simple; use the same system. From the light source, project several specific points from the arch onto the inner wall.

Fig. 1.34 (below): The light source intersects the front wall of the arch at points 1–5, and intersects the inner wall at points 1a–5a. Connect those points to find the curve of the shadow's lower edge. If the curve were to continue down to the ground plane, it would intersect point A, where the two visible lines of the shadow's edge on the ground meet.

Incidentally, if this is the only light source, then the room beyond the arch is in total darkness.

Fig. 1.35: Now the light source is coming from a different direction than in the other drawings. When key points for the shadow's edge are on the curved area of the arch itself (point F, as we will eventually find out), first project the point onto the vertical wall behind it (point AA), then bring it up to the surface of the arch following the process visualized here. This is essentially the same process that is used for shadows on inclined planes: Find the key point on the flat surface and then project it to the object's surface.

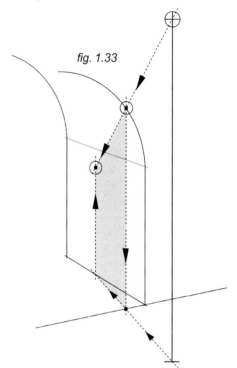

fig. 1.33

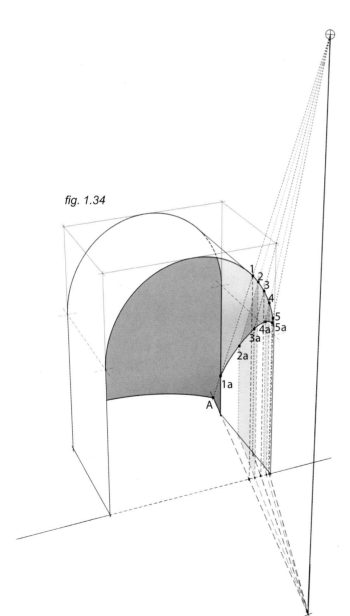

fig. 1.34

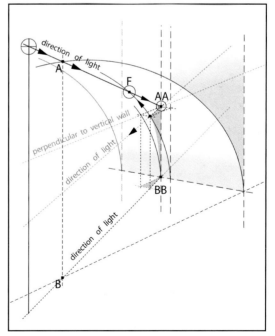

fig. 1.35

AA-BB: Vertical on which light hits the flat wall.
AA: Shadow point projected on the vertical wall.
F: The final point we were looking for.

Fig. 1.36: To get the appropriate shadows for this house, start with the eave (overhang). First, project its corner (point A) vertically to the ground plane (point B).

Next, draw guidelines from the light source and its base through points A and B respectively, onto the building's façade, creating points "aa" and "bb."

Point "aa" is the projection of the eave's corner on the façade. Draw a line from there to where the front corner meets the roof (point C), and then draw a parallel to the roof's edge from point "aa" to the opposite corner, (point D). These two lines (aa–C and aa–D) define the eave's shadow.

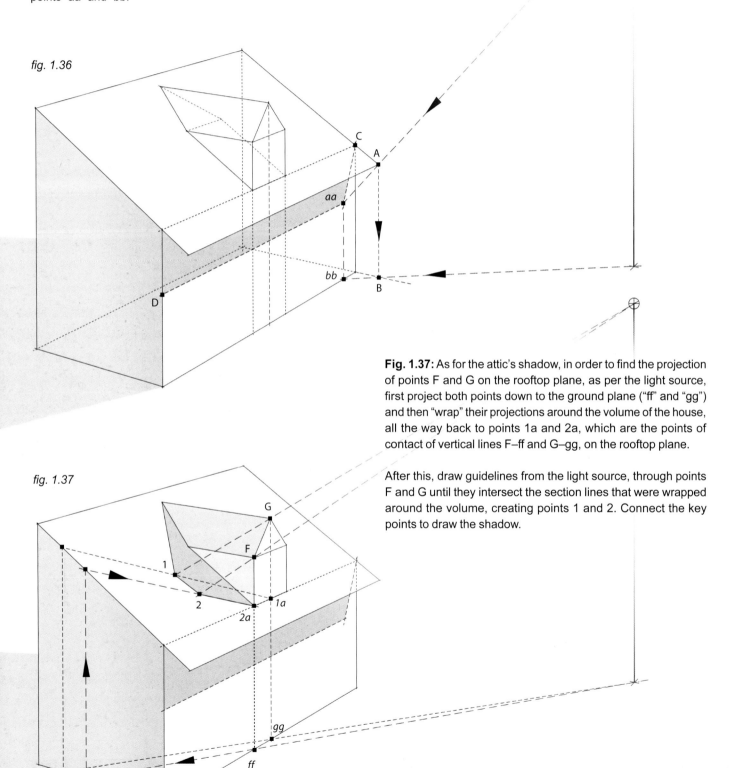

fig. 1.36

fig. 1.37

Fig. 1.37: As for the attic's shadow, in order to find the projection of points F and G on the rooftop plane, as per the light source, first project both points down to the ground plane ("ff" and "gg") and then "wrap" their projections around the volume of the house, all the way back to points 1a and 2a, which are the points of contact of vertical lines F–ff and G–gg, on the rooftop plane.

After this, draw guidelines from the light source, through points F and G until they intersect the section lines that were wrapped around the volume, creating points 1 and 2. Connect the key points to draw the shadow.

Fig. 1.38: Now for a staircase. To determine the shadow of the bottom stair on the ground plane, start by finding the shadows of its two front edges or corners (labeled A and B) as though they were sticks. This finds points C and D. Connect them to obtain the desired shadow.

Going one step up, this shadow is found the same way that has been practiced for inclined planes or elevated planes. Start at the foot of the light source and then "wrap" the line around the stair (see points 1, 2, 3 and 5).

To find point 4, the corner of the shadow, draw a line from the light source through the top corner of the step (Point E).

fig. 1.38

Fig. 1.39: For the shadow cast by the top step onto the middle one, repeat the same "wrapping" exercise. However in this case, the middle step is too narrow to do this. Therefore, extend the width of the middle step as much as is needed, (line 1-1a), in order to have the elements necessary to do the "wrapping."

fig. 1.39

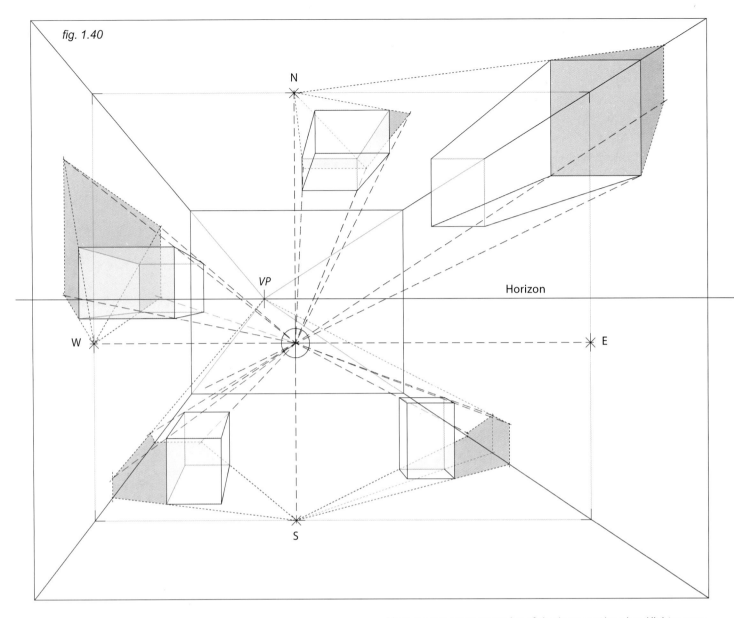

fig. 1.40

N

VP

Horizon

W

E

S

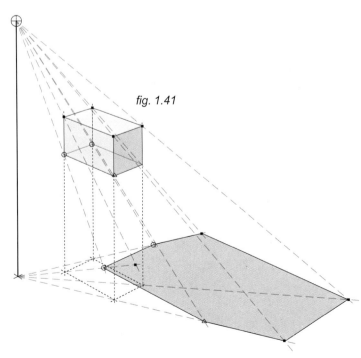

fig. 1.41

Here are two more examples of shadows cast by a local light source.

Fig. 1.40: Here is a room where the light source is either on a stand or hanging from the ceiling. Some objects are on the floor; others are attached to the ceiling or the walls.

To deal with this scenario, project the light source onto every wall (creating points N, S, E and W). These points will operate as the base of the light source, as seen in all of the previous examples, only this time they represent not only the vertical projection of the light source, but also its horizontal projection.

Fig. 1.41: To find the shadow of a floating object with a light source positioned above it, draw the projection of the object onto the floor so that the whole thing can be treated as a full polyhedron of which the lower section will eventually be cut off.

If the light source was located at a level lower than the box, do exactly the same thing but inverted, meaning the projection of the box would need to be found on the ceiling.

Fig. 1.42: When the light source is at an "immeasurable" distance from the viewer, like the sun or the moon, the mechanics are essentially the same; the difference is that the projection of the light source on the ground (point A) is found on the horizon.

Observe how this works when looking toward the light source.

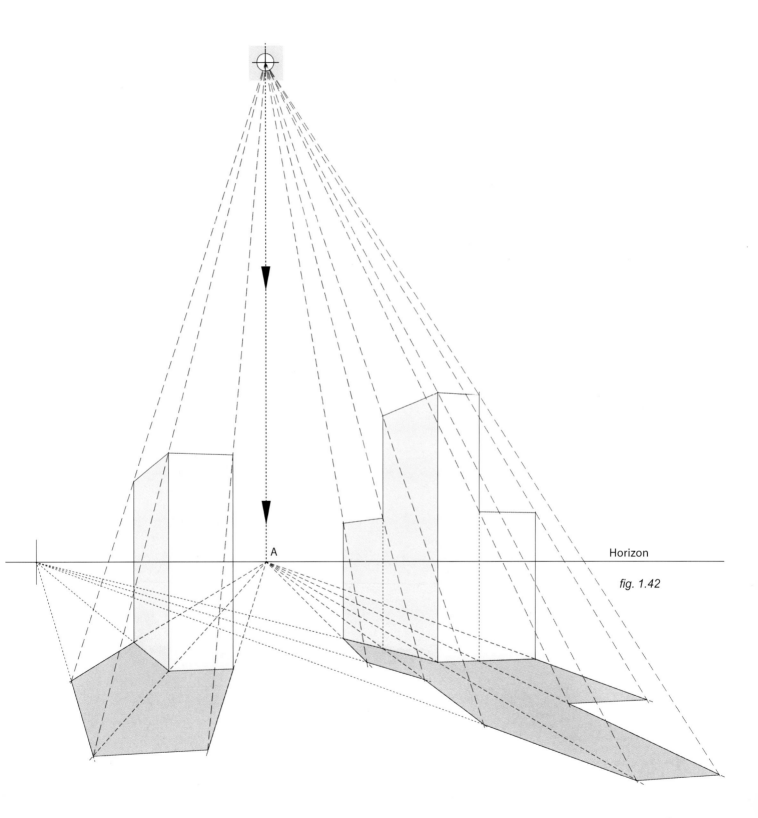

Horizon

fig. 1.42

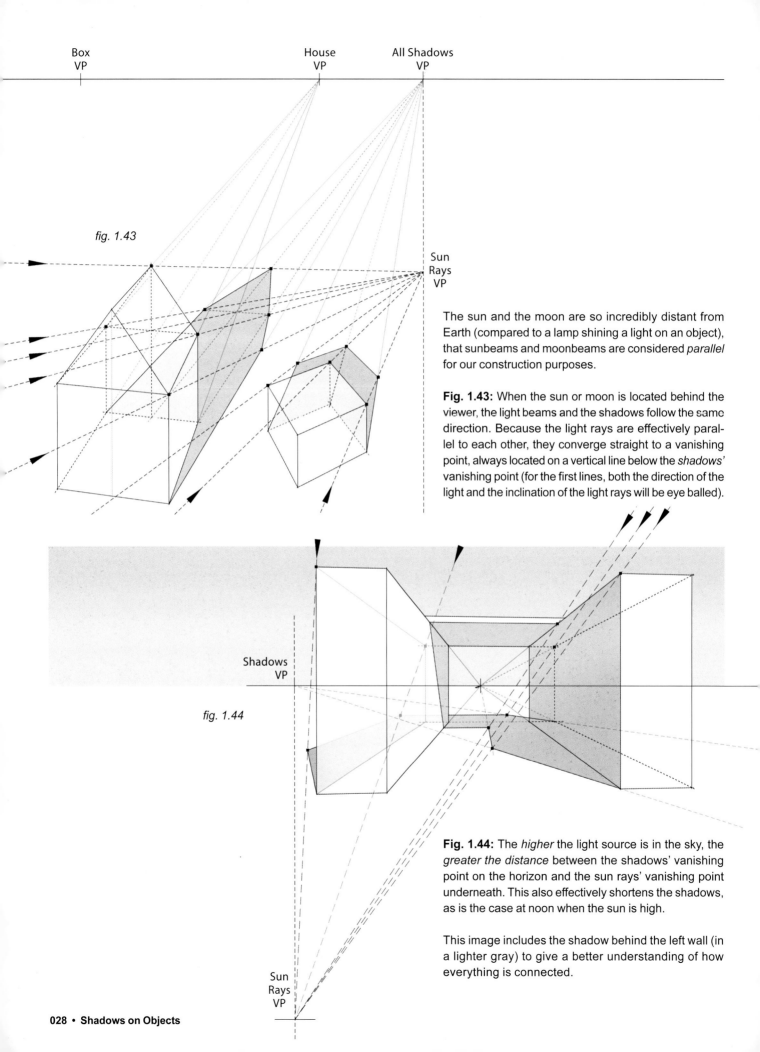

Box VP

House VP

All Shadows VP

fig. 1.43

Sun Rays VP

The sun and the moon are so incredibly distant from Earth (compared to a lamp shining a light on an object), that sunbeams and moonbeams are considered *parallel* for our construction purposes.

Fig. 1.43: When the sun or moon is located behind the viewer, the light beams and the shadows follow the same direction. Because the light rays are effectively parallel to each other, they converge straight to a vanishing point, always located on a vertical line below the *shadows'* vanishing point (for the first lines, both the direction of the light and the inclination of the light rays will be eye balled).

Shadows VP

fig. 1.44

Sun Rays VP

Fig. 1.44: The *higher* the light source is in the sky, the *greater the distance* between the shadows' vanishing point on the horizon and the sun rays' vanishing point underneath. This also effectively shortens the shadows, as is the case at noon when the sun is high.

This image includes the shadow behind the left wall (in a lighter gray) to give a better understanding of how everything is connected.

Fig. 1.45: When rays of sunlight come perfectly from the side they appear parallel to each other and the direction of the shadow on the ground plane is perfectly horizontal.

This cube has been rendered a bit translucently to show how the shadow works.

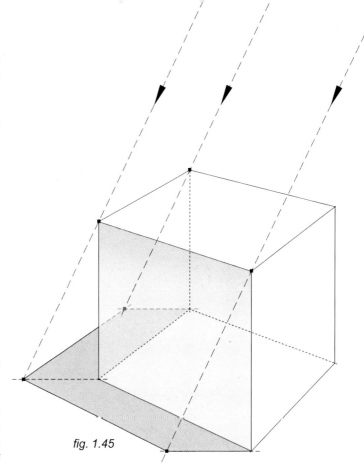

fig. 1.45

Fig. 1.46: Below is a more complex case, also with sunlight coming from the side.

Observe that line A–B is interrupted by a large, volumetric shape in the form of a box attached to the right of the main object. In this case, draw the entire line from point A to B as if no obstacle were there, and then project points "A1" and "B1" to the side of the box on which the shadow will be projected (between points "A2" and "B2") following the wall's vanishing point.

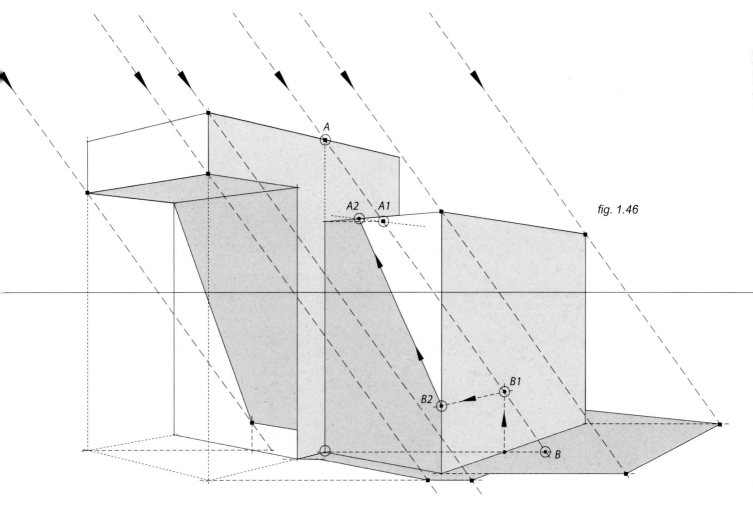

fig. 1.46

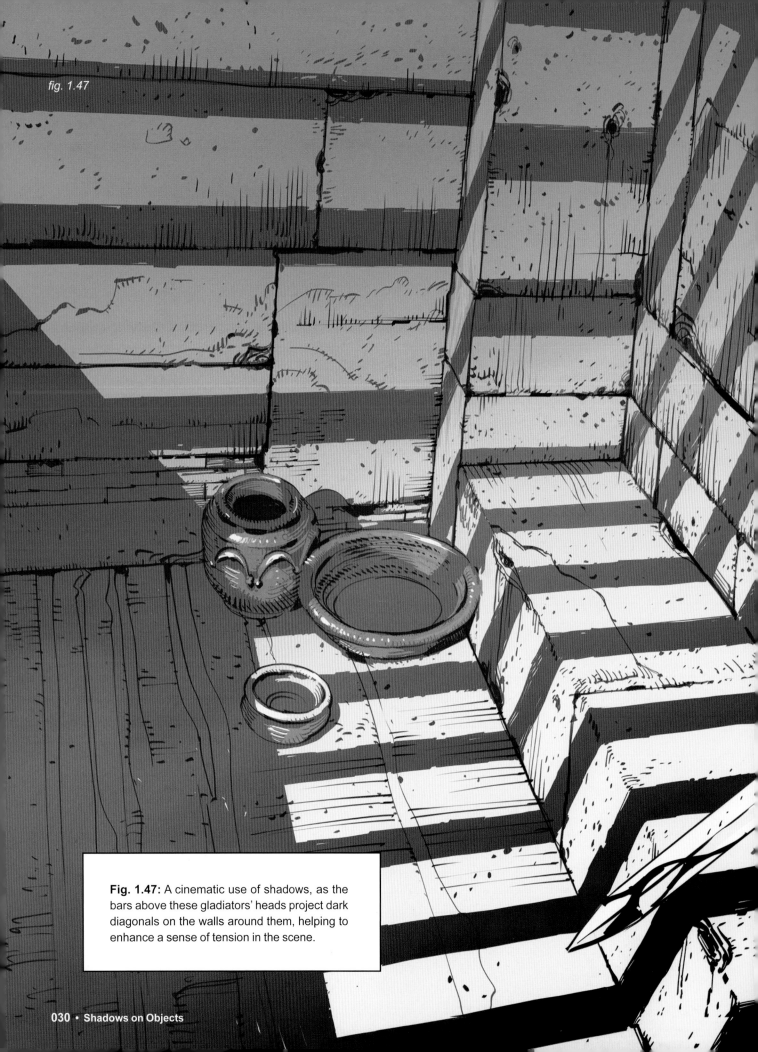

fig. 1.47

Fig. 1.47: A cinematic use of shadows, as the bars above these gladiators' heads project dark diagonals on the walls around them, helping to enhance a sense of tension in the scene.

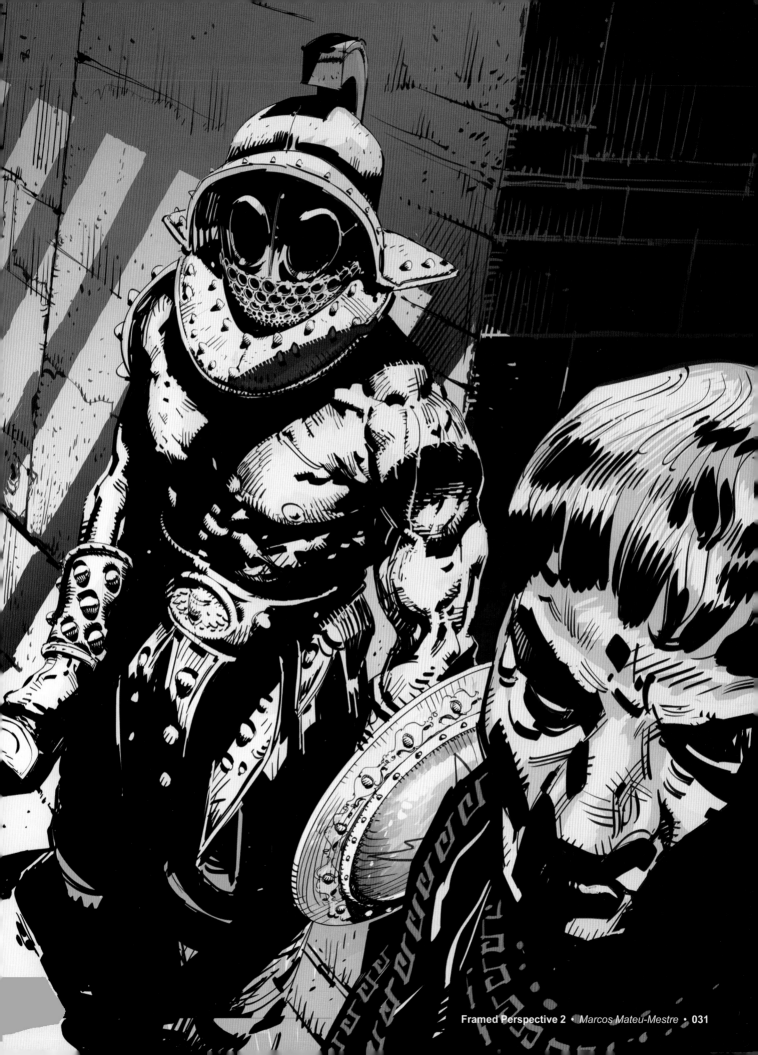

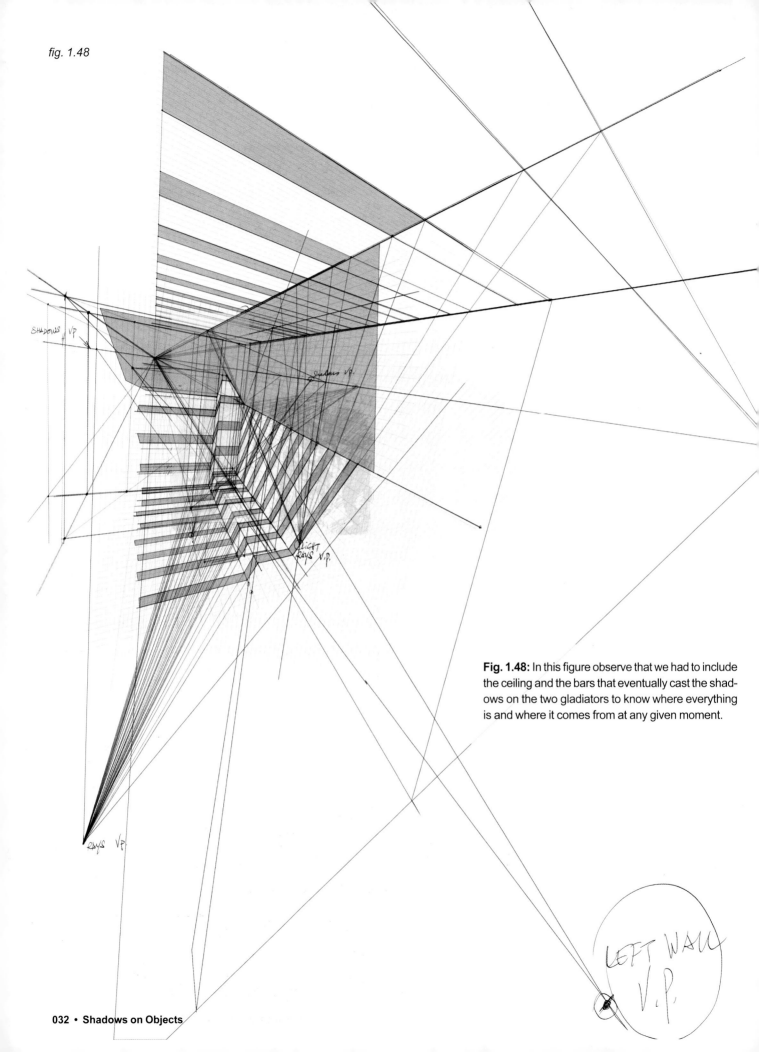

fig. 1.48

SHADOWS VP

Shadows VP.

LIGHT RAYS V.P.

RAYS VP.

LEFT WALL V.P.

Fig. 1.48: In this figure observe that we had to include the ceiling and the bars that eventually cast the shadows on the two gladiators to know where everything is and where it comes from at any given moment.

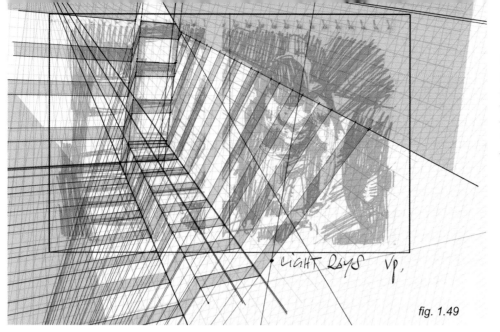

Fig. 1.49: This figure is a view of one of the steps. Note we still have the original sketch we are trying to adhere to. Remember, first there is the artistic view or vision, then we bring it into 'reality' through the use of the perspective principles, modeled in this book.

LIGHT RAYS VP.

fig. 1.49

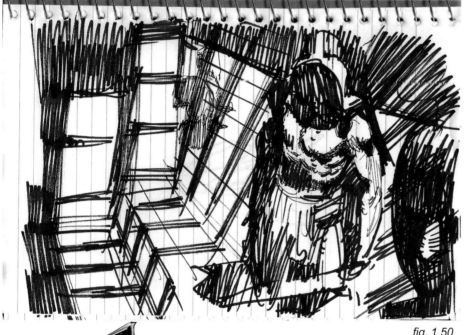

fig. 1.50

Fig. 1.50: This is the original sketch, drawn purely by intuition. Experience and practice will take you to the point where even a small thumbnail will follow at least the basic rules of perspective quite reasonably.

Fig. 1.51 (below): The choice of a Murmillo helmet for this drawing, out of all the types of gladiator helmets, was motivated by its capability to cast incredibly graphic shadows on the fighter's torso. (Photo-based sketches are from the author's personal files.)

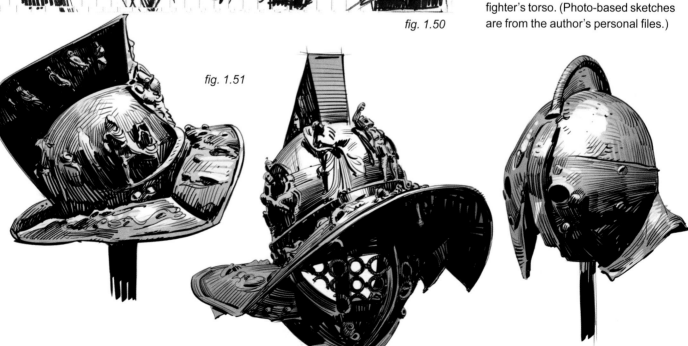

fig. 1.51

fig. 1.52

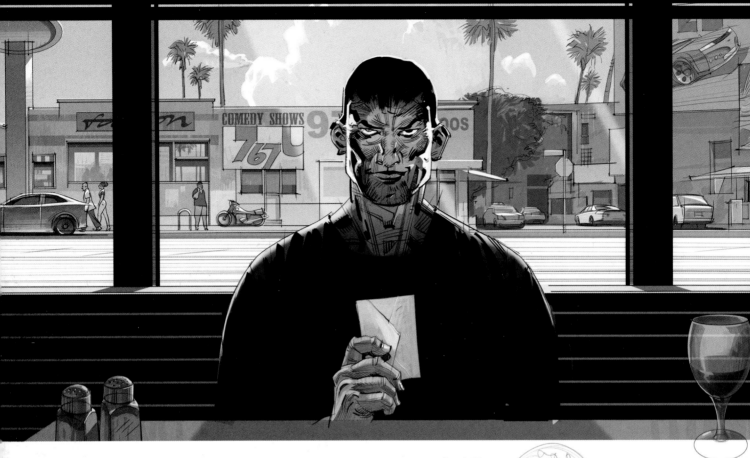

Fig. 1.52: Technicalities aside, directly backlighting a scene offers us the possibility of going very graphic and straight forward, creating clear and dramatic shots with the use of rimlights.

Fig. 1.53 (right): This is a sketch for "The Passage Ahead" illustration shown on the next page. See that we always have to visualize the horizon and vanishing points, for both the architectural elements as well as for the shadows themselves.

Fig. 1.54 (next page): Setting up the light source behind the camera allows the characters, in this case, to stand out in a pool of light up against a dark backdrop.

fig. 1.53

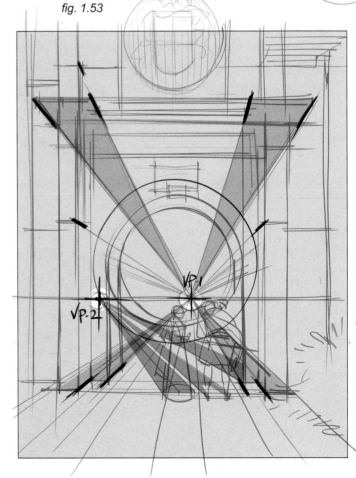

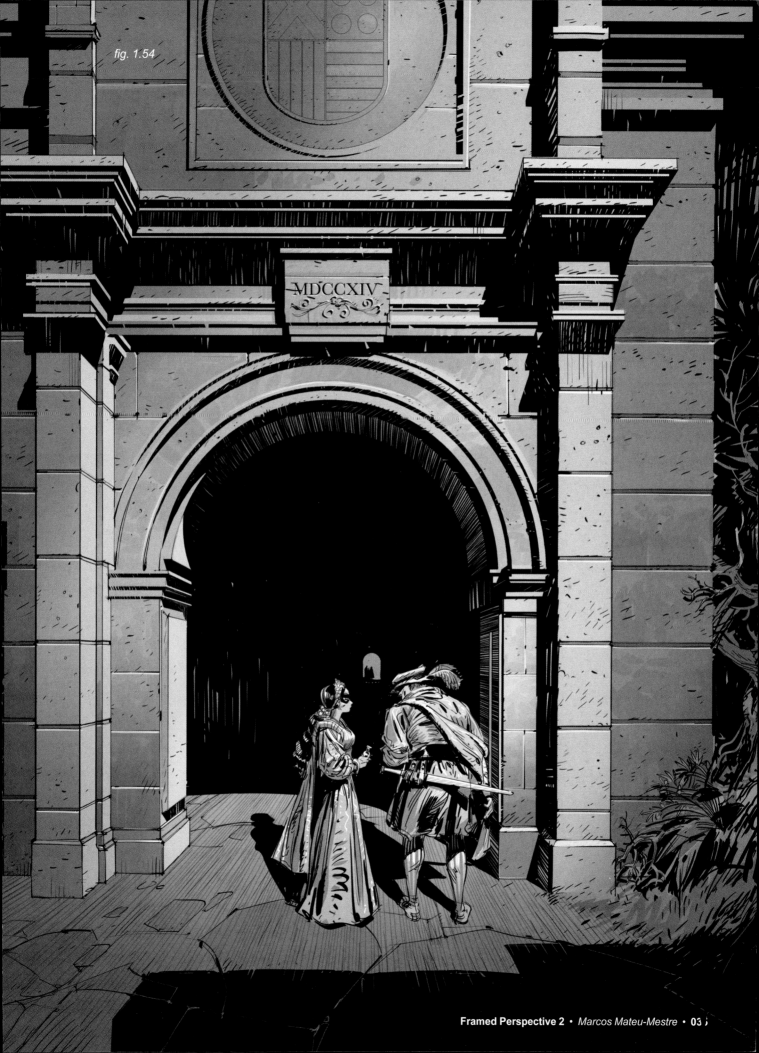

fig. 1.54

MDCCXIV

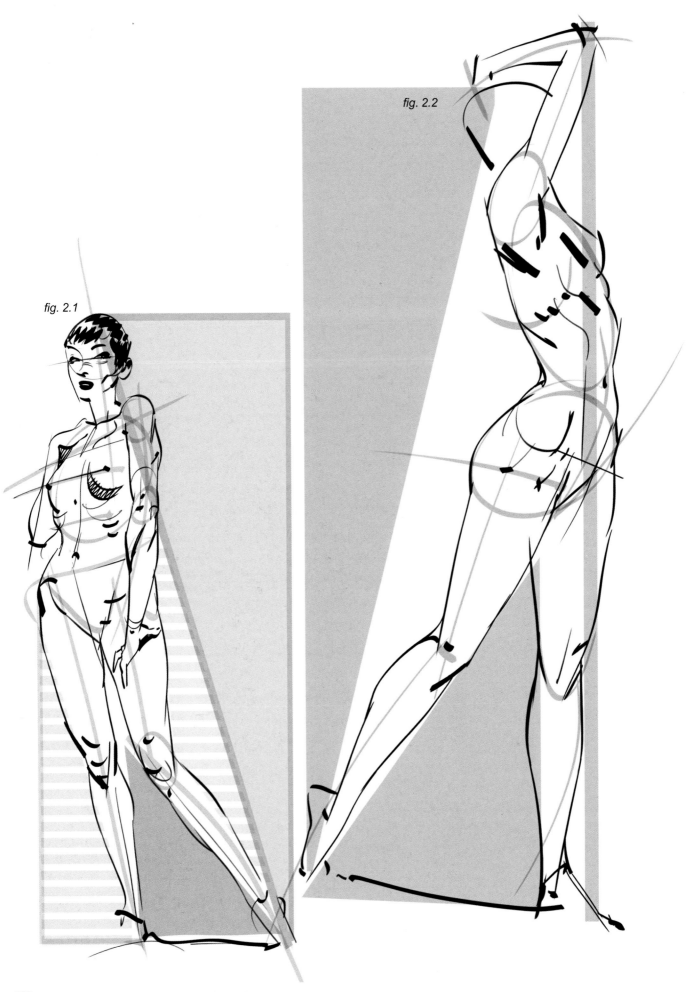

fig. 2.1

fig. 2.2

2

CHARACTERS IN PERSPECTIVE

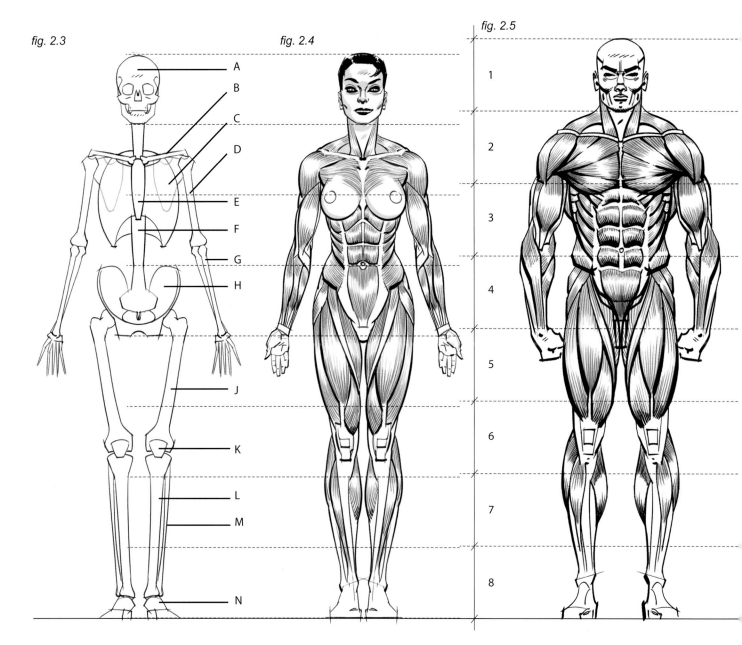

fig. 2.3

A
B
C
D
E
F
G
H
J
K
L
M
N

fig. 2.4

fig. 2.5

1
2
3
4
5
6
7
8

All of the lessons of the previous chapters can be applied to drawing the human figure, specifically comparing distances and proportions, recognizing negative space, and finding angles of inclination.

The first step in being able to draw a human body is to study the bare minimum amount of anatomy to understand its general structure. This structure is based on bones and muscles that create shapes.

Fig. 2.3: This illustration shows the basic bones that support the entire anatomy of the body, with their names listed on page 039.

Figs. 2.4 and 2.5: The height of an average human body of rather athletic/heroic proportions is approximately 8 times the height of its own head.

Figs. 2.6–2.9: Observe a human body from the front, side and back; all of the muscles shown make three-dimensional sense. Their names are numbered and listed at the bottom of page 039.

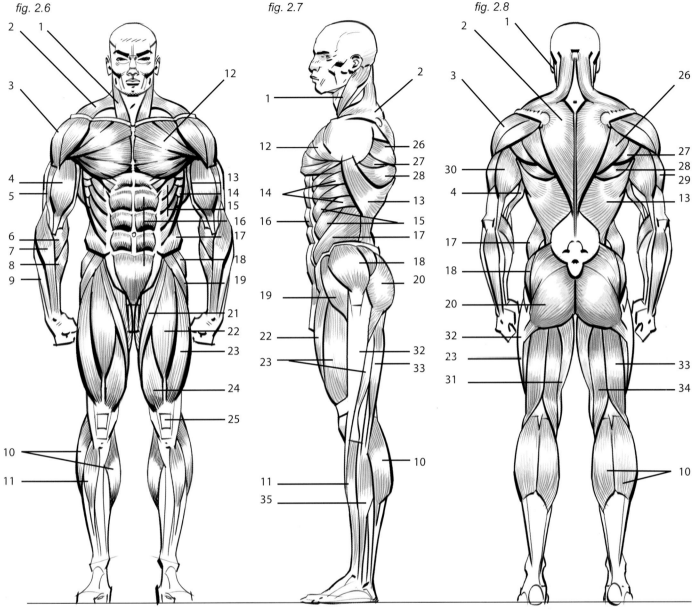

fig. 2.6 *fig. 2.7* *fig. 2.8*

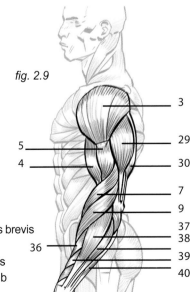

fig. 2.9

A- Skull
B- Clavicle
C- Scapula
D- Humerus
E- Sternum
F- Spine
G- Radius
H- Hipbone
J- Femur
K- Patella
L- Tibia
M- Fibula
N- Tarsal bones

1- Sternocleidomastoid
2- Trapezius
3- Deltoid
4- Biceps

5- Brachialis anticus
6- Pronator teres
7- Supinator longus
8- Flexor carpi radialis
9- Extensor carpi radialis
10- Gastrocnemius (calf)
11- Tibialis anterior
12- Pectoralis major
13- Latissimus dorsi
14- Serratus anterior
15- Serratus magnus
16- Rectus abdominis
17- External oblique
18- Gluteus medius
19- Tensor fasciae latae
20- Gluteus maximus
21- Sartorius
22- Rectus femoris

23- Vastus lateralis
24- Vastus medialis
25- Patella (kneecap)
26- Infraspinatus
27- Teres minor
28- Teres major
29- Triceps outer head
30- Triceps long head
31- Gracilis
32- Iliotibial tract
33- Biceps femoris
34- Semitendinosus
35- Peroneus longus
36- Extensor carpi radialis brevis
37- Extensor digitorum
38- Extensor carpi ulnaris
39- Extensor of the thumb
40- Flexor carpi ulnaris

It is important to understand the main differences between the general shapes of the male anatomy versus the female anatomy. Here are a number of indications that make that easier.

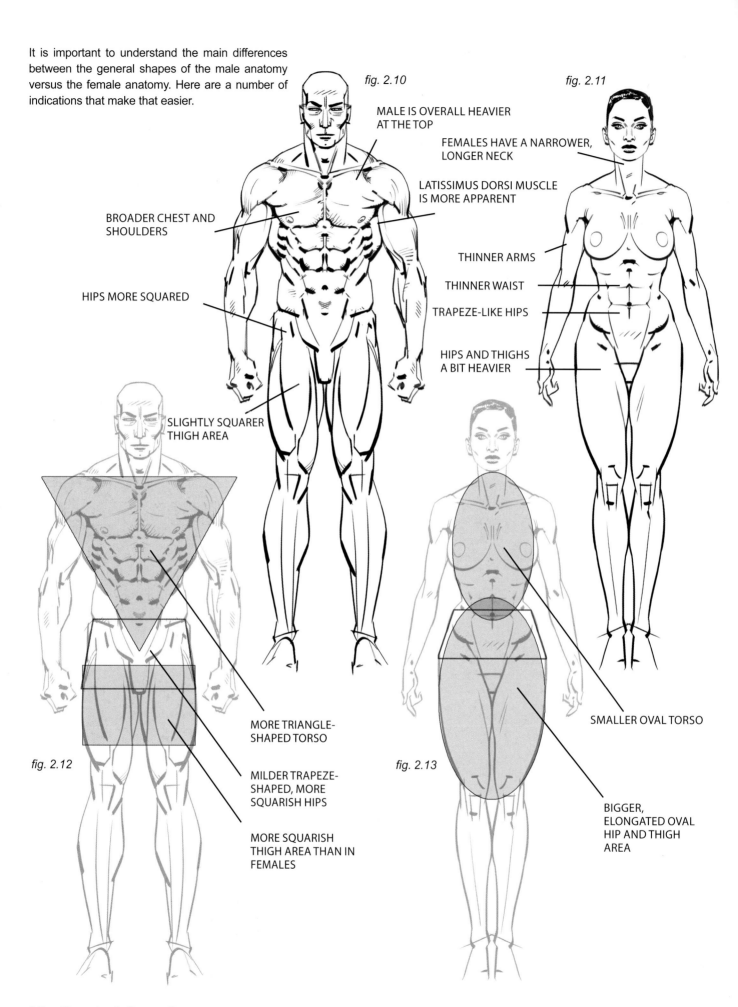

fig. 2.10

fig. 2.11

MALE IS OVERALL HEAVIER AT THE TOP

FEMALES HAVE A NARROWER, LONGER NECK

LATISSIMUS DORSI MUSCLE IS MORE APPARENT

BROADER CHEST AND SHOULDERS

THINNER ARMS

THINNER WAIST

HIPS MORE SQUARED

TRAPEZE-LIKE HIPS

HIPS AND THIGHS A BIT HEAVIER

SLIGHTLY SQUARER THIGH AREA

MORE TRIANGLE-SHAPED TORSO

SMALLER OVAL TORSO

fig. 2.12

MILDER TRAPEZE-SHAPED, MORE SQUARISH HIPS

fig. 2.13

MORE SQUARISH THIGH AREA THAN IN FEMALES

BIGGER, ELONGATED OVAL HIP AND THIGH AREA

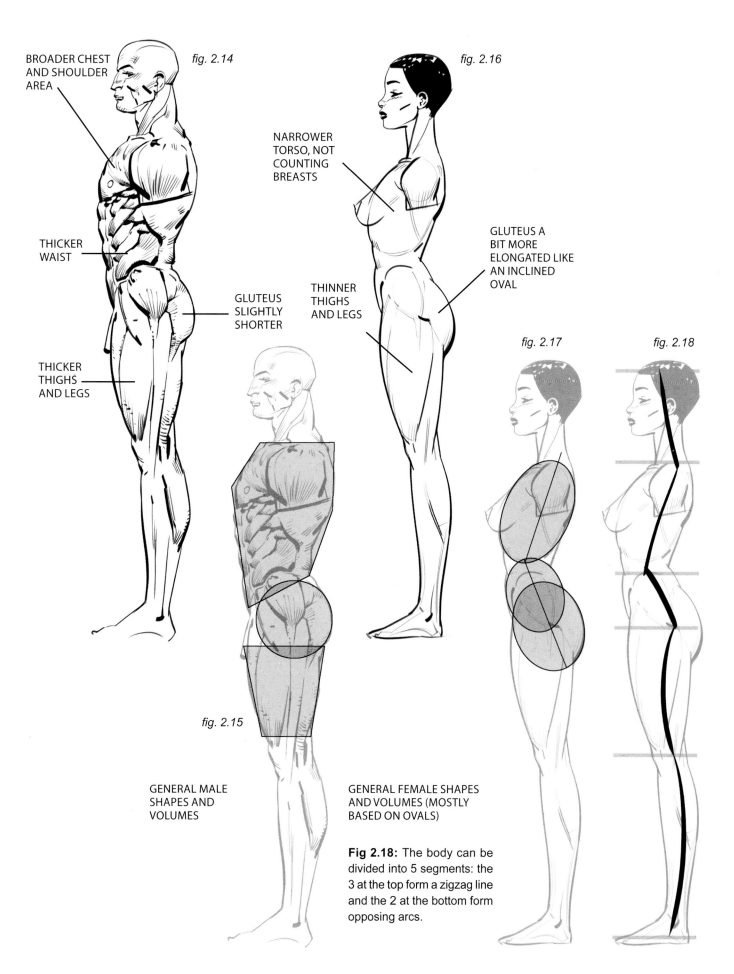

BROADER CHEST AND SHOULDER AREA

fig. 2.14

THICKER WAIST

GLUTEUS SLIGHTLY SHORTER

THICKER THIGHS AND LEGS

NARROWER TORSO, NOT COUNTING BREASTS

fig. 2.16

GLUTEUS A BIT MORE ELONGATED LIKE AN INCLINED OVAL

THINNER THIGHS AND LEGS

fig. 2.17

fig. 2.18

fig. 2.15

GENERAL MALE SHAPES AND VOLUMES

GENERAL FEMALE SHAPES AND VOLUMES (MOSTLY BASED ON OVALS)

Fig 2.18: The body can be divided into 5 segments: the 3 at the top form a zigzag line and the 2 at the bottom form opposing arcs.

Besides dynamics, proportion, and anatomy, it is important to understand the basic volumes contained within the human figure, as these become key elements in determining the correct shapes, lighting and perspective to draw.

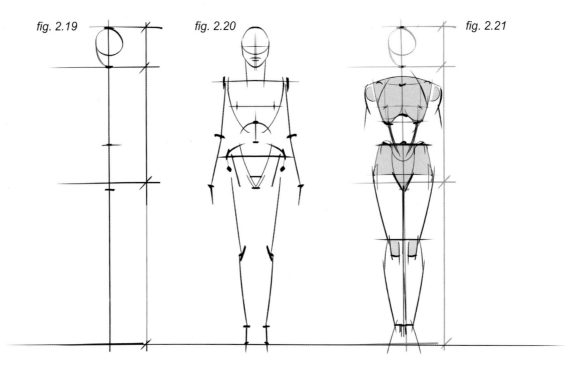

fig. 2.19 fig. 2.20 fig. 2.21

Fig. 2.19: A common height for a standing female figure is "eight heads," meaning that total height equals the height of the head multiplied by eight. To start, divide a vertical line into eight equal parts. But remember, each body type is different and the height "in heads" is not always eight.

The mid-point of the figure's total height coincides with the area just above the crotch.

Fig. 2.20: Next, define the points where the torso, hips, knees, ankles, shoulders, elbows, and wrists are.

Fig. 2.21: Define the volumes bordered by these body landmarks so that the figure starts to take proper shape.

Fig. 2.22: Use a volume like this inverted teardrop shape (shaded gray) to define the shape of the hips and thighs.

Fig. 2.23: It is time to define the legs and arms...

Fig. 2.24: ...and then to do the final render of the character.

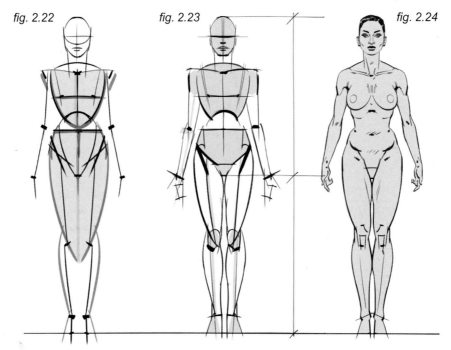

fig. 2.22 fig. 2.23 fig. 2.24

Figs. 2.25–2.29: Here are more examples of the human body represented as volumes in specific perspectives, which is the nitty-gritty of this chapter. Once the overall proportions of a figure are understood, as well as how its basic volumes fit within those proportions, it can be more easily rotated in space and represented from different points of view.

fig. 2.25

fig. 2.26

fig. 2.27

fig. 2.28

fig. 2.29

Remember to pay close attention to people and objects in everyday life. Once the technical aspects discussed here are understood it is important to continue to attend life-drawing classes as much as possible. It is very helpful to observe and draw subjects from different angles as they hold the same pose.

Your understanding of depth and volume will increase, and you will start to create a visual archive in your memory, which in turn will aid your power of observation and improve your drawings. We live in a three-dimensional world and it is important to use this sense of space and volume in our work.

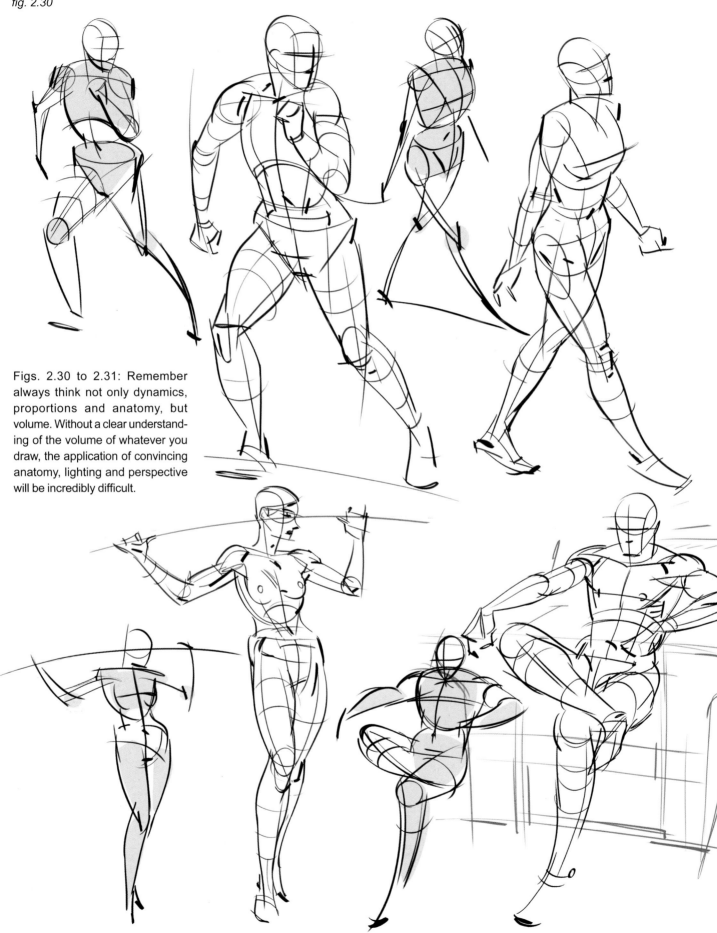

fig. 2.30

Figs. 2.30 to 2.31: Remember always think not only dynamics, proportions and anatomy, but volume. Without a clear understanding of the volume of whatever you draw, the application of convincing anatomy, lighting and perspective will be incredibly difficult.

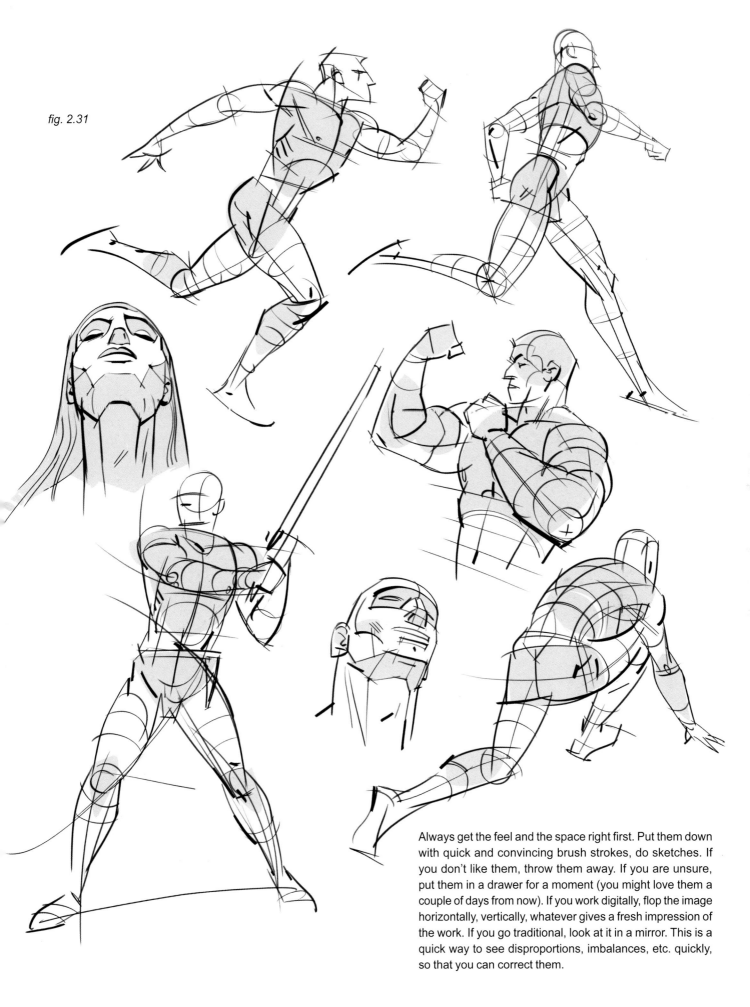

fig. 2.31

Always get the feel and the space right first. Put them down with quick and convincing brush strokes, do sketches. If you don't like them, throw them away. If you are unsure, put them in a drawer for a moment (you might love them a couple of days from now). If you work digitally, flop the image horizontally, vertically, whatever gives a fresh impression of the work. If you go traditional, look at it in a mirror. This is a quick way to see disproportions, imbalances, etc. quickly, so that you can correct them.

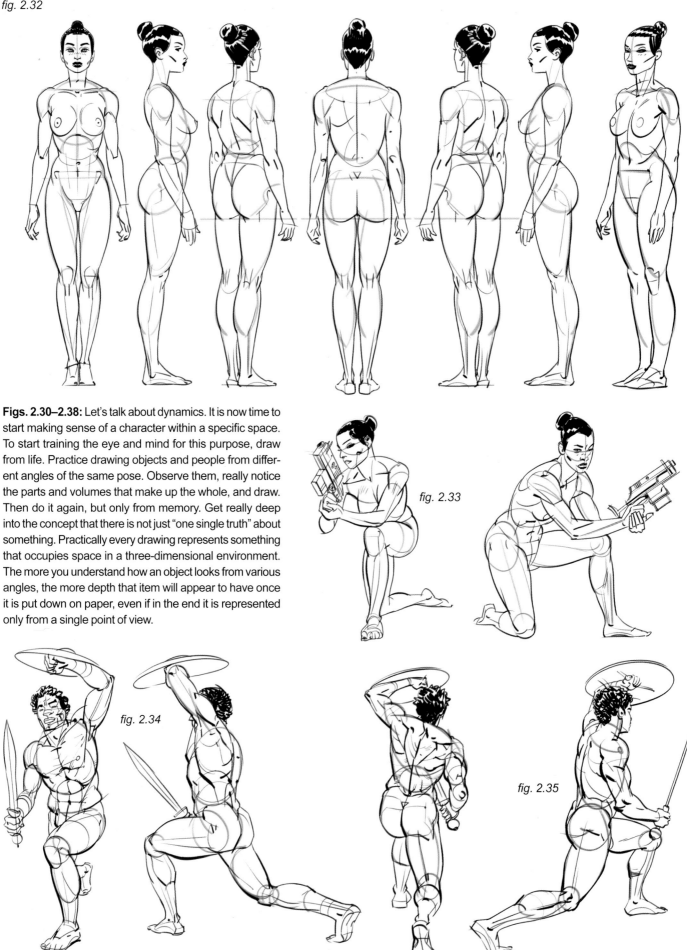

fig. 2.32

fig. 2.33

fig. 2.34

fig. 2.35

Figs. 2.30–2.38: Let's talk about dynamics. It is now time to start making sense of a character within a specific space. To start training the eye and mind for this purpose, draw from life. Practice drawing objects and people from different angles of the same pose. Observe them, really notice the parts and volumes that make up the whole, and draw. Then do it again, but only from memory. Get really deep into the concept that there is not just "one single truth" about something. Practically every drawing represents something that occupies space in a three-dimensional environment. The more you understand how an object looks from various angles, the more depth that item will appear to have once it is put down on paper, even if in the end it is represented only from a single point of view.

As mentioned earlier, there are three crucial concepts to keep in mind the moment you start to draw characters: **perspective, dynamics,** and **volume.**

Whether within the confines of a specific environment, with its defined perspective space and vanishing points, or when the character is isolated from any of these circumstances, like a body floating in space, the figures always need to obey the basic rules of perspective. A character has structural lines, or points that are aligned in such a way that they do in fact form lines, like the line

that goes from shoulder to shoulder, knee to knee, hip to hip, or the two points at either side of the base of the rib cage. These lines need to converge to their own vanishing point.

How exaggerated or dramatic the perspective looks depends again on whether a longer or a wide-angle lens is used. I recommend reserving the use of wide-angle lenses for the most dramatic moments within a story, whether they involve extreme action or extreme drama.

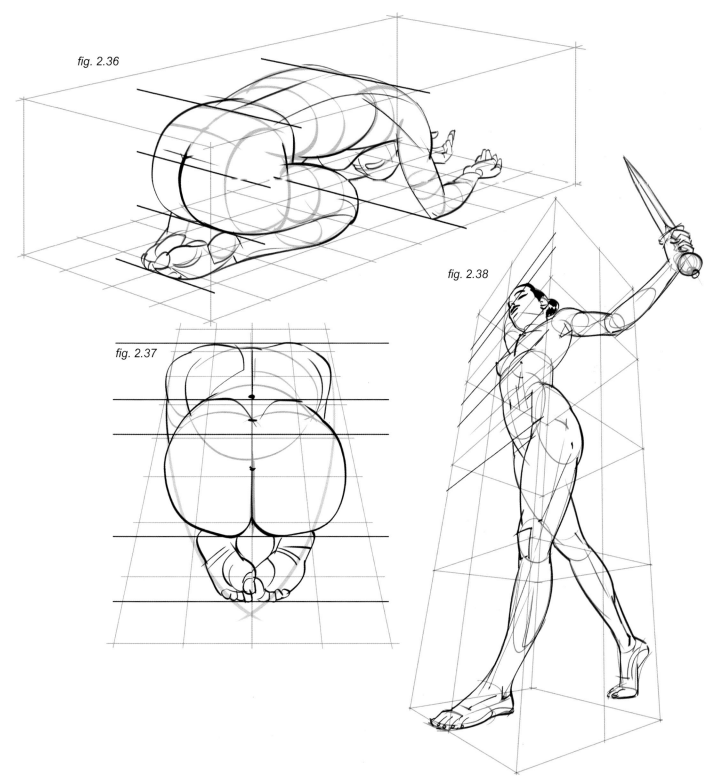

fig. 2.36

fig. 2.37

fig. 2.38

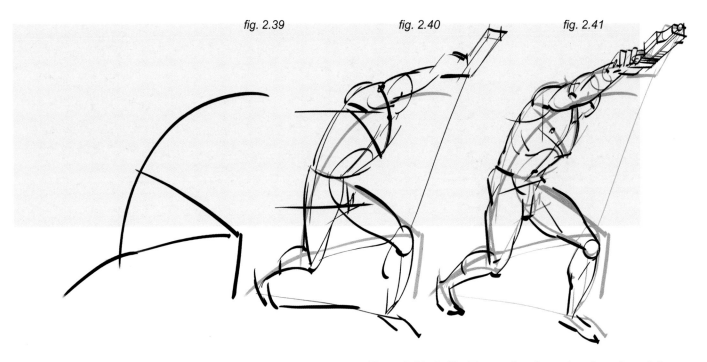

fig. 2.39　　　　*fig. 2.40*　　　　*fig. 2.41*

Figs. 2.39–2.43: These drawings developed as follows: dynamic lines followed by a quick sketch over them to establish the general shapes and volumes, and finally a more formal, yet energetic drawing.

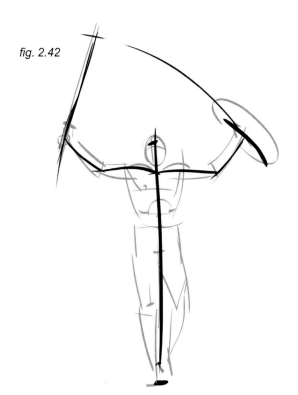

fig. 2.42

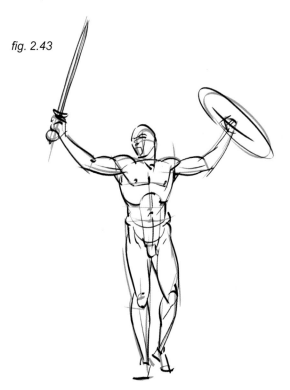

fig. 2.43

When establishing the **dynamics** of a drawing (either from imagination or a live model) it is so easy to play it safe and to water things down in the process. Train yourself to push shapes and dynamics; you can always pull back from there. Experience the joy of channeling and transforming all of your energies into drawings on paper. Have a good time, erasers exist so no need to panic.

Eventually and naturally the tendency to "normalize" things takes over, to make them "more real." Remember the goal is to make the audience vibrate through what is on that piece of paper—a piece of paper that you as an artist have transformed into an experience.

So for now, while practicing, just go for it.

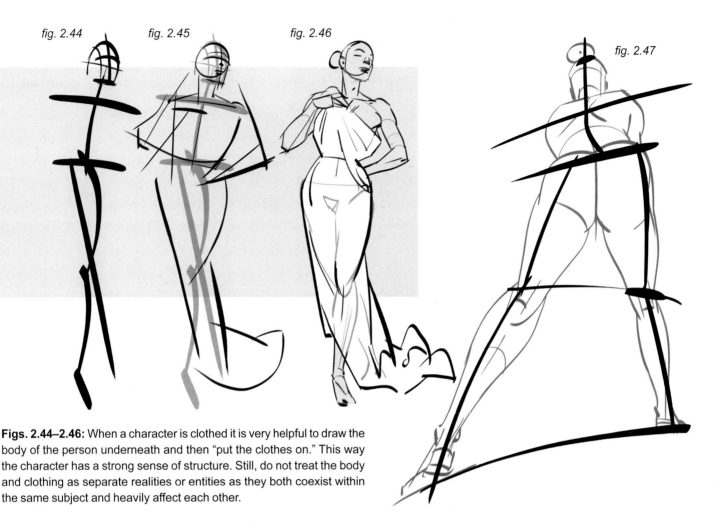

fig. 2.44 *fig. 2.45* *fig. 2.46*

fig. 2.47

Figs. 2.44–2.46: When a character is clothed it is very helpful to draw the body of the person underneath and then "put the clothes on." This way the character has a strong sense of structure. Still, do not treat the body and clothing as separate realities or entities as they both coexist within the same subject and heavily affect each other.

Fig. 2.47: This is a straightforward example of action informed by a dynamic underlying structure.

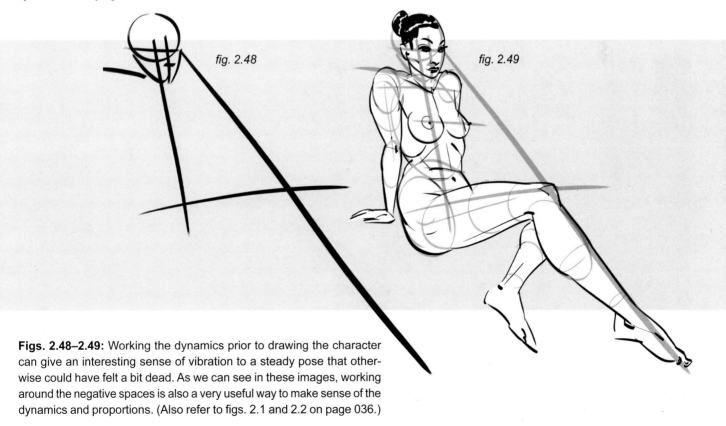

fig. 2.48 *fig. 2.49*

Figs. 2.48–2.49: Working the dynamics prior to drawing the character can give an interesting sense of vibration to a steady pose that otherwise could have felt a bit dead. As we can see in these images, working around the negative spaces is also a very useful way to make sense of the dynamics and proportions. (Also refer to figs. 2.1 and 2.2 on page 036.)

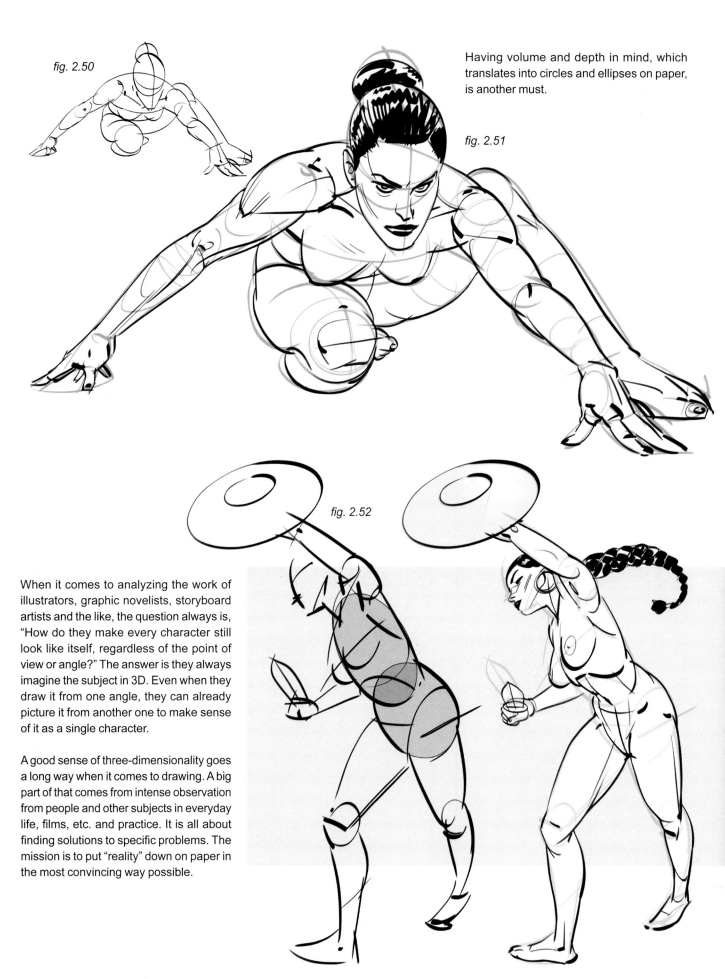

fig. 2.50

Having volume and depth in mind, which translates into circles and ellipses on paper, is another must.

fig. 2.51

fig. 2.52

When it comes to analyzing the work of illustrators, graphic novelists, storyboard artists and the like, the question always is, "How do they make every character still look like itself, regardless of the point of view or angle?" The answer is they always imagine the subject in 3D. Even when they draw it from one angle, they can already picture it from another one to make sense of it as a single character.

A good sense of three-dimensionality goes a long way when it comes to drawing. A big part of that comes from intense observation from people and other subjects in everyday life, films, etc. and practice. It is all about finding solutions to specific problems. The mission is to put "reality" down on paper in the most convincing way possible.

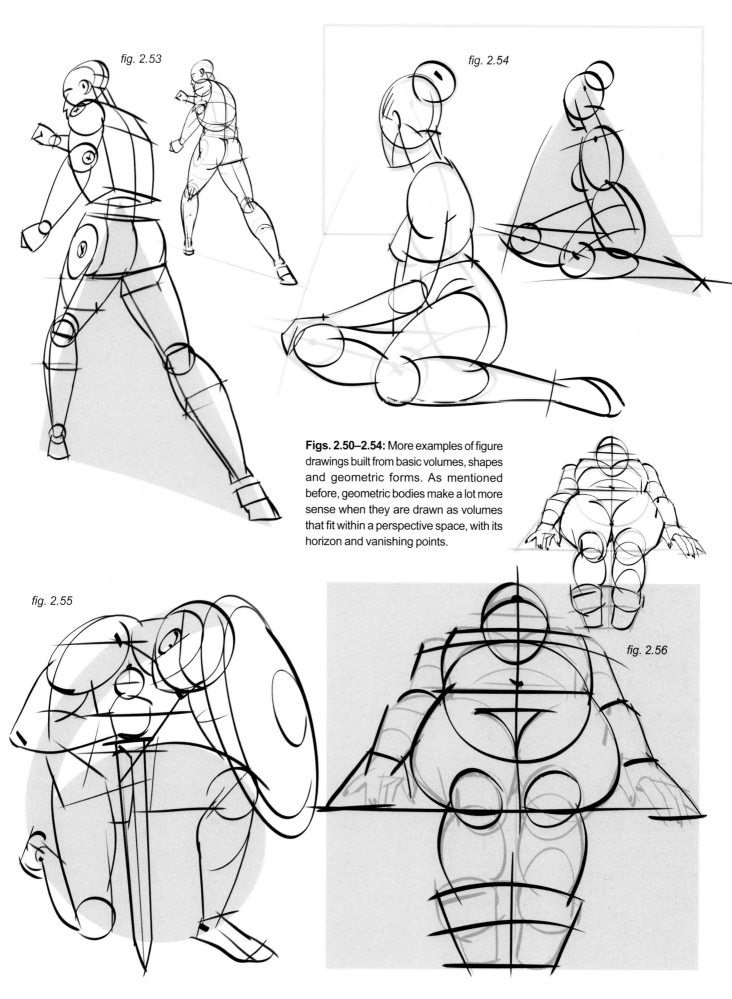

fig. 2.53

fig. 2.54

Figs. 2.50–2.54: More examples of figure drawings built from basic volumes, shapes and geometric forms. As mentioned before, geometric bodies make a lot more sense when they are drawn as volumes that fit within a perspective space, with its horizon and vanishing points.

fig. 2.55

fig. 2.56

Sometimes only by moving the camera around a bit we can get much more dynamic angles (compare with fig 2.48 two pages before). This can give us the opportunity to create interesting foreshortening that immediately establish a more cinematic, geared to impact, new image.

Again to resolve this type of situation successfully we will first make sure we understand the perspective space our character is moving within (fig 2.57, top right).

fig. 2.57

fig. 2.58

Fig. 2.57: After that we will constantly work the body as masses of volume that can be next to one another or superimposed as they come closer to our eye (see how specifically the arm and hand have been worked out this way, with ellipses representing the volumes of arm, fore-arm and hand, and all the anatomy within...

...to then step it up to a final drawing (fig 2.59, bottom right, as well as detail to the left) in which we made sure lines are not just flat elements on paper but the representation of the outlines within which the masses that make up the body are contained.

fig. 2.59

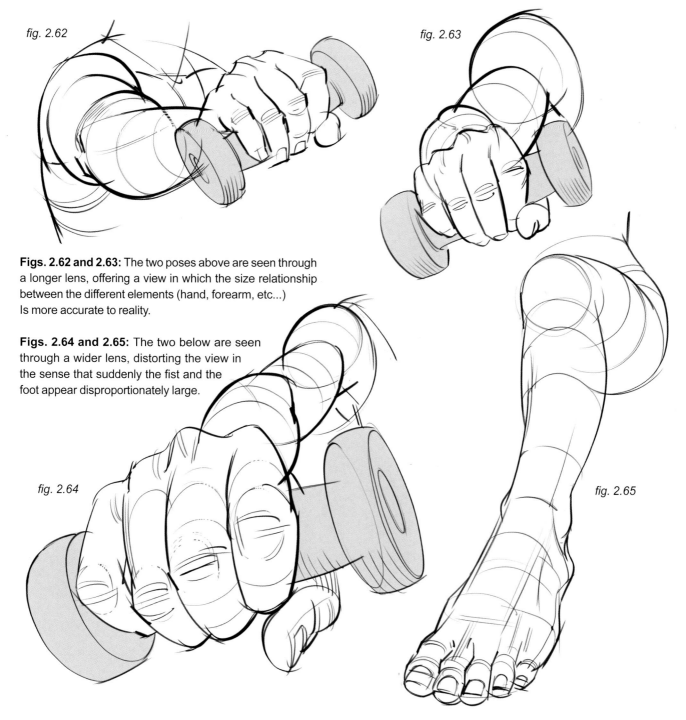

Figs. 2.60 and 2.61: Imagine a card with four horizontal strips of different values (a, b, c and d), when this card is displayed vertical in front of our eyes we will see the height of all stripes as high as they actually are.

The moment we tilt the card as seen in the second pose our perception of the strips' height will be different, as if all of them had suddenly shrunk. That's what happens when we see objects in a foreshortened manner.

Figs. 2.62 and 2.63: The two poses above are seen through a longer lens, offering a view in which the size relationship between the different elements (hand, forearm, etc...) Is more accurate to reality.

Figs. 2.64 and 2.65: The two below are seen through a wider lens, distorting the view in the sense that suddenly the fist and the foot appear disproportionately large.

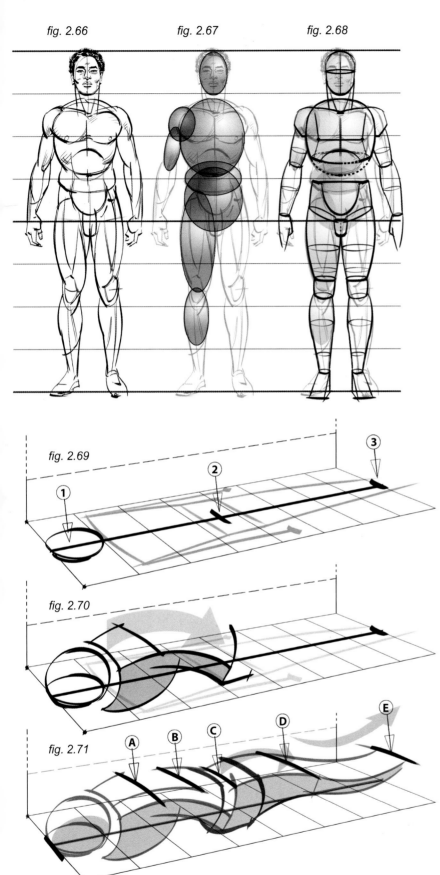

fig. 2.66 *fig. 2.67* *fig. 2.68*

fig. 2.69

fig. 2.70

fig. 2.71

Before going any further on integrating characters in actual perspective spaces, let me say that all of these theories must be complemented as much as possible with a good, persistent routine of drawing from life, either with proper models or just spontaneous poses in the street, at the beach, or anywhere you can practice without annoying anyone.

Fig. 2.66: Let's take a typical athletic figure, 8 heads tall. First, it is important to understand the body in a simple upright position based on its proportions and volumes. Then envision the body and its parts as a group. Imagine seeing it from various points of view, as might be required by a comic book panel.

Fig. 2.67: Knowing and understanding the volumes that form the body of a character is essential. When creating a view of a three-dimensional body in perspective, there needs to be a very clear idea of the masses and volumes that compose the body (represented here by these very basic balloon shapes).

Fig. 2.68: The balloon shapes have been refined into more defined, box-like pieces.

The three principles of figure drawing are *perspective*, *dynamics* and *volume*. Here are the steps to draw a character stretched out and face up (figs. 2.69–2.73).

First, draw a perspective grid that will contain the character and that matches the surrounding environment; otherwise the character will not appear to belong in the image or panel. Do not, for now, limit the height of the space or box containing the character; have a sense of freedom this way and pay more attention to the body feeling correct as an overall volume.

Fig. 2.69: On the grid, draw a quick flat "blueprint" of the whole body. Draw the points of contact of the head (1), the butt (2) and the feet (3) on the grid according to the proportions already studied. Everything else in the drawing will need to fit in with these three key points.

Fig. 2.70: Draw the head, torso and hips in volume, describing the curve seen in fig. 2.18 on page 041.

Fig. 2.71: Draw the legs, again counting on the curved dynamics already mentioned. Do not exaggerate these curves; keep them graphic, but reasonable. It is very important that structural lines like parallels A–E converge to the same vanishing points as the perspective grid.

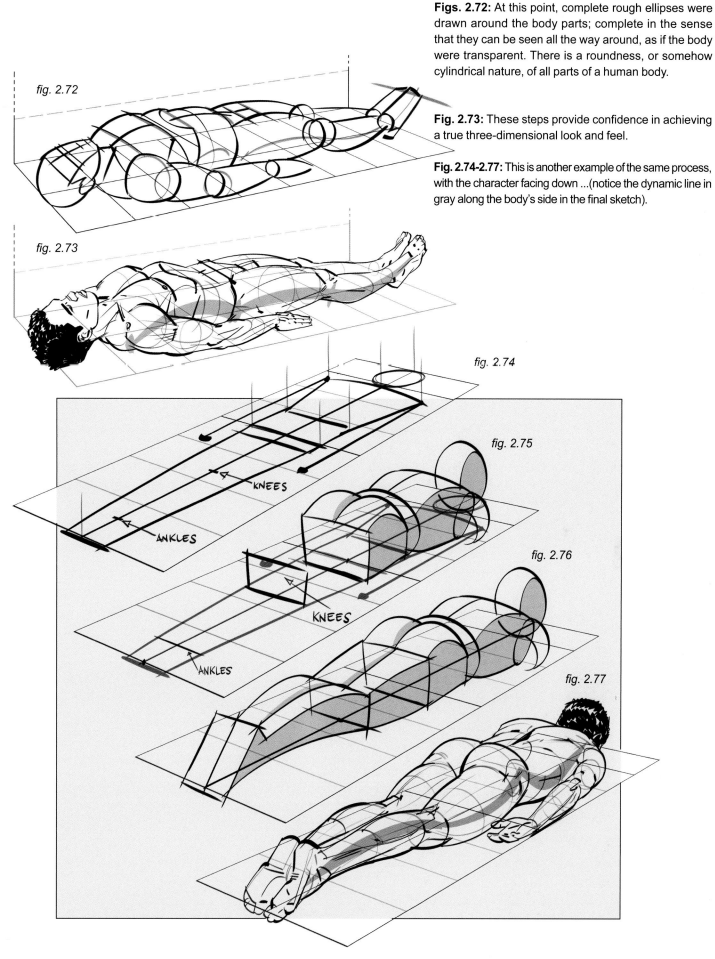

Figs. 2.72: At this point, complete rough ellipses were drawn around the body parts; complete in the sense that they can be seen all the way around, as if the body were transparent. There is a roundness, or somehow cylindrical nature, of all parts of a human body.

Fig. 2.73: These steps provide confidence in achieving a true three-dimensional look and feel.

Fig. 2.74-2.77: This is another example of the same process, with the character facing down ...(notice the dynamic line in gray along the body's side in the final sketch).

fig. 2.72

fig. 2.73

fig. 2.74

fig. 2.75

fig. 2.76

fig. 2.77

KNEES

ANKLES

KNEES

ANKLES

Fig. 2.78: Something to pay a lot of attention to when drawing characters in a foreshortened perspective is the fact that most of the time we view other people in an upright, mostly frontal, position. That informs our most common understanding of how a human body looks.

Fig. 2.79: When observing a person from an unusual point of view, we sometimes try to see what we "know" instead of what we really see. In other words, when looking at a foreshortened character our brains 'see' a more elongated one, as though it were standing up (as it is a more usual every day case). That is why it is so important to keep a strong sense of the body's perspective matching the surrounding environment.

Fig. 2.80: If you were to draw a model stretched out in front of you, observe that the totality of the body on the floor is a lot closer to a perfect square than one would assume after a quick glance.

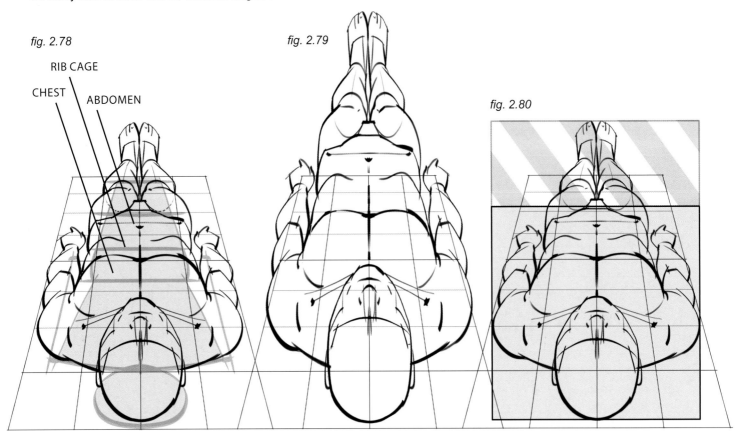

fig. 2.78

fig. 2.79

fig. 2.80

RIB CAGE

CHEST

ABDOMEN

Fig. 2.81: In the same way, wrestling the character into a point of view that looks more familiar and somehow more "correct" can end up disconnecting it from its surrounding environment, like in this drawing.

Fig. 2.82: This character is drawn in a perspective that matches the environment.

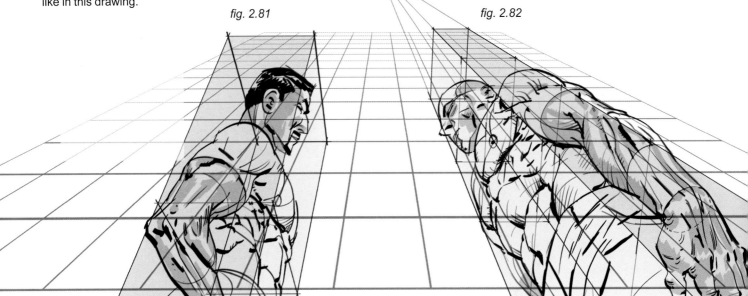

fig. 2.81

fig. 2.82

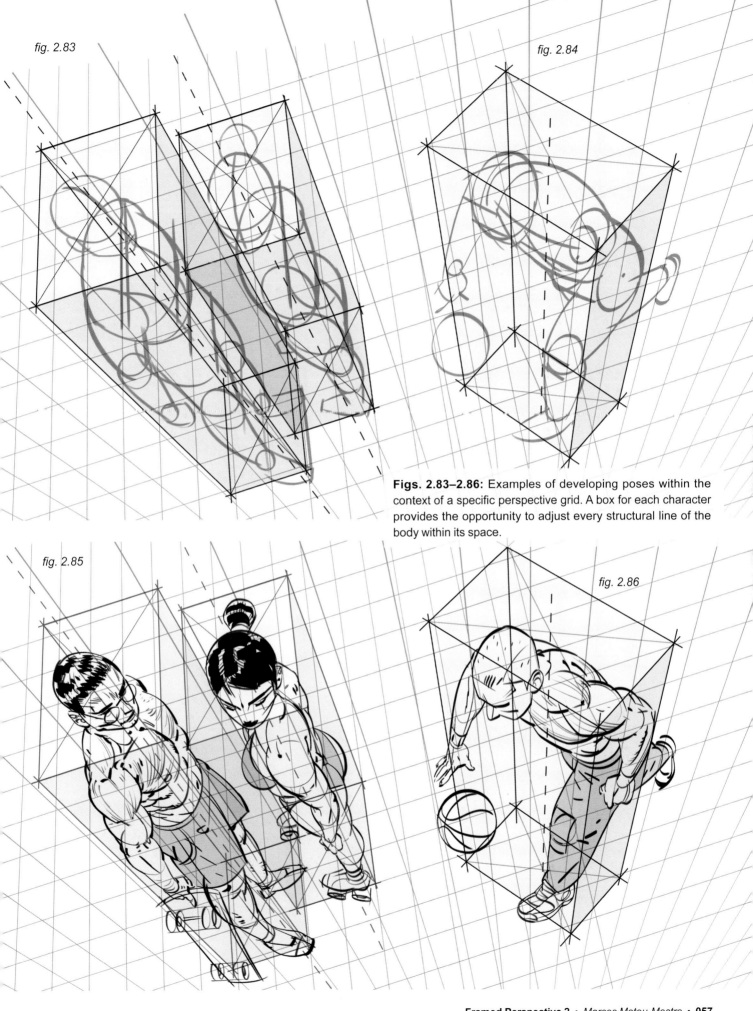

fig. 2.83

fig. 2.84

Figs. 2.83–2.86: Examples of developing poses within the context of a specific perspective grid. A box for each character provides the opportunity to adjust every structural line of the body within its space.

fig. 2.85

fig. 2.86

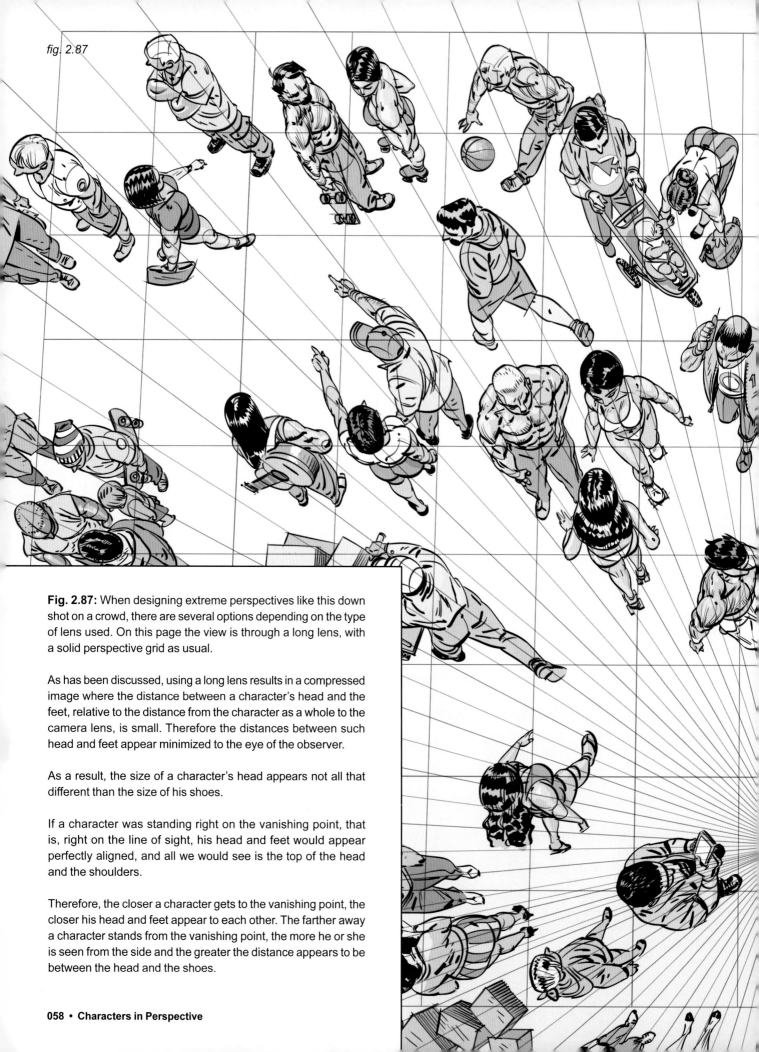

fig. 2.87

Fig. 2.87: When designing extreme perspectives like this down shot on a crowd, there are several options depending on the type of lens used. On this page the view is through a long lens, with a solid perspective grid as usual.

As has been discussed, using a long lens results in a compressed image where the distance between a character's head and the feet, relative to the distance from the character as a whole to the camera lens, is small. Therefore the distances between such head and feet appear minimized to the eye of the observer.

As a result, the size of a character's head appears not all that different than the size of his shoes.

If a character was standing right on the vanishing point, that is, right on the line of sight, his head and feet would appear perfectly aligned, and all we would see is the top of the head and the shoulders.

Therefore, the closer a character gets to the vanishing point, the closer his head and feet appear to each other. The farther away a character stands from the vanishing point, the more he or she is seen from the side and the greater the distance appears to be between the head and the shoes.

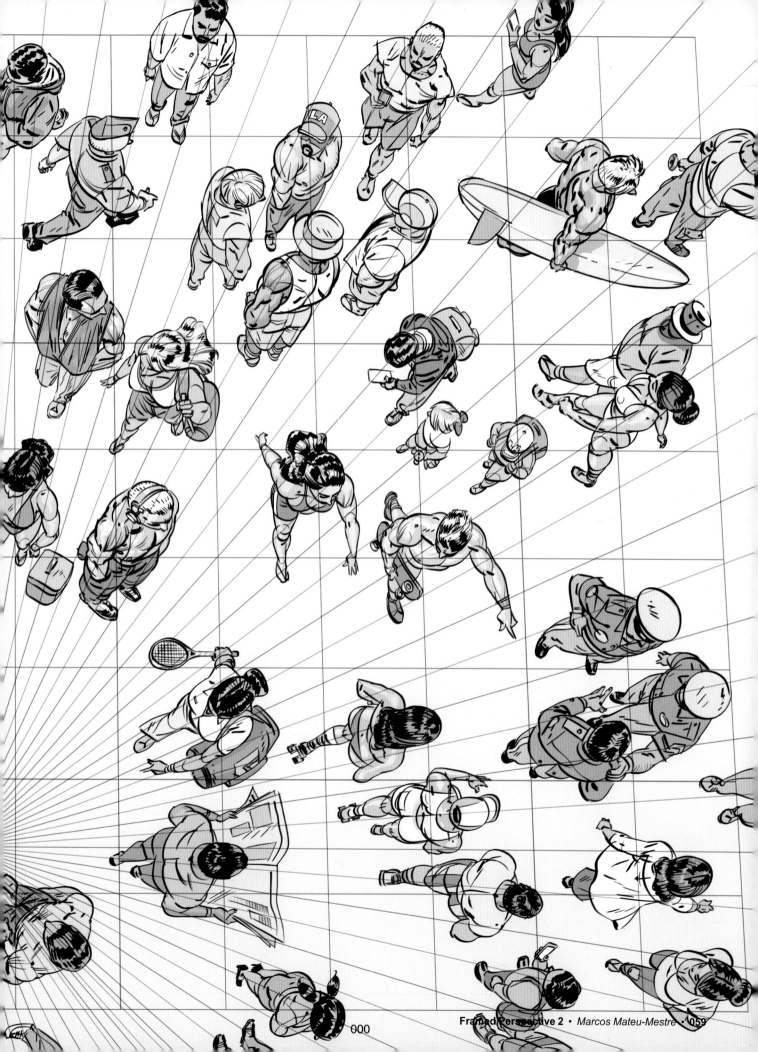

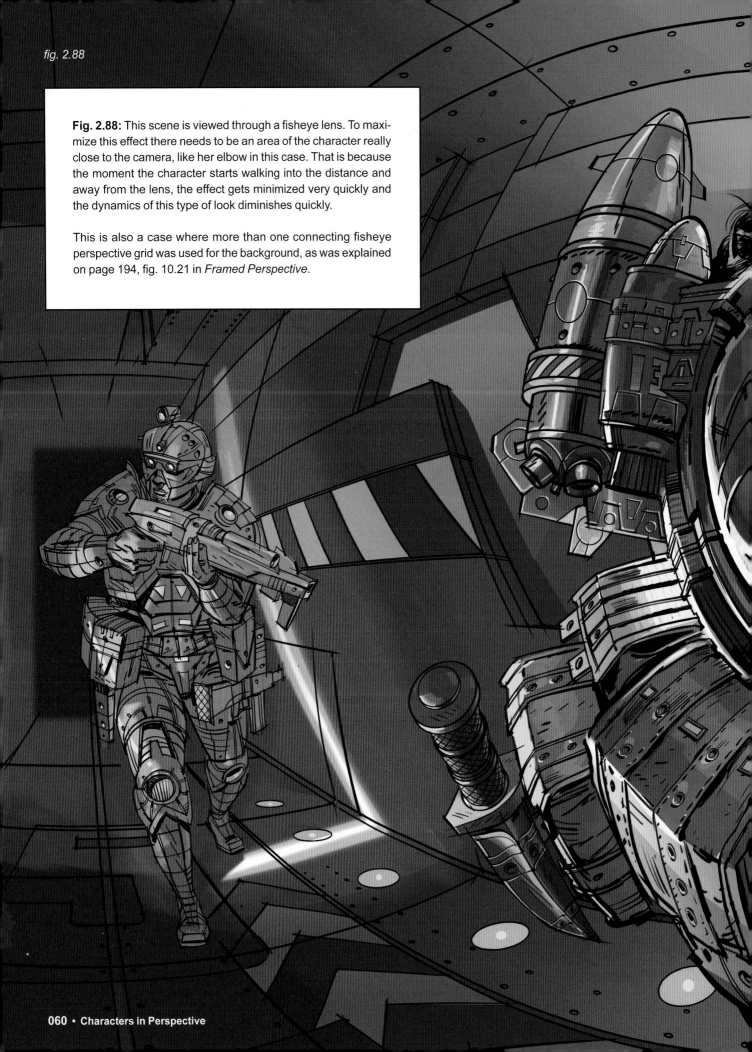

fig. 2.88

Fig. 2.88: This scene is viewed through a fisheye lens. To maximize this effect there needs to be an area of the character really close to the camera, like her elbow in this case. That is because the moment the character starts walking into the distance and away from the lens, the effect gets minimized very quickly and the dynamics of this type of look diminishes quickly.

This is also a case where more than one connecting fisheye perspective grid was used for the background, as was explained on page 194, fig. 10.21 in *Framed Perspective*.

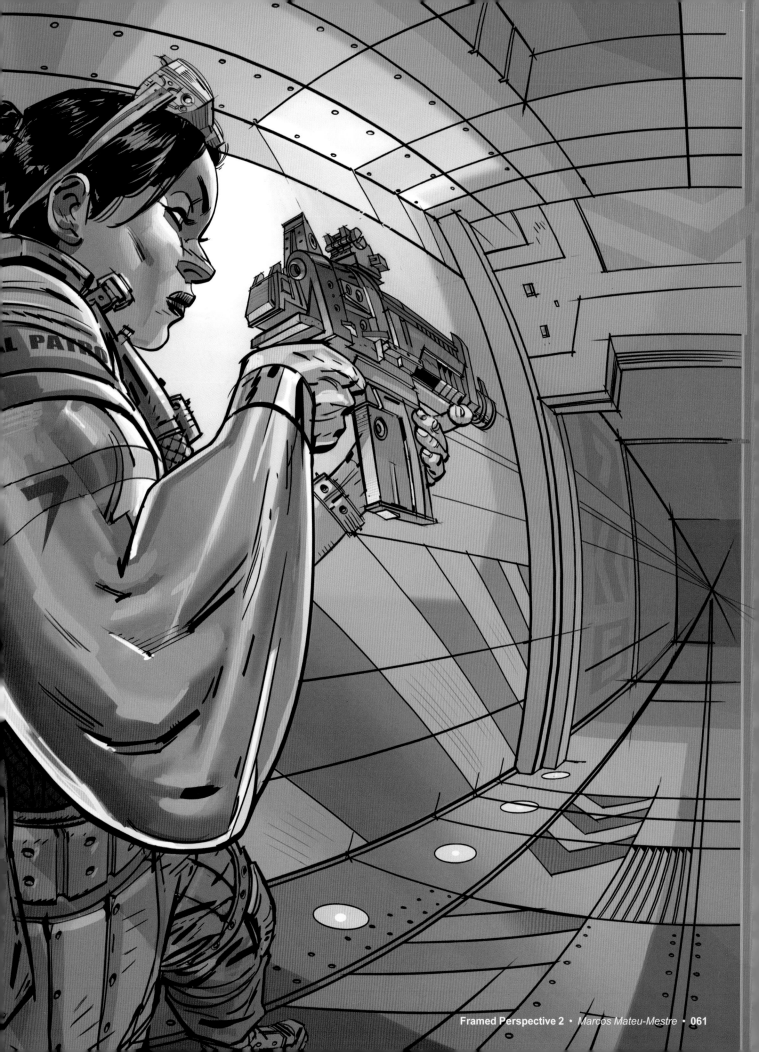

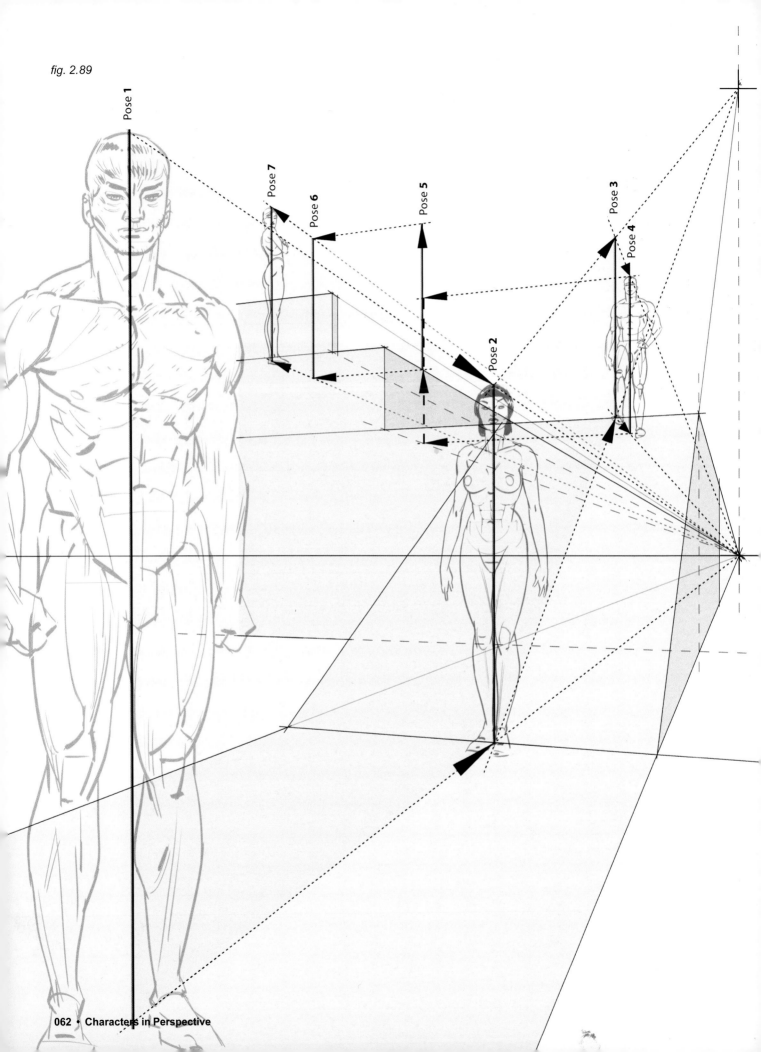

fig. 2.89

Pose **1**

Pose **7**

Pose **6**

Pose **5**

Pose **3**

Pose **4**

Pose **2**

Fig. 2.89: To move characters around within a perspective setup, simply establish the size of the character with a vertical, or height marker, at a specific point within the scene. Choose the one point that is key in the development of the scene to make sure the character works perfectly where it matters the most. From there, literally slide this height marker around using the necessary vanishing point, as seen in this example.

Notice in poses 4 and 7 the characters are partly hidden by either the floor (because of the upshot view in pose 4), or the railing (pose 7).

Also, when drawing characters of the same height on the same flat horizontal ground plane (as in poses 1 and 2) the horizon line always coincides with the body at exactly the same point (the crotch in this example).

Fig. 2.90: When moving characters around the same floor plane, it is important to account for the unique peculiarities of each one. After establishing the standard height of a standard character with a vertical line, then adjust to the different poses: Pose 8 the character is jumping, pose 9 is sitting, pose 10 is walking, pose 11 is wearing high heels and the guy in pose 12 is a head taller than the rest.

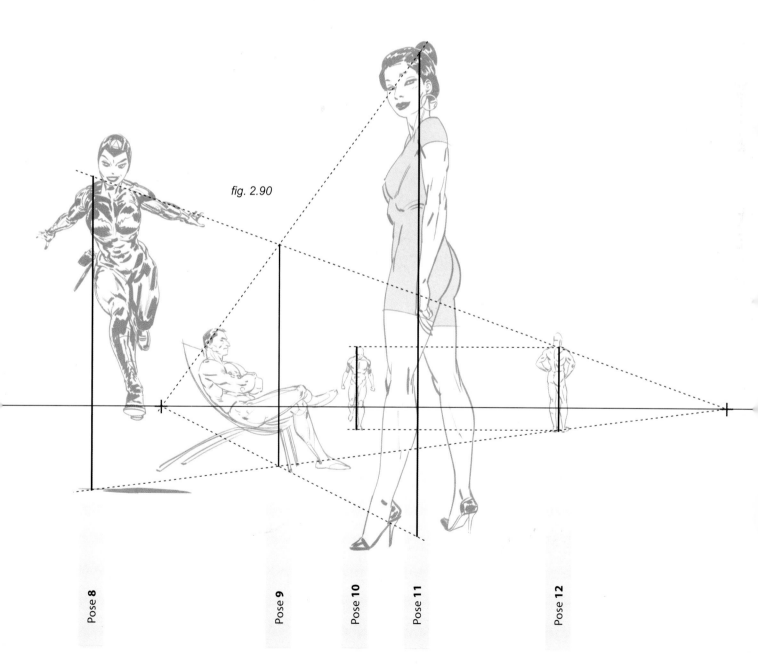

fig. 2.90

Pose **8**

Pose **9**

Pose **10**

Pose **11**

Pose **12**

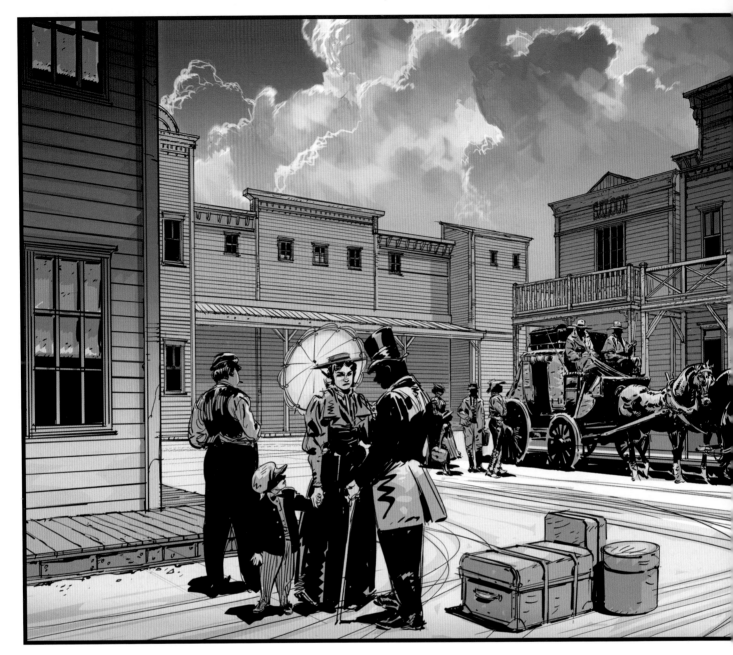

fig. 2.91

Fig. 2.91: In this illustration, there was the need to get the size of each character right depending on height, distance from the character to the camera, and placement of a character on more elevated ground. The size-relationship between people, houses and horses had to be established as well to make sure all these elements feel solidly placed on the general ground plane.

Fig. 2.92: As part of the creative process, here is the first sketch I did for this piece. Although I kept the basic idea for the final illustration, I discarded this specific approach because the vanishing points are so close together that it gives the image a wide-angle lens feel that I did not want.

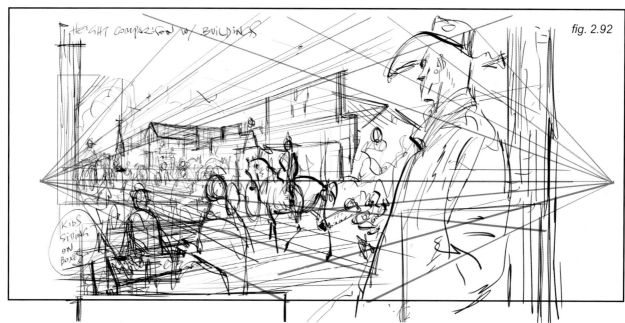

fig. 2.92

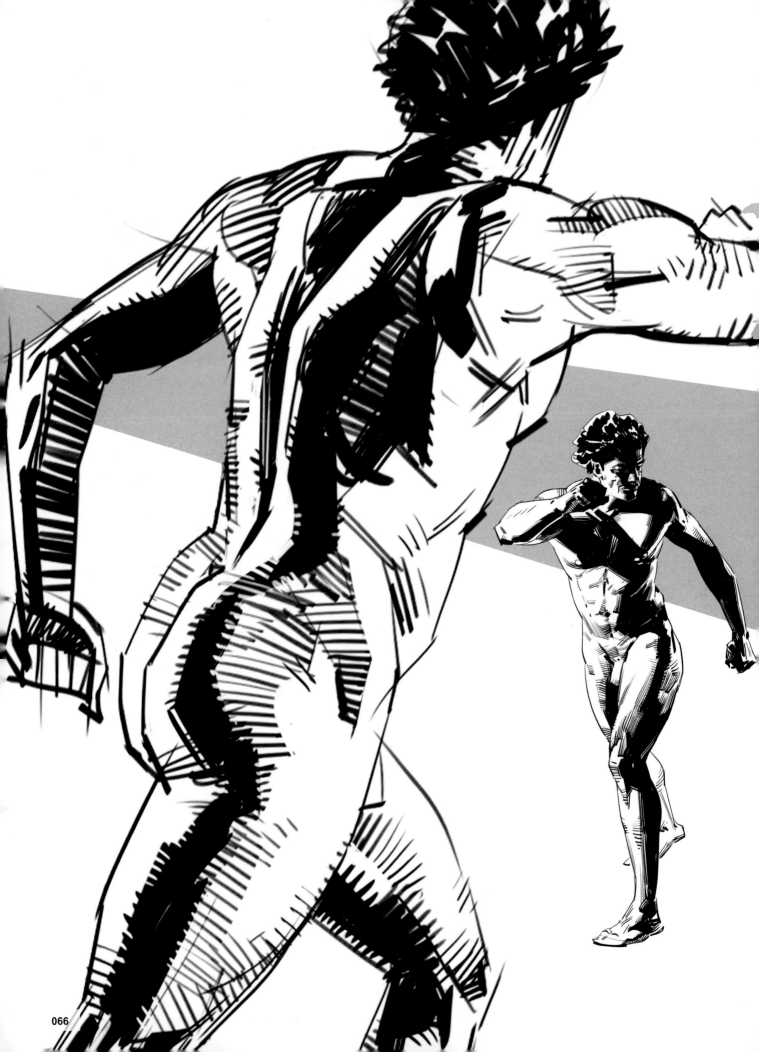

3

SHADOWS ON CHARACTERS

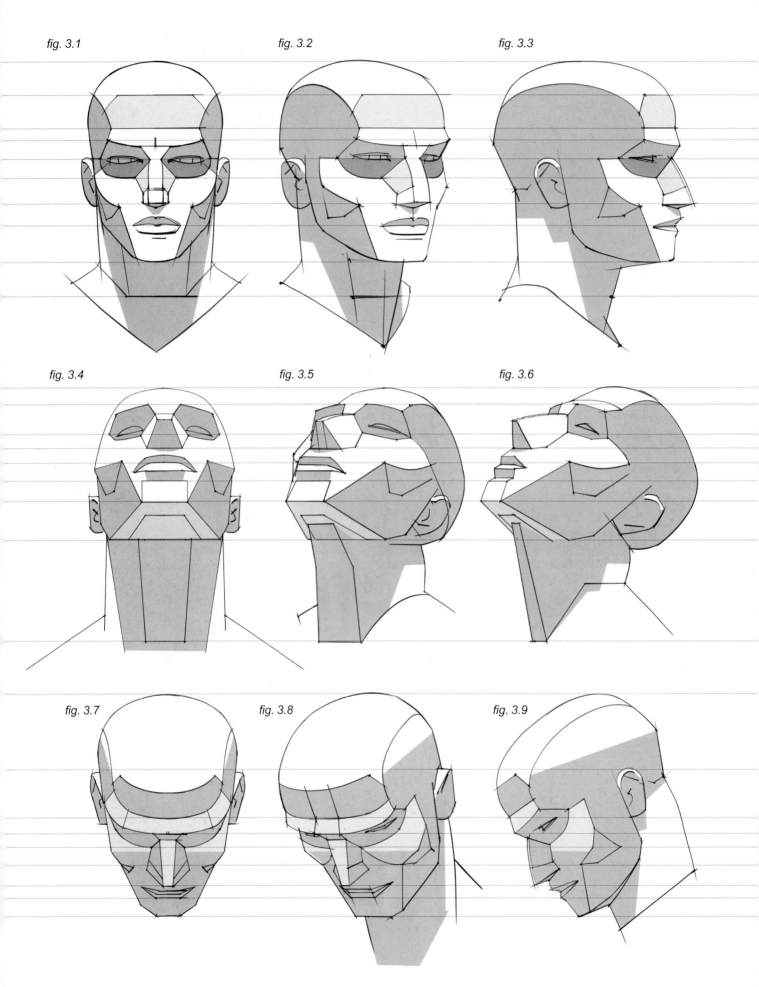

fig. 3.1

fig. 3.2

fig. 3.3

fig. 3.4

fig. 3.5

fig. 3.6

fig. 3.7

fig. 3.8

fig. 3.9

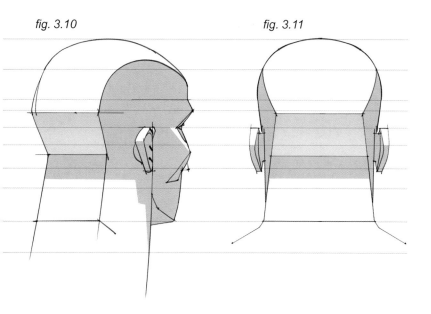

fig. 3.10 *fig. 3.11*

Figs. 3.1–3.11: This book has already covered shadows falling on objects, now let's study the effect of light on the human body, starting with the part most featured in illustration work of any nature: The head.

These illustrations use a geometrical simplification of the head, all the better for perceiving it as an object. Such simplification makes it easier to organize your views and thoughts on how to proceed.

The light source is located directly above each of the 11 poses of this head.

Figs. 3.12–3.14: The shapes in these 3 poses have been simplified even more.

Drawing something is actually an exercise in translation. The drawing will never be "reality as-is," but rather an interpretation of what is observed and is believed to be crucial to put down on paper to communicate this particular perception of reality. This can range anywhere from a photo-real attempt to an extremely stylized abstraction, and all the steps in between.

What ends up on paper is a fantasy. In order to achieve an effective one that delivers what it needs to, it is important to synthesize what is seen in the model, to "own and digest" the information extracted from the observation process that precedes the actual moment of drawing.

So simplify and get as organized and structured as possible in the mind's eye before drawing lines or masses of black (again, refer my previous book *Framed Ink*). This will only help you be more assertive and specific from the moment pen touches paper.

From here, go as detailed or as economical as possible in the execution, but whichever it is it must be done in a knowledgeable and conscious manner.

The process of simplification indicated on this page will help you achieve better results.

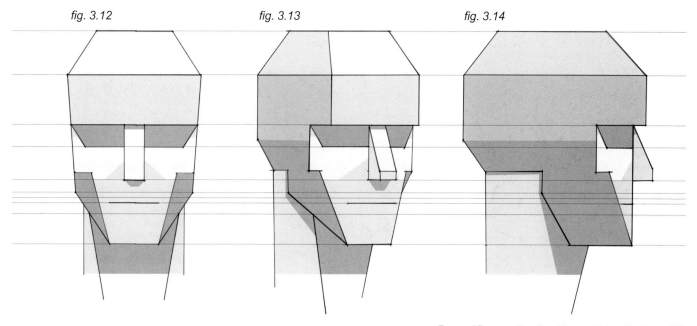

fig. 3.12 *fig. 3.13* *fig. 3.14*

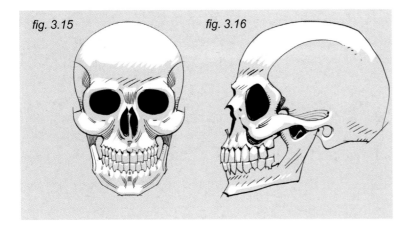

fig. 3.15 fig. 3.16

Before tackling how light visually affects the human body, it is important to have an idea of what type of landscape or geography the human body has. Let's take a look at it, starting with the head.

Figs. 3.15 and 3.16: Going from the inside out, these illustrations represent the skull...

Figs 3.21 and 3.22: ...on which the muscle tissue is attached.

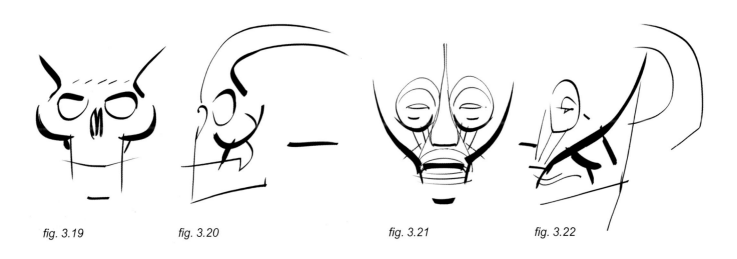

fig. 3.19 fig. 3.20 fig. 3.21 fig. 3.22

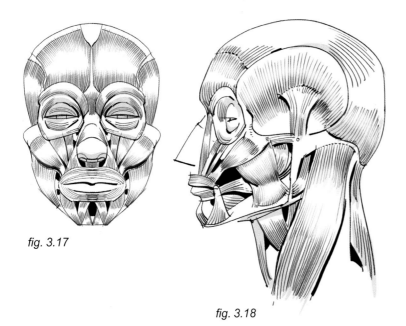

fig. 3.17

fig. 3.18

Figs. 3.19–3.22: The dynamics of the head and face shapes have been extracted and represented in these 4 sketches.

Observing all four drawings, realize that there are obvious similarities between the general dynamics of all the shapes, the powerful impact of the eyeball area and the contour of the cheekbones, in general, giving a lot of character to a face and head.

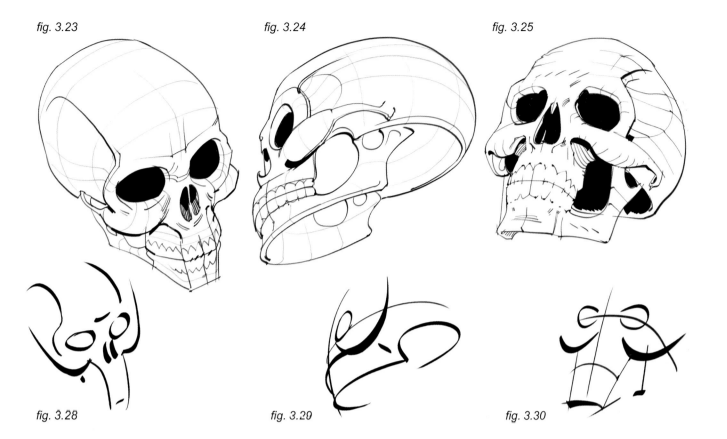

fig. 3.23

fig. 3.24

fig. 3.25

fig. 3.28

fig. 3.29

fig. 3.30

Figs. 3.23–3.25: Here are more examples of skulls...

Figs. 3.26 and 3.27: ...and muscle tissue, as seen from different angles.

Figs. 3.28–3.30, 3.31–3.32: These sketches show the dynamic lines that better describe the construction of these pieces and are those to which close attention should be given. Once the basics are right, then build a believable structure around them.

Observe on the following pages how all of this can be applied to lighting solutions.

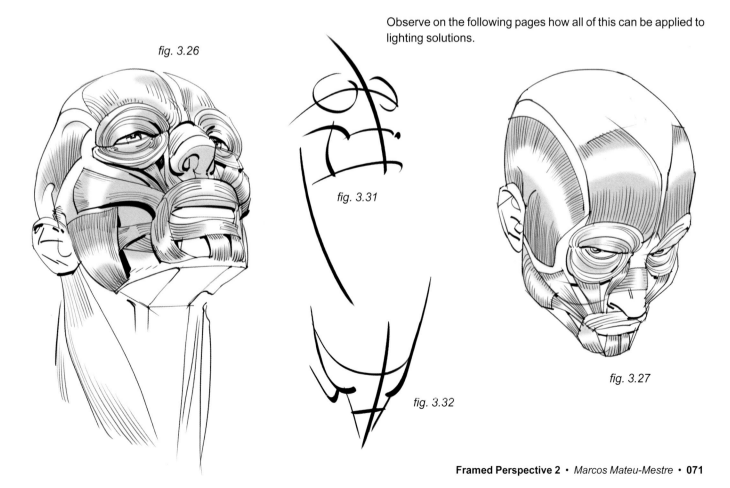

fig. 3.26

fig. 3.31

fig. 3.32

fig. 3.27

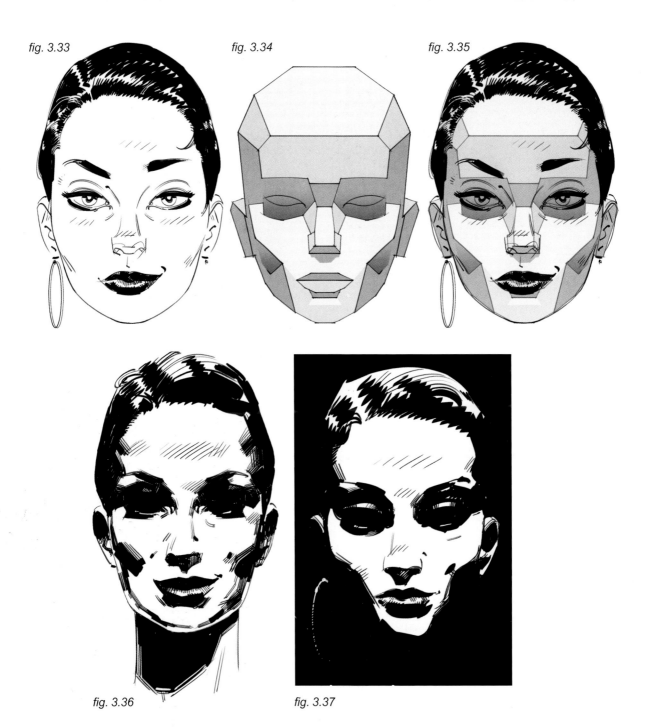

fig. 3.33 fig. 3.34 fig. 3.35

fig. 3.36 fig. 3.37

Lighting a face from directly above the head usually results in very dramatic lighting, especially when using black and white, which pushes the contrast to the very limit.

Fig. 3.34 and 3.35: The head made of flat planes shows a few shades of gray.

Fig. 3.36: What happens when this sense of volume is applied to the head and only black and white is used? Depending on the moment in the story, some details of the character's expression might need to be seen, so the solution is to throw a bit of light onto her eyes, just enough to see some detail. Otherwise, go for it and push the blacks like there is no tomorrow, use light to make a statement, turn this head into a virtual skull if need be.

In cases like this, be careful about the shadows on the lower sides of the face and chin. It is a woman's face and therefore these shadows should not look like a beard. One option is to add a bit of reflected light from below the face.

Fig. 3.37: Or push the blacks not only around her face and chin but also in the surrounding space. Here, pretty much all the blacks become one, as do the lit areas which now appear to be floating in the dark.

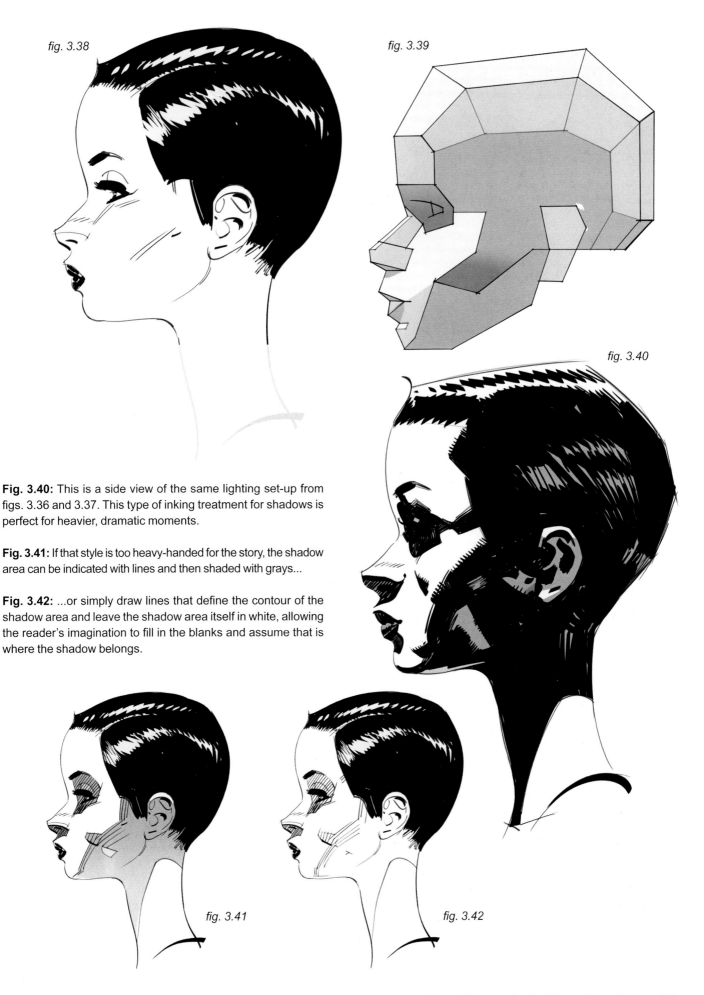

fig. 3.38

fig. 3.39

fig. 3.40

Fig. 3.40: This is a side view of the same lighting set-up from figs. 3.36 and 3.37. This type of inking treatment for shadows is perfect for heavier, dramatic moments.

Fig. 3.41: If that style is too heavy-handed for the story, the shadow area can be indicated with lines and then shaded with grays...

Fig. 3.42: ...or simply draw lines that define the contour of the shadow area and leave the shadow area itself in white, allowing the reader's imagination to fill in the blanks and assume that is where the shadow belongs.

fig. 3.41

fig. 3.42

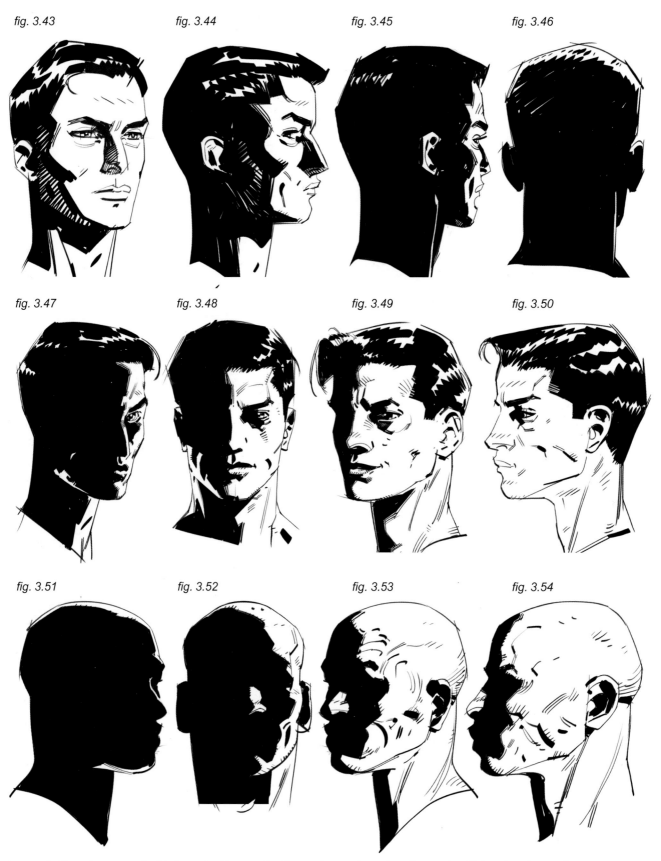

fig. 3.43 fig. 3.44 fig. 3.45 fig. 3.46

fig. 3.47 fig. 3.48 fig. 3.49 fig. 3.50

fig. 3.51 fig. 3.52 fig. 3.53 fig. 3.54

As seen in these turnarounds, it is important to pay attention and be consistent when drawing the same head from different points of view, while the light source remains constant. For this, the best approach is to start from reality-based images, like sketches from a model or photographs, and then make graphic statements based on them, simplifying the shapes for a more direct, final look. When most of the face is in shadow, make a choice between creating a solid gray that allows more of the facial expressions to be seen or simply to make a bold black and white statement.

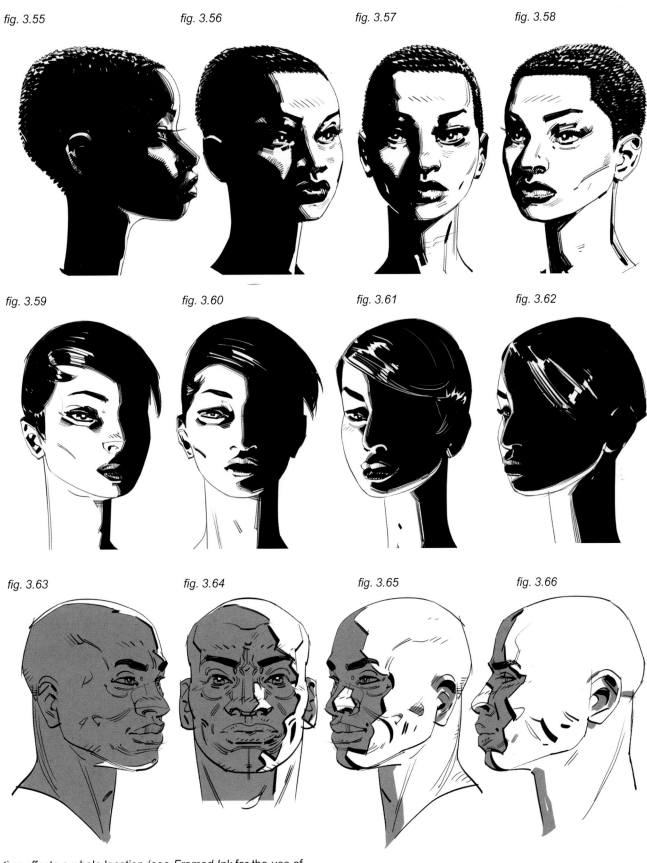

fig. 3.55 fig. 3.56 fig. 3.57 fig. 3.58

fig. 3.59 fig. 3.60 fig. 3.61 fig. 3.62

fig. 3.63 fig. 3.64 fig. 3.65 fig. 3.66

Lighting affects a whole location (see *Framed Ink* for the use of light in the composition of full images) but the examples on these two pages have been detached from their immediate surroundings, for now, to focus exclusively on the heads themselves.

Turn the page for examples of lighting that include the values of the immediate surrounding environment.

fig. 3.67

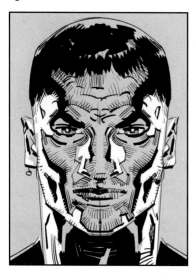

fig. 3.68

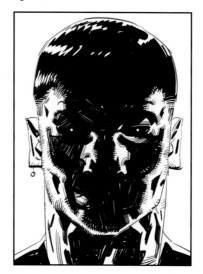

fig. 3.69

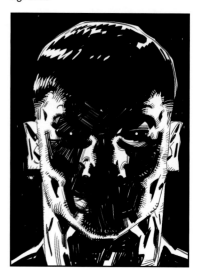

fig. 3.70

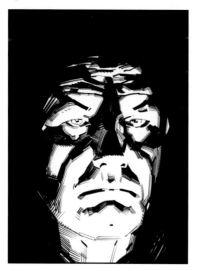

fig. 3.71

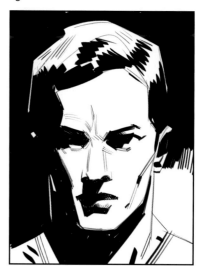

On the next three pages are some examples of how to tackle the inking of shadows on a character's head and face.

Figs. 3.67–3.69: Applying a rim of light on both sides of a head is a striking way to define the periphery or edges, making it the focus instead of the facial expression which is more commonly the center of attention (see fig 1.52 on page 034).

Three different solutions have been developed here. In fig. 3.67 the face's expression is more readable thanks to the use of a gray tone in the central area. Fig. 3.68 uses solid black ink for the central area with an overexposed (white) background, and fig. 3.69 has a solid black background, which brings up the side rim lights to a more prominent level.

Fig. 3.70: Lighting a head, a body, or a location from below offers a very unusual look at the object. Because light sources (sun, moon, streetlight, ceiling lamp) are usually located above the subject, the viewer feels unsettled about the anomaly of the situation. Hence the abundant use of low-angle lighting in horror scenes.

Fig. 3.71: A more graphic approach gives a rather spontaneous, hard-edged and chiseled look.

fig. 3.72

fig. 3.73

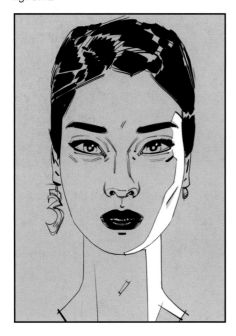

Fig. 3.72: Adding rim light to only one side of the face can provide a softer, mysterious, somehow more romantic look when combined with the use of gray on the face, making the drawing have a less harsh appearance.

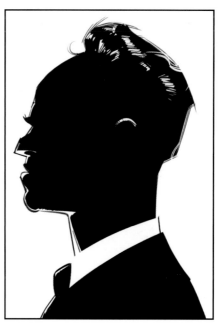

Fig. 3.73: A purely backlit silhouette helps to define a character by its unique contour or outline.

fig. 3.74

fig. 3.75

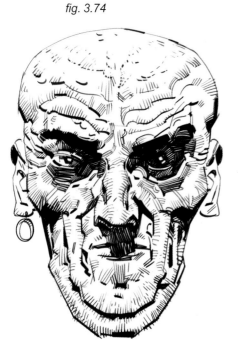

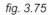

Fig. 3.74: A merciless blast of light from the top-front exposes the rugged texture of weathered skin.

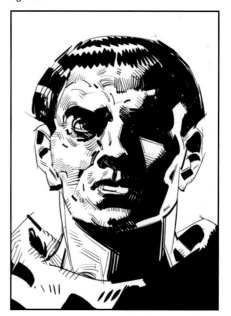

Fig. 3.75: A top-light coming in from one side creates this always-appealing triangle of light on the opposite side's cheek. This can be further enhanced by a rim light, adding to the complexity of the image.

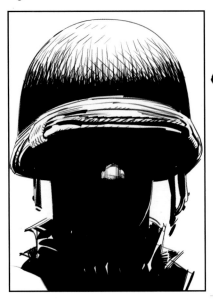

fig. 3.76

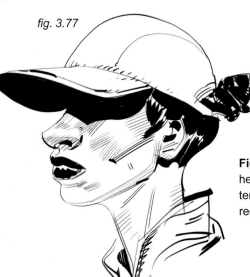

fig. 3.77

Fig. 3.76 and 3.77: A cast shadow from a helmet or a hat adds intrigue to a character's visual personality when the moment requires a bit of extra drama.

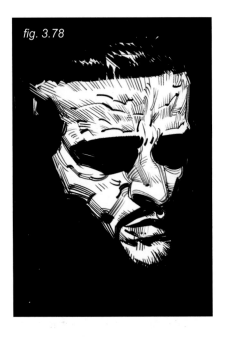

fig. 3.78

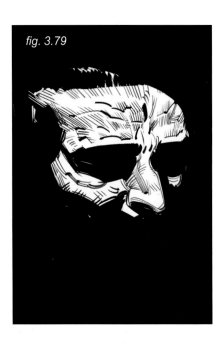

fig. 3.79

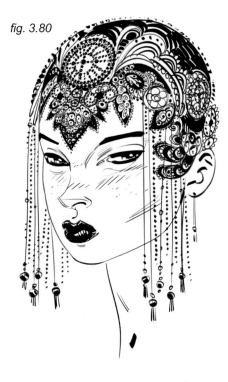

fig. 3.80

Fig. 3.78: Limiting the amount of surface exposed to the light source will do for a more minimalist approach...

Fig. 3.79: ...which can be pushed even further by cropping the image.

Fig. 3.80: Avoiding the use of shadows altogether can enhance intricate details, as is the case with this character's ornamental headdress.

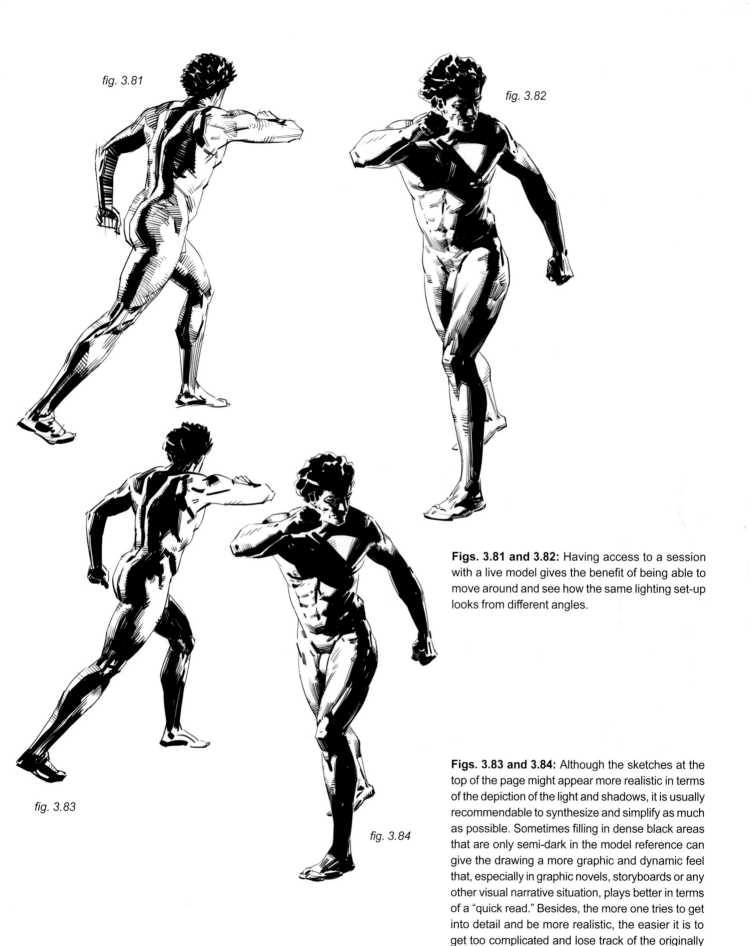

fig. 3.81

fig. 3.82

fig. 3.83

fig. 3.84

Figs. 3.81 and 3.82: Having access to a session with a live model gives the benefit of being able to move around and see how the same lighting set-up looks from different angles.

Figs. 3.83 and 3.84: Although the sketches at the top of the page might appear more realistic in terms of the depiction of the light and shadows, it is usually recommendable to synthesize and simplify as much as possible. Sometimes filling in dense black areas that are only semi-dark in the model reference can give the drawing a more graphic and dynamic feel that, especially in graphic novels, storyboards or any other visual narrative situation, plays better in terms of a "quick read." Besides, the more one tries to get into detail and be more realistic, the easier it is to get too complicated and lose track of the originally intended expression of the drawing.

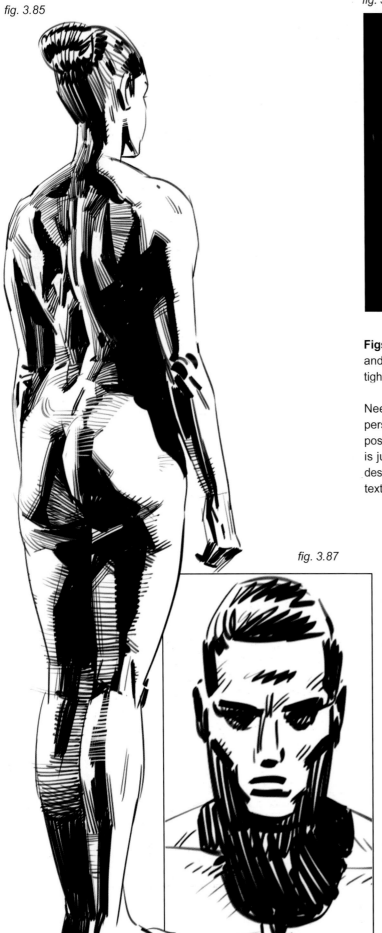

fig. 3.85

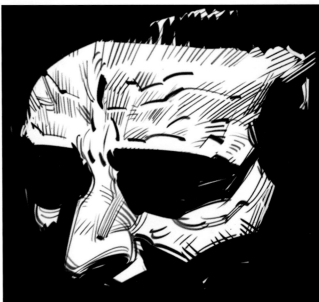

fig. 3.86

Figs. 3.85–3.88: Here are various close-up views of rendering and inking samples that deal with light and shadows—some tighter, some looser.

Needless to say each of us has a particular view, idea and personality that influences all of our work. There are as many possibilities and ways of doing this as artists in the world. This is just a suggestion of how to use ink in a way that not only describes masses of light and dark, but also helps define volume, texture and surface direction.

fig. 3.87

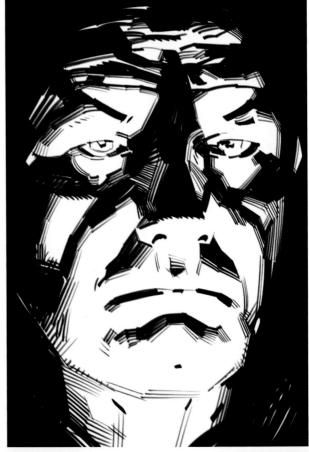

fig. 3.88

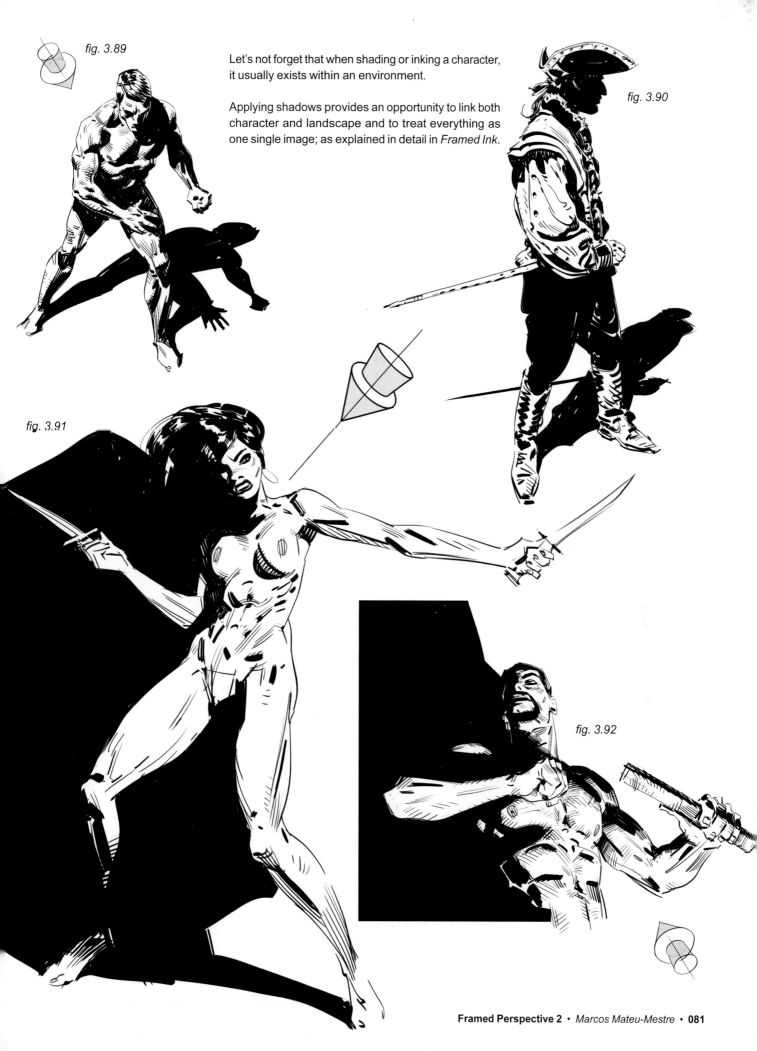

fig. 3.89

fig. 3.90

fig. 3.91

fig. 3.92

Let's not forget that when shading or inking a character, it usually exists within an environment.

Applying shadows provides an opportunity to link both character and landscape and to treat everything as one single image; as explained in detail in *Framed Ink*.

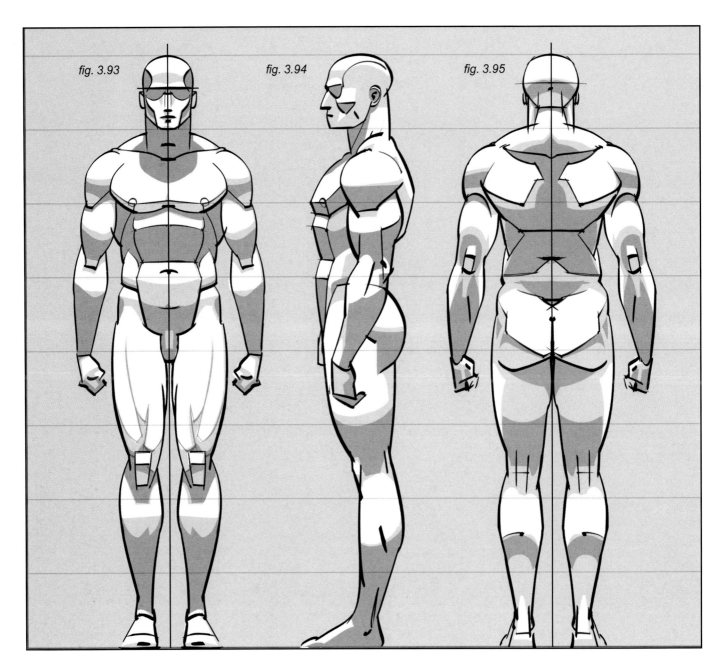

fig. 3.93 *fig. 3.94* *fig. 3.95*

Figs. 3.93–3.95: Regarding the effect of light on the human body, first take into account the bulk of the main shapes and volumes that constitute the body, and study the planes that these shapes form. By simplifying the intricacies of the anatomy, it is easier to understand how light impacts them, reflecting off the brightest areas and keeping others in shadow, depending on the position of the body and the direction of the light source. In the above examples, the subjects are top-lit.

The next pages show examples of how light behaves on male and female bodies while hitting them from different directions. The position and tilt of the light source is indicated by the cylindrical arrows.

Fig. 3.96: Light hits the subject from above and slightly from the front. It is always important to keep in mind a three-dimensional idea of the subject. In the little mannequin figure at the bottom, see how some planes get hit directly by light, sometimes casting shadows on lower surfaces in the process (chin on chest) while other areas are left in shadow (under the arms and legs).

Fig. 3.97: The light source is still above the subject but is now slightly behind him, tilting forward. Most of his front is in shadow. The surfaces hit by light are the top of the head, shoulder, knee area of the right leg and the top of the feet (see also the little mannequin at bottom).

Fig. 3.98: The light is from the side, slightly from above and in front. Roughly, her left side is illuminated and her right side is in shadow. For this type of work the details need to be correct (although graphic!) based on observation of reality, live models, photographic reference or all of the above.

The shadow side can always be treated as solid black (more dramatic) or a lighter shade of gray (bottom).

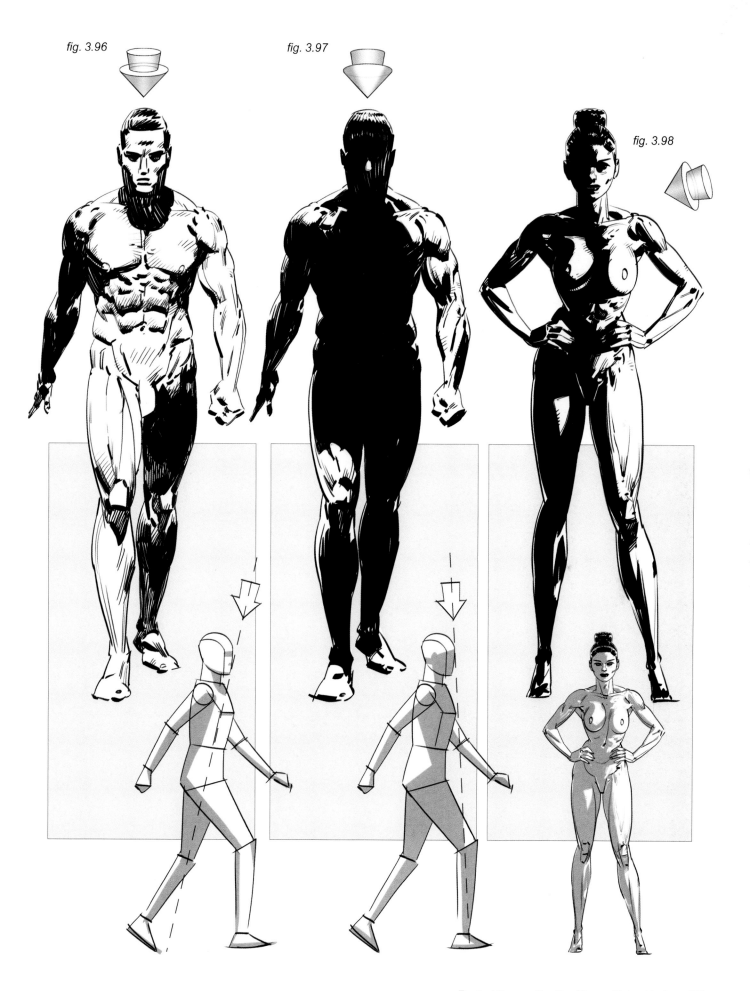

fig. 3.96

fig. 3.97

fig. 3.98

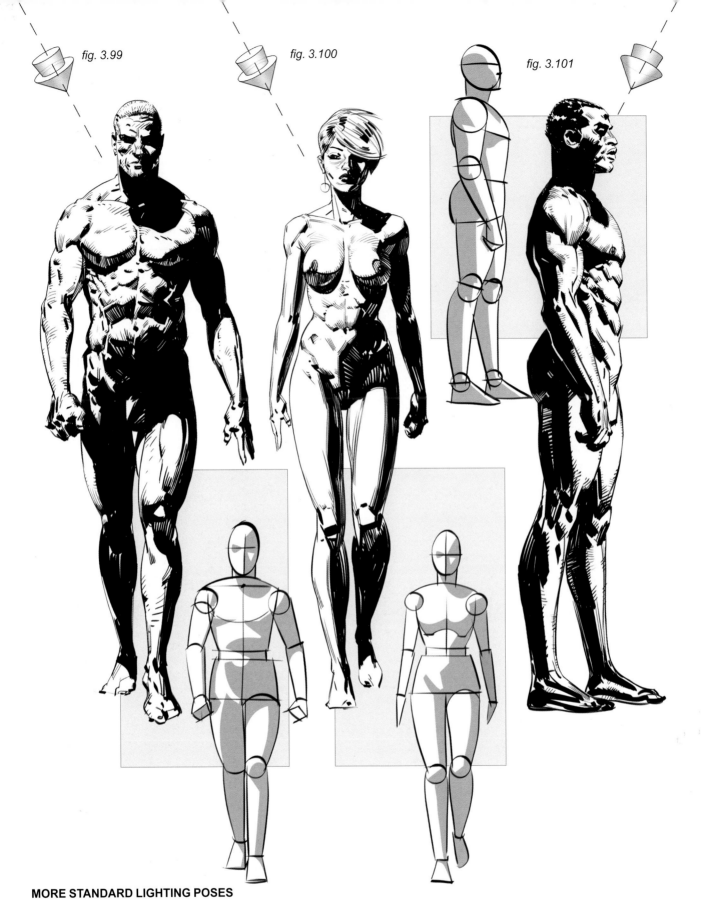

fig. 3.99 _fig. 3.100_ _fig. 3.101_

MORE STANDARD LIGHTING POSES

Figs. 3.99 and 3.100 receive top light from a frontal, diagonal direction. The planes lit are similar to fig. 3.98, but this time at a higher angle. Still, one of the sides of the character is left in shadow.

Fig. 3.101: Also getting hit with frontal, diagonal top light, but because of the camera's point of view, the character appears slightly backlit.

fig. 3.102

fig. 3.103

fig. 3.104

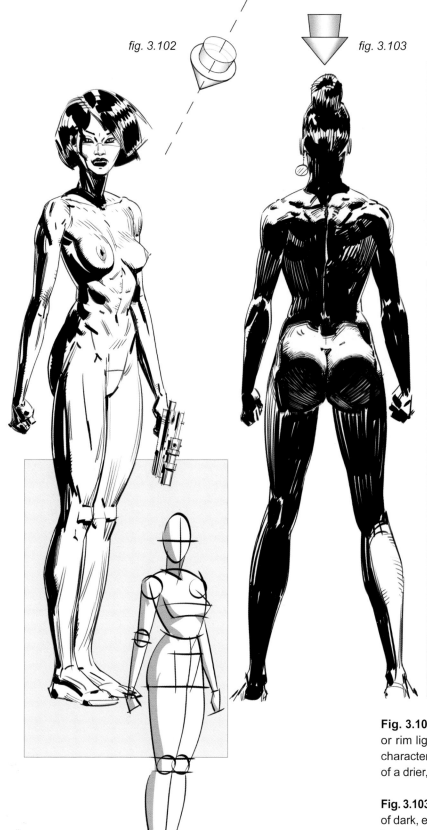

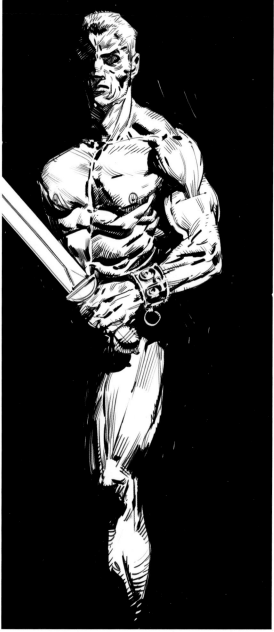

Fig. 3.102: Sometimes adding a slight sense of reflected light, or rim light, between the shadow area and the outline of the character provides the piece with a certain sense of air instead of a drier, heavier look.

Fig. 3.103: Also as a suggestion, when there are big heavy areas of dark, either go solid on the blacks or brush them in a way that keeps some of the white bleeding through, offering a some-how more casual, vibrant look. Always follow the direction of the muscles and the body surface to enhance the three-dimension-ality of the figure.

Fig. 3.104: Let's not forget that the subject's shadows can play an integral part of the darks of the full image, eliminating the outlines of the drawing altogether in the process, as explained in full detail in *Framed Ink*.

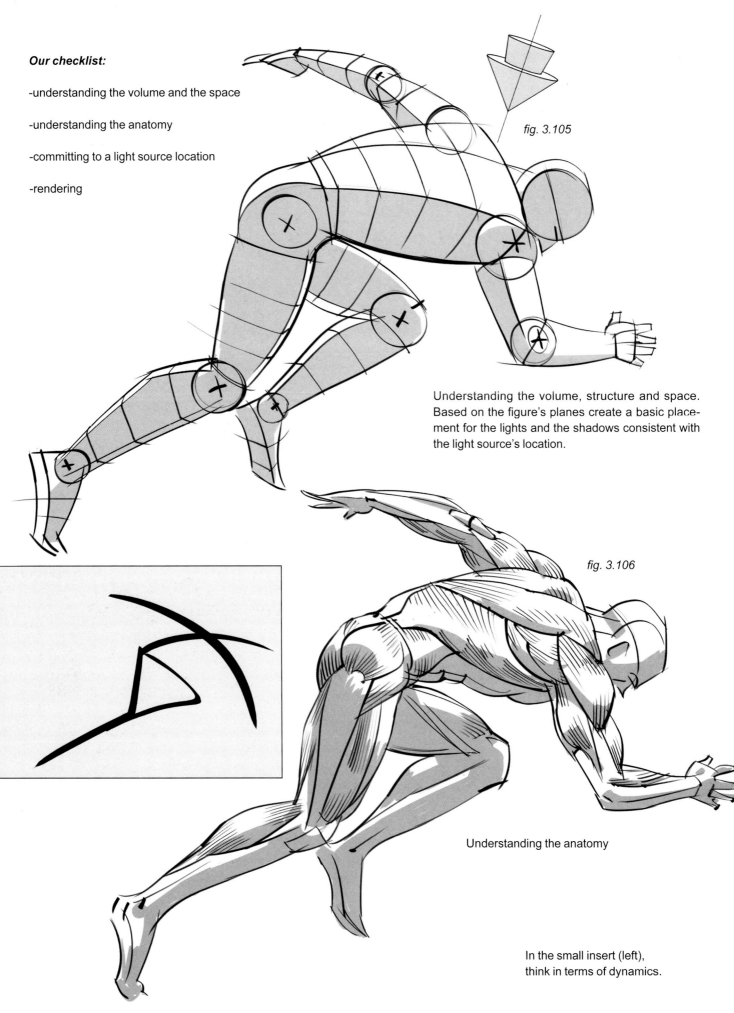

Our checklist:

-understanding the volume and the space

-understanding the anatomy

-committing to a light source location

-rendering

fig. 3.105

Understanding the volume, structure and space. Based on the figure's planes create a basic placement for the lights and the shadows consistent with the light source's location.

fig. 3.106

Understanding the anatomy

In the small insert (left), think in terms of dynamics.

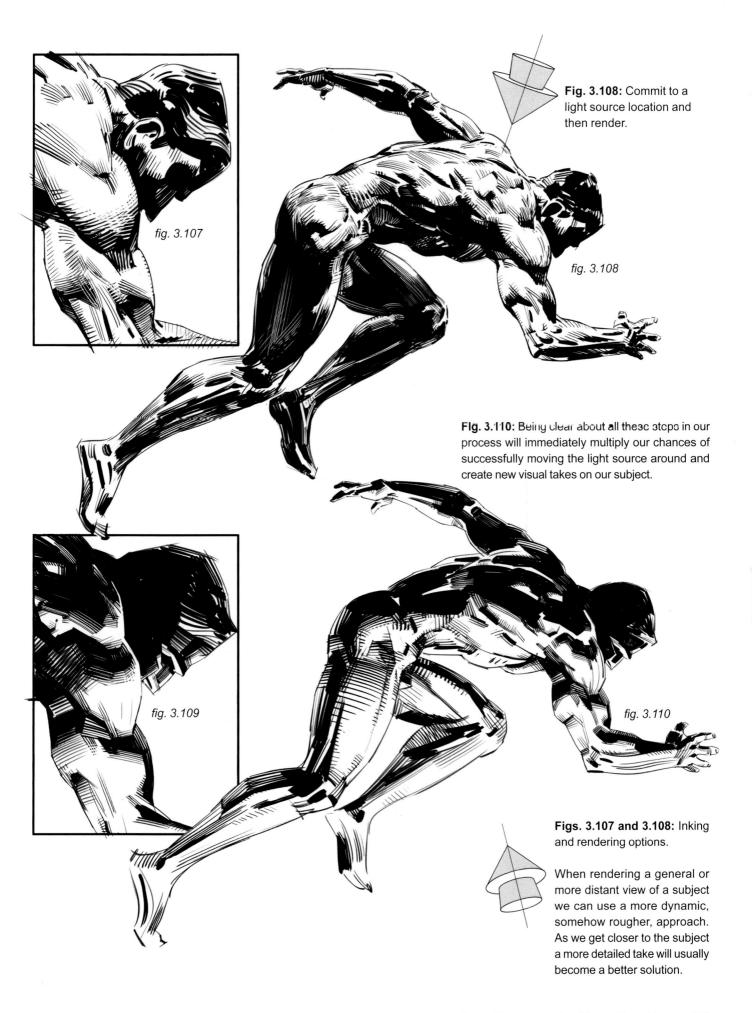

fig. 3.107

Fig. 3.108: Commit to a light source location and then render.

fig. 3.108

Fig. 3.110: Being clear about all these steps in our process will immediately multiply our chances of successfully moving the light source around and create new visual takes on our subject.

fig. 3.109

fig. 3.110

Figs. 3.107 and 3.108: Inking and rendering options.

When rendering a general or more distant view of a subject we can use a more dynamic, somehow rougher, approach. As we get closer to the subject a more detailed take will usually become a better solution.

Up until now, we have discussed anatomy and lighting, the sense of dynamics, structure and perspective with a strong sense of proportion. After absorbing and practicing all of these, after observing reality a thousand times and doing sketches with live models in the studio and in the streets, studying photographs and developing a solid understanding of the volume and three-dimensionality of things, go ahead and use some *artistic license*, stylize the characters and make it work for the stories you want to tell.

As seen on this page, it is good to let the brushes be a bit loose, not so beholden to reality but rather making an artistic interpretation of it, sometimes exaggerating the anatomy more than it would ever appear on a real body, helping to accentuate the shapes and dynamics (**fig. 3.111**), or simplifying the shapes and the way light works on them by having a quick and graphic understanding of it.

In **fig. 3.115** the shadow of the character's right arm on his hip area helps bring distance, volume and space to this pose in a fast way. Shadow accents under his left arm and on the legs get the job done right (see also **fig. 3.114**).

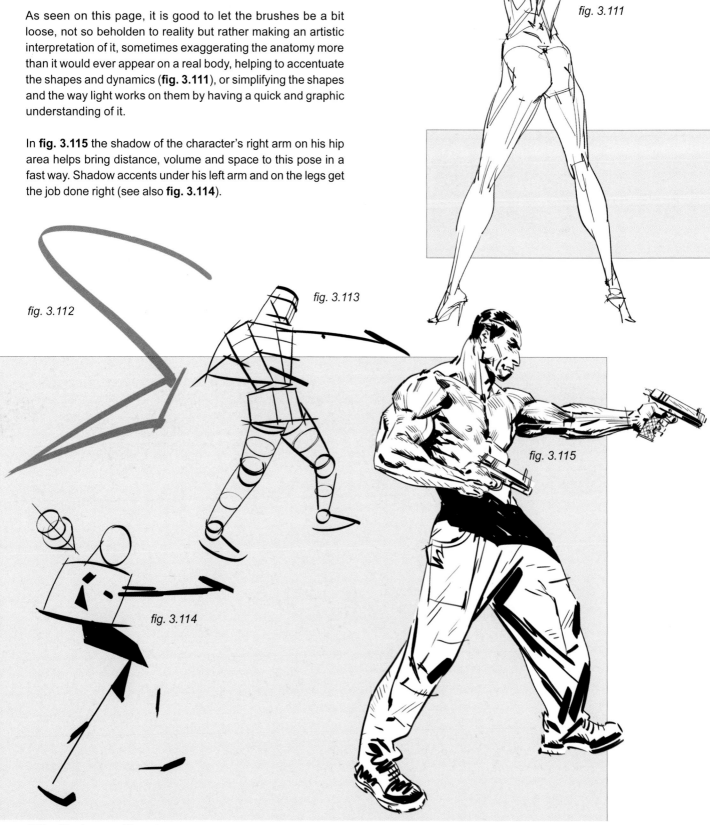

fig. 3.111

fig. 3.112

fig. 3.113

fig. 3.114

fig. 3.115

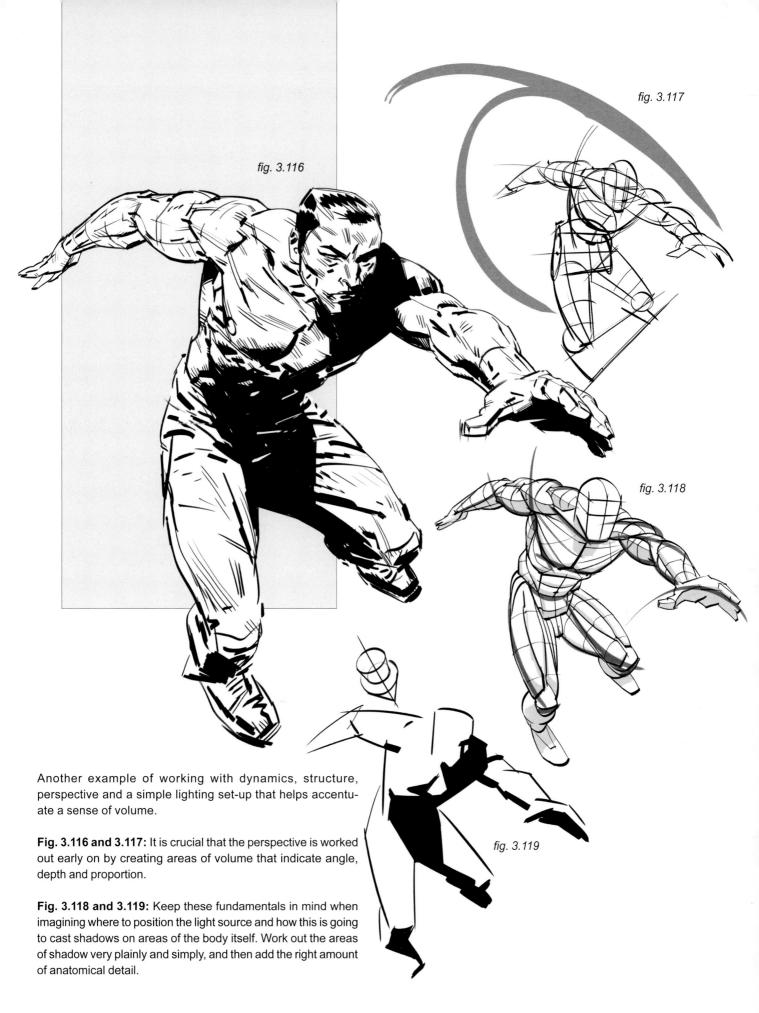

fig. 3.116

fig. 3.117

fig. 3.118

fig. 3.119

Another example of working with dynamics, structure, perspective and a simple lighting set-up that helps accentuate a sense of volume.

Fig. 3.116 and 3.117: It is crucial that the perspective is worked out early on by creating areas of volume that indicate angle, depth and proportion.

Fig. 3.118 and 3.119: Keep these fundamentals in mind when imagining where to position the light source and how this is going to cast shadows on areas of the body itself. Work out the areas of shadow very plainly and simply, and then add the right amount of anatomical detail.

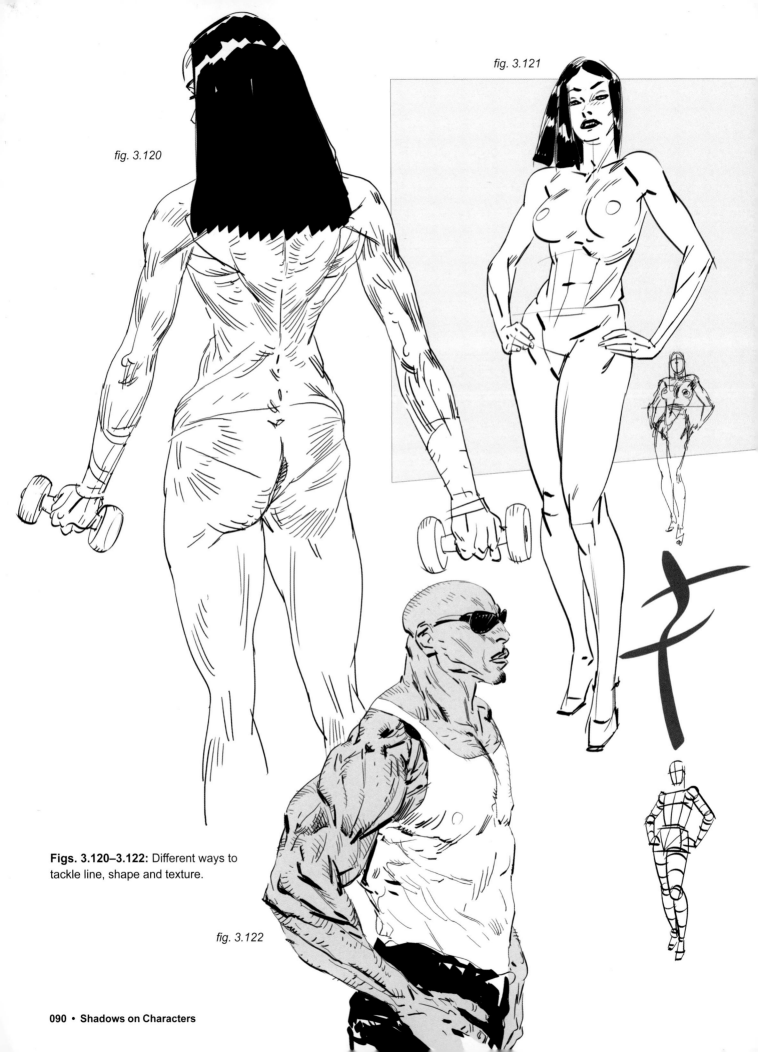

fig. 3.120

fig. 3.121

Figs. 3.120–3.122: Different ways to tackle line, shape and texture.

fig. 3.122

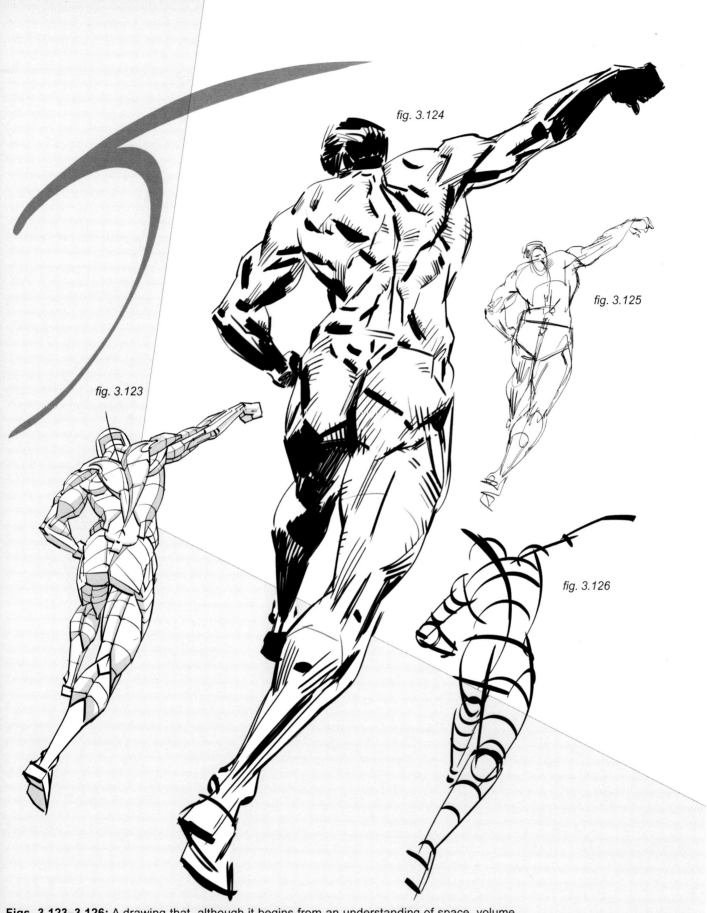

fig. 3.124

fig. 3.125

fig. 3.123

fig. 3.126

Figs. 3.123–3.126: A drawing that, although it begins from an understanding of space, volume, dynamics and anatomy, ends up as a loose and free interpretation of it all in order to achieve a more expressive feel, rather than a naturalistic and accurate one.

Figs. 3.127–3.133: Here are some figures that are more action-oriented. The starting "mannequin" has been simplified by making its planes structure boxier than before. Whether using a model or not, it is important to be aware of the planes that configure the character, and how each plane is exposed to the light or faces away from it.

Starting off this way helps to keep the whole process graphic. Even if the end result is very detailed and realistic, the audience still relies on the initial quick read. This step settles the essential basics of the work and adds readability and believability.

fig. 3.127

fig. 3.128

fig. 3.129

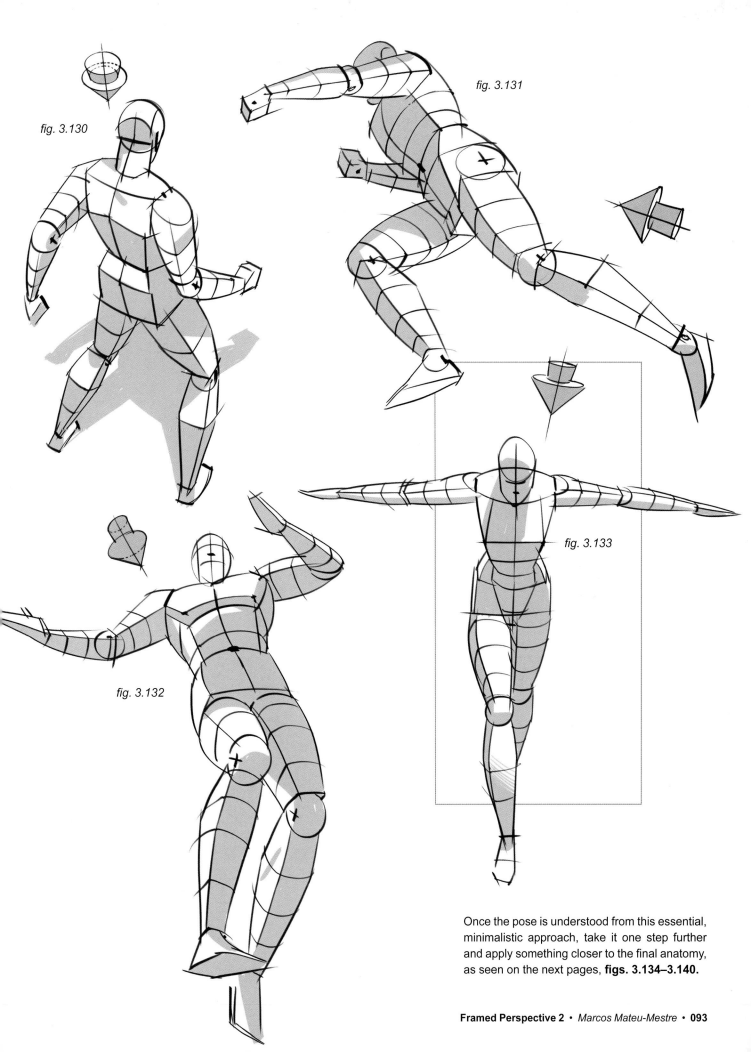

fig. 3.130

fig. 3.131

fig. 3.132

fig. 3.133

Once the pose is understood from this essential, minimalistic approach, take it one step further and apply something closer to the final anatomy, as seen on the next pages, **figs. 3.134–3.140.**

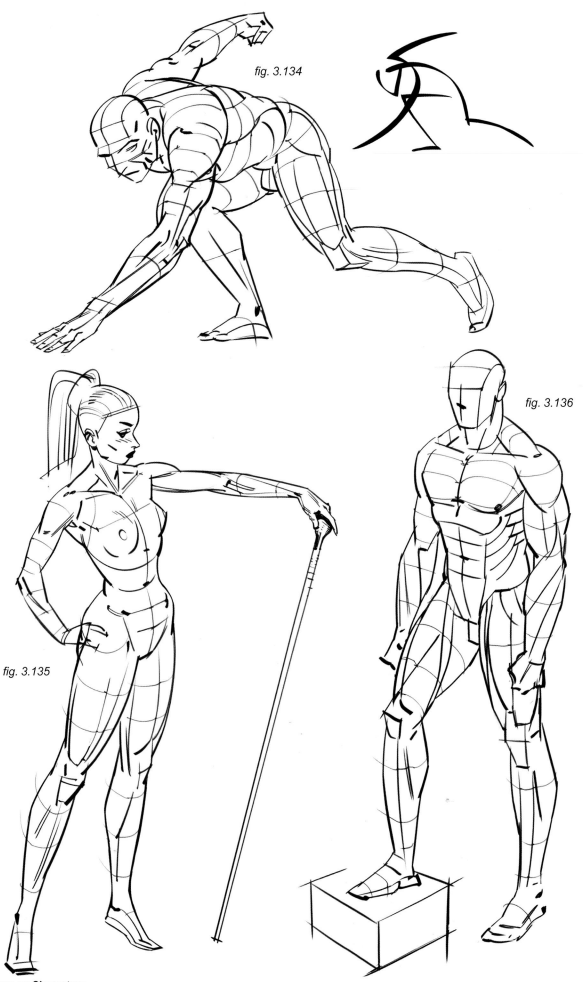

fig. 3.134

fig. 3.135

fig. 3.136

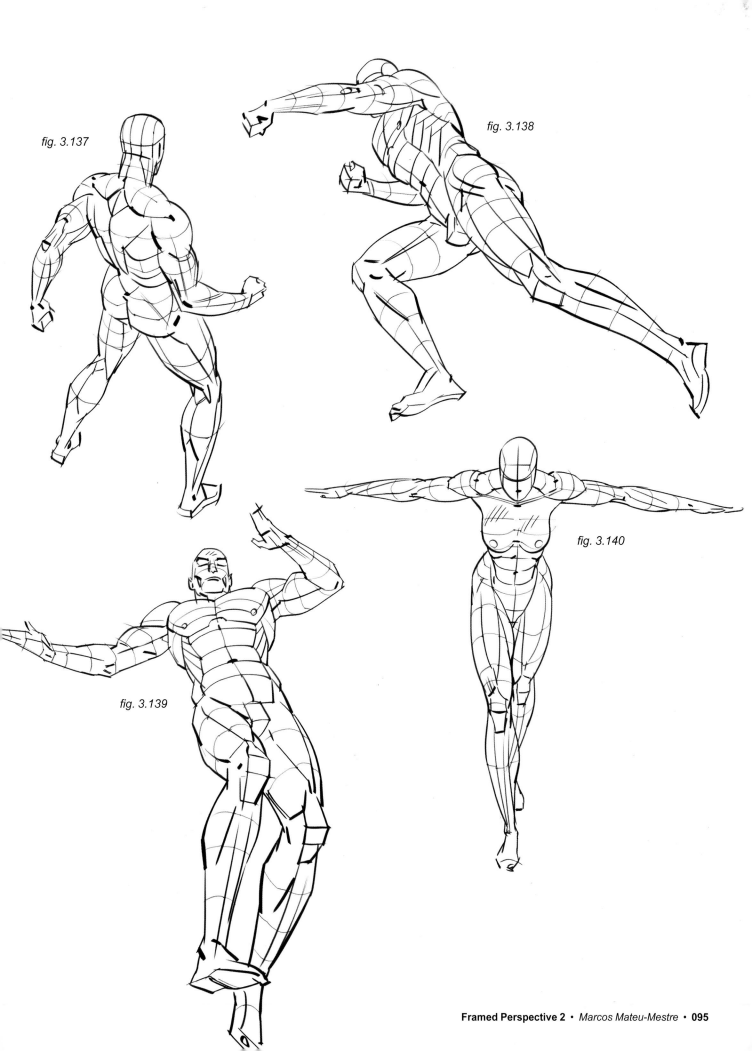

fig. 3.137

fig. 3.138

fig. 3.139

fig. 3.140

Figs. 3.141–3.143: Once the subject's basic volumes, anatomy and how light affects all of these are worked out and understood, it is time to tackle the final pass.

As with all works from the imagination, add a sense of grace by controlling how the ink moves on the surface. Combine strong, solid and graphic blacks with more illuminated (and therefore more rendered) medium areas, as well as pure white, strong lights.

Personal note: When inking, I always tackle contour lines and shadow/light blocks as one. I never draw an outline to then 'fill it in' with shadows. To me, this would almost always head for a somehow stiff or less than naturalistic result.

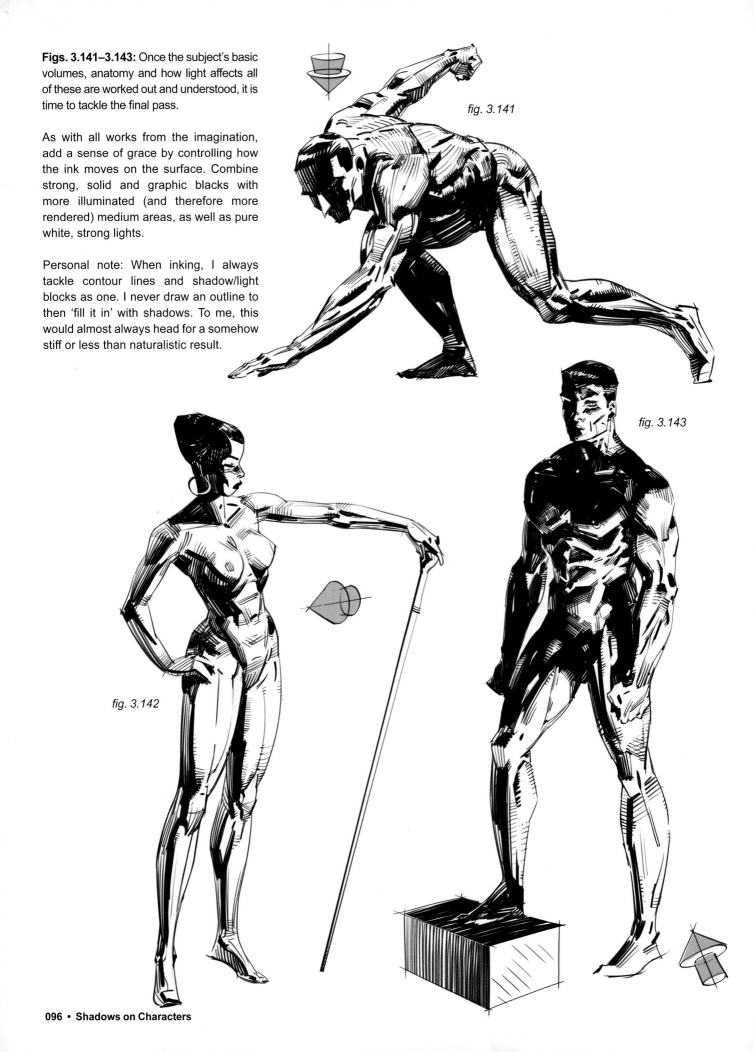

fig. 3.141

fig. 3.143

fig. 3.142

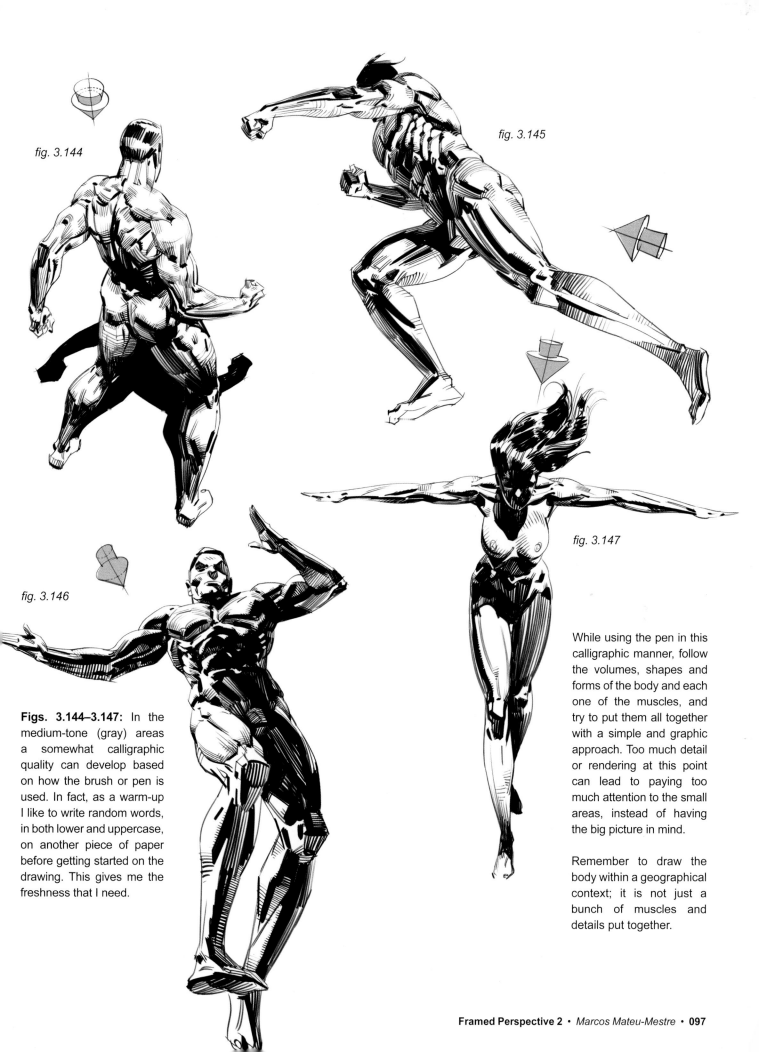

fig. 3.144

fig. 3.145

fig. 3.146

fig. 3.147

Figs. 3.144–3.147: In the medium-tone (gray) areas a somewhat calligraphic quality can develop based on how the brush or pen is used. In fact, as a warm-up I like to write random words, in both lower and uppercase, on another piece of paper before getting started on the drawing. This gives me the freshness that I need.

While using the pen in this calligraphic manner, follow the volumes, shapes and forms of the body and each one of the muscles, and try to put them all together with a simple and graphic approach. Too much detail or rendering at this point can lead to paying too much attention to the small areas, instead of having the big picture in mind.

Remember to draw the body within a geographical context; it is not just a bunch of muscles and details put together.

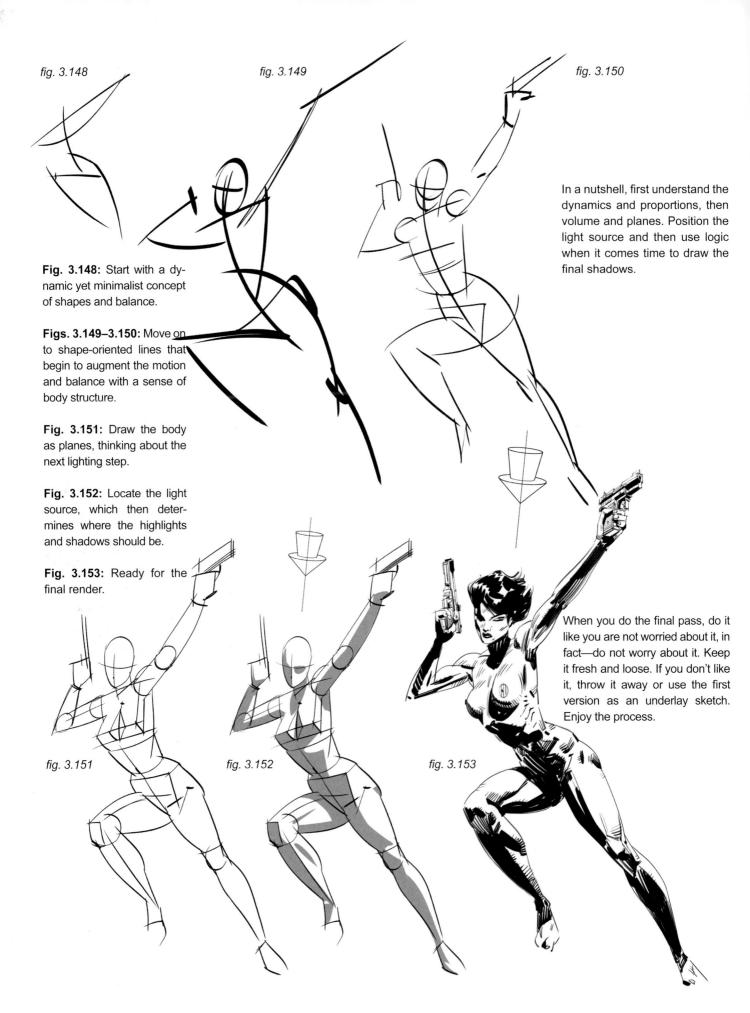

fig. 3.148

fig. 3.149

fig. 3.150

Fig. 3.148: Start with a dynamic yet minimalist concept of shapes and balance.

Figs. 3.149–3.150: Move on to shape-oriented lines that begin to augment the motion and balance with a sense of body structure.

Fig. 3.151: Draw the body as planes, thinking about the next lighting step.

Fig. 3.152: Locate the light source, which then determines where the highlights and shadows should be.

Fig. 3.153: Ready for the final render.

In a nutshell, first understand the dynamics and proportions, then volume and planes. Position the light source and then use logic when it comes time to draw the final shadows.

When you do the final pass, do it like you are not worried about it, in fact—do not worry about it. Keep it fresh and loose. If you don't like it, throw it away or use the first version as an underlay sketch. Enjoy the process.

fig. 3.151

fig. 3.152

fig. 3.153

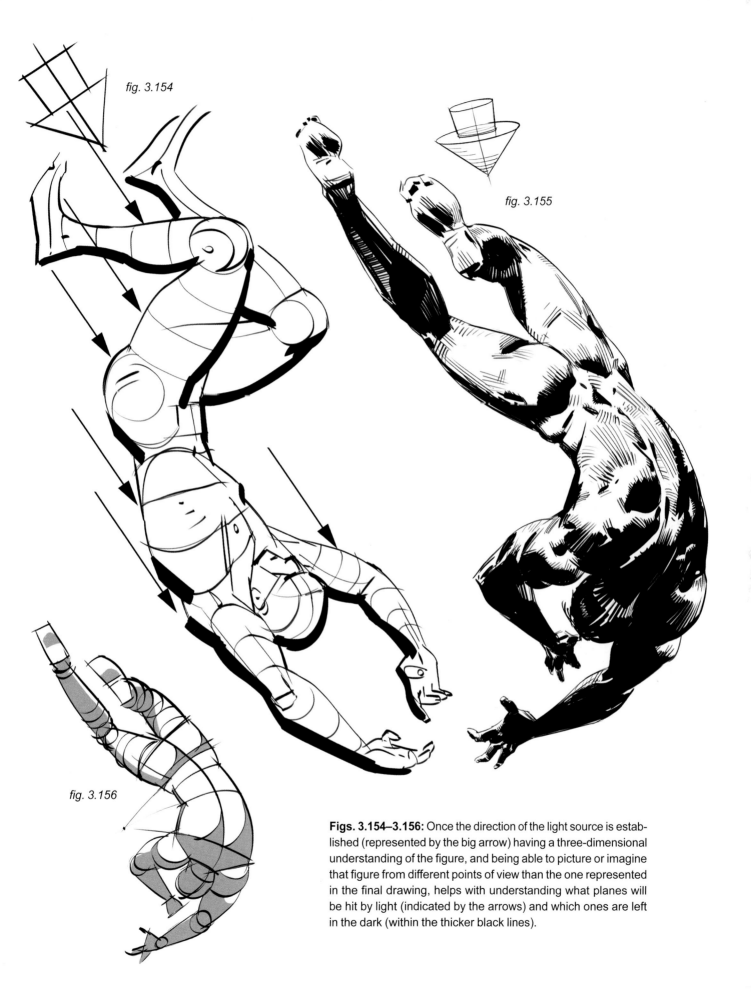

fig. 3.154

fig. 3.155

fig. 3.156

Figs. 3.154–3.156: Once the direction of the light source is established (represented by the big arrow) having a three-dimensional understanding of the figure, and being able to picture or imagine that figure from different points of view than the one represented in the final drawing, helps with understanding what planes will be hit by light (indicated by the arrows) and which ones are left in the dark (within the thicker black lines).

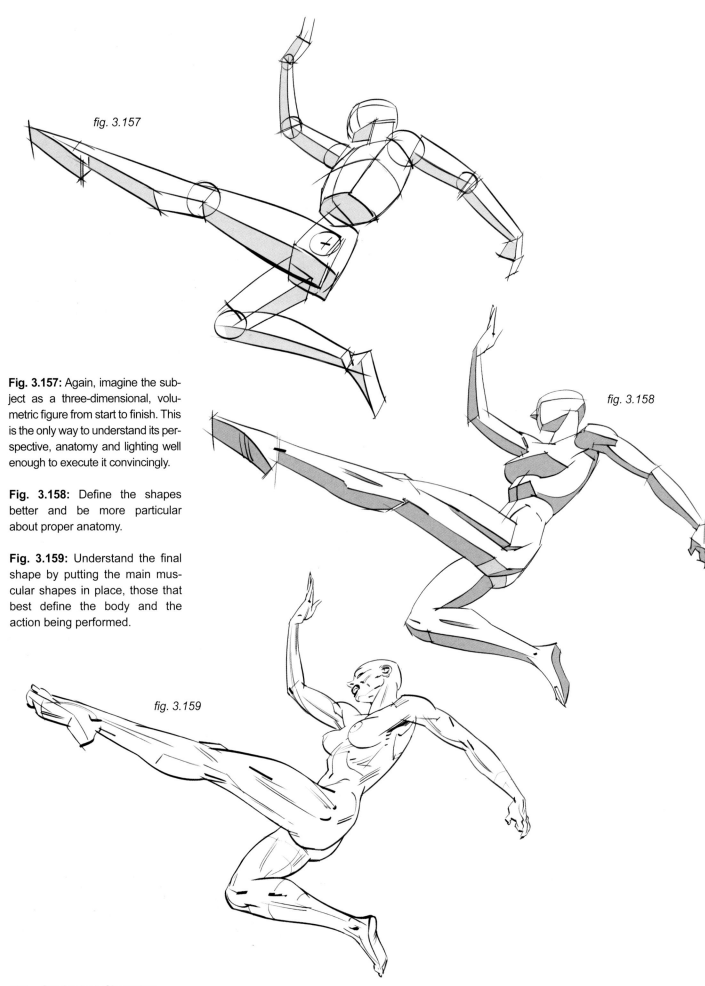

Fig. 3.157: Again, imagine the subject as a three-dimensional, volumetric figure from start to finish. This is the only way to understand its perspective, anatomy and lighting well enough to execute it convincingly.

Fig. 3.158: Define the shapes better and be more particular about proper anatomy.

Fig. 3.159: Understand the final shape by putting the main muscular shapes in place, those that best define the body and the action being performed.

fig. 3.157

fig. 3.158

fig. 3.159

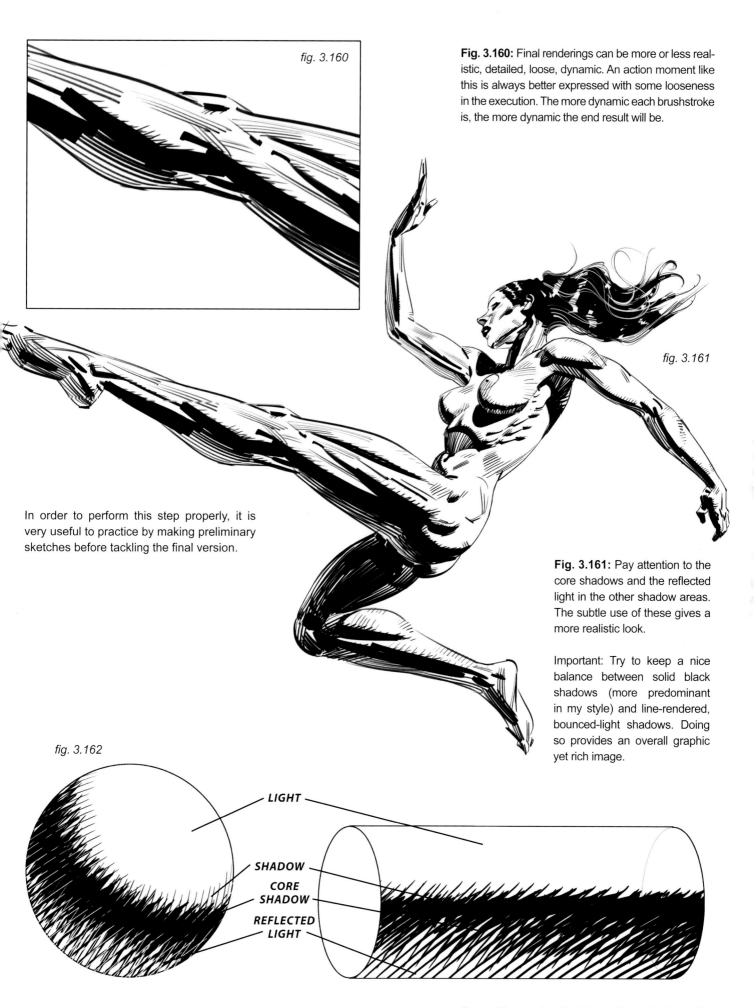

fig. 3.160

Fig. 3.160: Final renderings can be more or less realistic, detailed, loose, dynamic. An action moment like this is always better expressed with some looseness in the execution. The more dynamic each brushstroke is, the more dynamic the end result will be.

fig. 3.161

In order to perform this step properly, it is very useful to practice by making preliminary sketches before tackling the final version.

Fig. 3.161: Pay attention to the core shadows and the reflected light in the other shadow areas. The subtle use of these gives a more realistic look.

Important: Try to keep a nice balance between solid black shadows (more predominant in my style) and line-rendered, bounced-light shadows. Doing so provides an overall graphic yet rich image.

fig. 3.162

LIGHT

SHADOW

CORE SHADOW

REFLECTED LIGHT

4

CLOTHING THE CHARACTERS

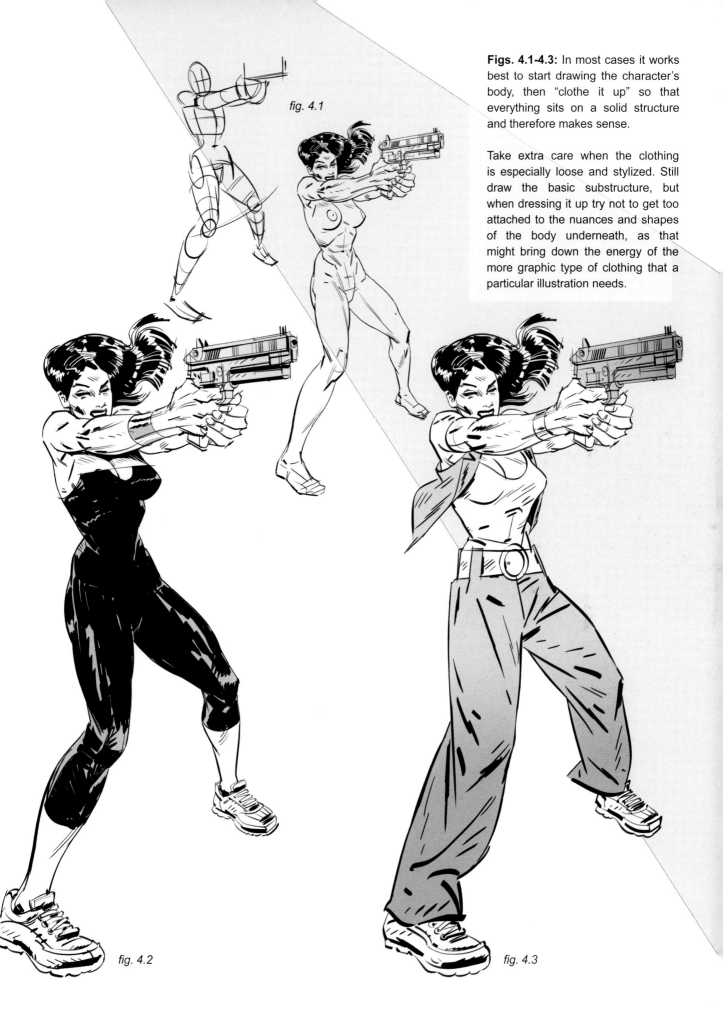

Figs. 4.1-4.3: In most cases it works best to start drawing the character's body, then "clothe it up" so that everything sits on a solid structure and therefore makes sense.

Take extra care when the clothing is especially loose and stylized. Still draw the basic substructure, but when dressing it up try not to get too attached to the nuances and shapes of the body underneath, as that might bring down the energy of the more graphic type of clothing that a particular illustration needs.

fig. 4.1

fig. 4.2

fig. 4.3

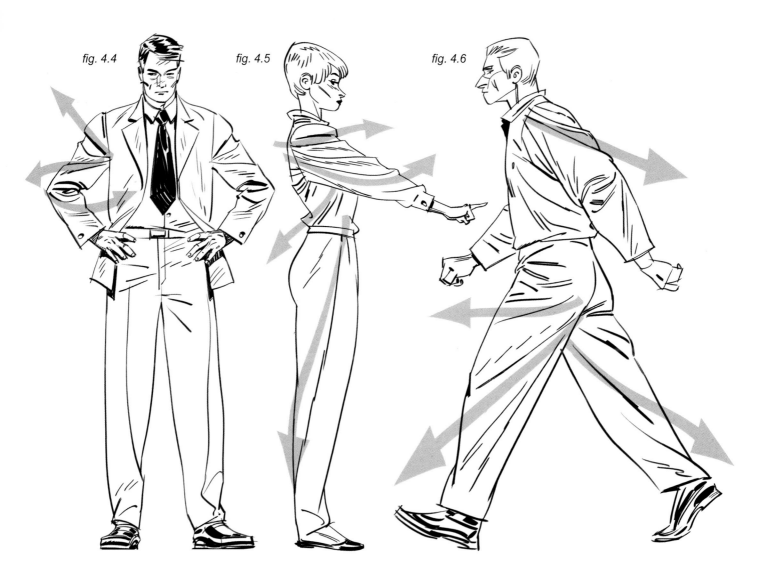

fig. 4.4 fig. 4.5 fig. 4.6

Figs. 4.4-4.6: The possibilities are endless depending on the type of fabric, how thick or thin it is and how tight or loose it fits. Here are the basic ways clothing behaves on a human body in its more common, regular poses.

Unless the clothing is very loose, like Roman togas or Renaissance costumes, there are a limited number of basic ways to represent folds and draping to make it look and feel realistic, believable and convincing.

These basics not only describe and define the clothing on a moving body but also help to inform the audience about the dynamics of the character.

Figs. 4.7-4.8: Before going any further, remember that all of the upcoming examples have three-dimensional volumes as their basis. Always imagine the body being composed of cylinders and spheres, no matter the point of view. Then add clothing and describe its folds as it wraps around these basic volumetric shapes.

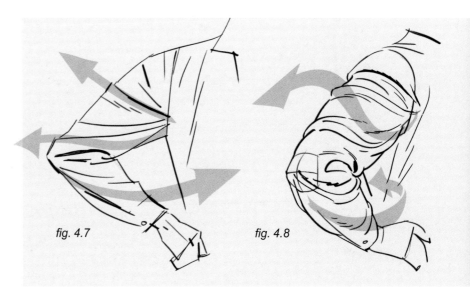

fig. 4.7 fig. 4.8

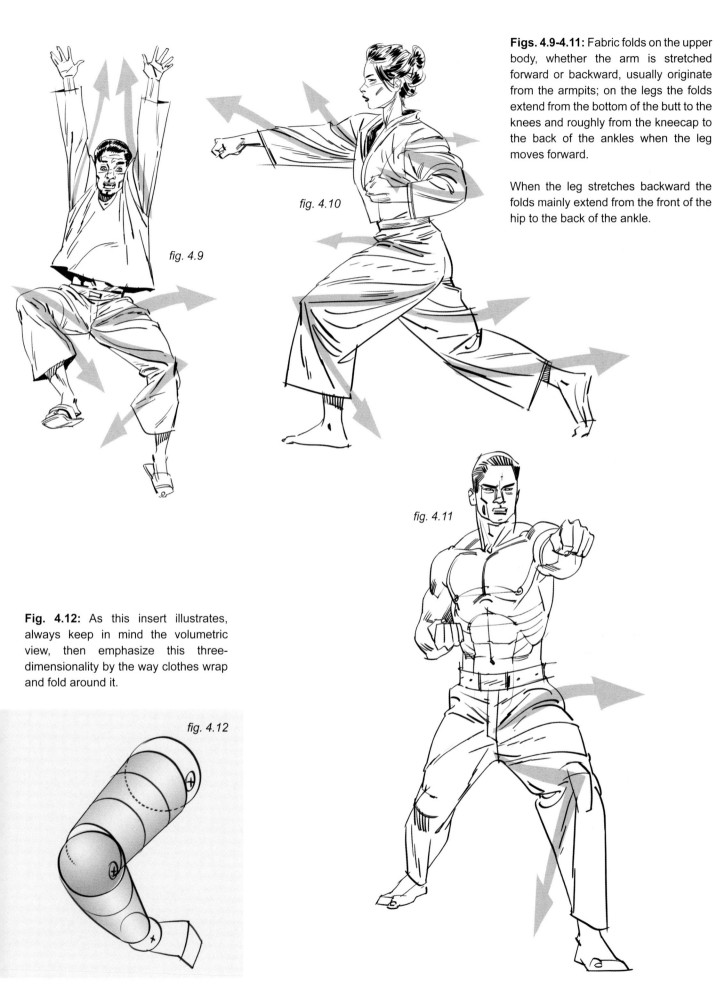

Figs. 4.9-4.11: Fabric folds on the upper body, whether the arm is stretched forward or backward, usually originate from the armpits; on the legs the folds extend from the bottom of the butt to the knees and roughly from the kneecap to the back of the ankles when the leg moves forward.

When the leg stretches backward the folds mainly extend from the front of the hip to the back of the ankle.

fig. 4.10

fig. 4.9

fig. 4.11

Fig. 4.12: As this insert illustrates, always keep in mind the volumetric view, then emphasize this three-dimensionality by the way clothes wrap and fold around it.

fig. 4.12

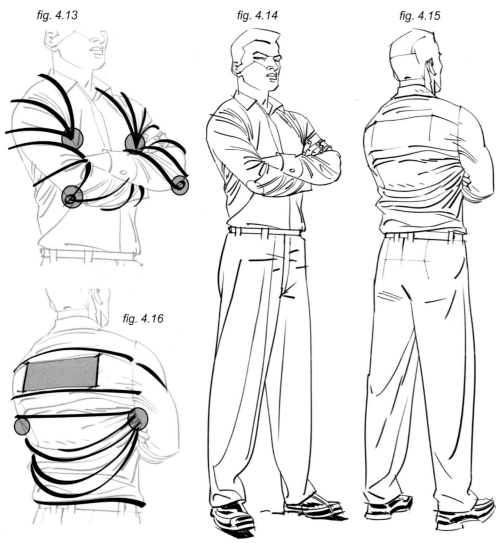

fig. 4.13

fig. 4.14

fig. 4.15

fig. 4.16

Figs. 4.13-4.14: As seen from the front, when arms are crossed the folds direct toward the armpits in the shoulder and upper-arm areas, then wrap around the forearms from elbow to wrist.

Figs. 4.15-4.16: As seen from behind, the folds stretch from shoulder to shoulder across the upper-torso area, stretching the most between the two shoulder blades (gray rectangle) since these usually protrude the most from the back. Then, moving lower toward the waistline, which is usually a narrower area, the fabric does not have much support anymore and is on a somewhat "emptier" area. Therefore folds adopt a looser fashion and arch down toward the lower back. Again, except for the folds at the very top of the back, the rest extend from the armpits.

Note: For clarity, the folds in these examples are a bit heavy on the ink. Normally they would be rendered a bit lighter.

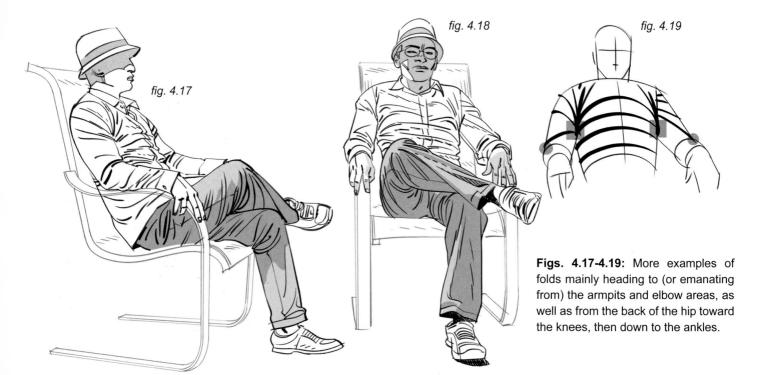

fig. 4.17

fig. 4.18

fig. 4.19

Figs. 4.17-4.19: More examples of folds mainly heading to (or emanating from) the armpits and elbow areas, as well as from the back of the hip toward the knees, then down to the ankles.

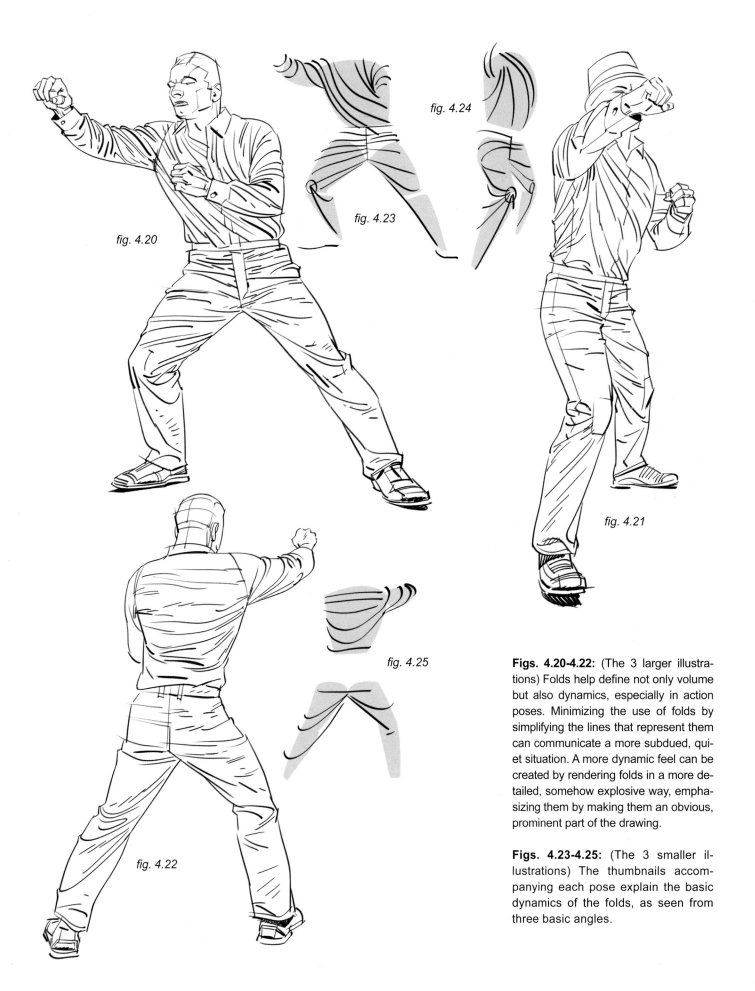

fig. 4.20

fig. 4.24

fig. 4.23

fig. 4.21

fig. 4.25

fig. 4.22

Figs. 4.20-4.22: (The 3 larger illustrations) Folds help define not only volume but also dynamics, especially in action poses. Minimizing the use of folds by simplifying the lines that represent them can communicate a more subdued, quiet situation. A more dynamic feel can be created by rendering folds in a more detailed, somehow explosive way, emphasizing them by making them an obvious, prominent part of the drawing.

Figs. 4.23-4.25: (The 3 smaller illustrations) The thumbnails accompanying each pose explain the basic dynamics of the folds, as seen from three basic angles.

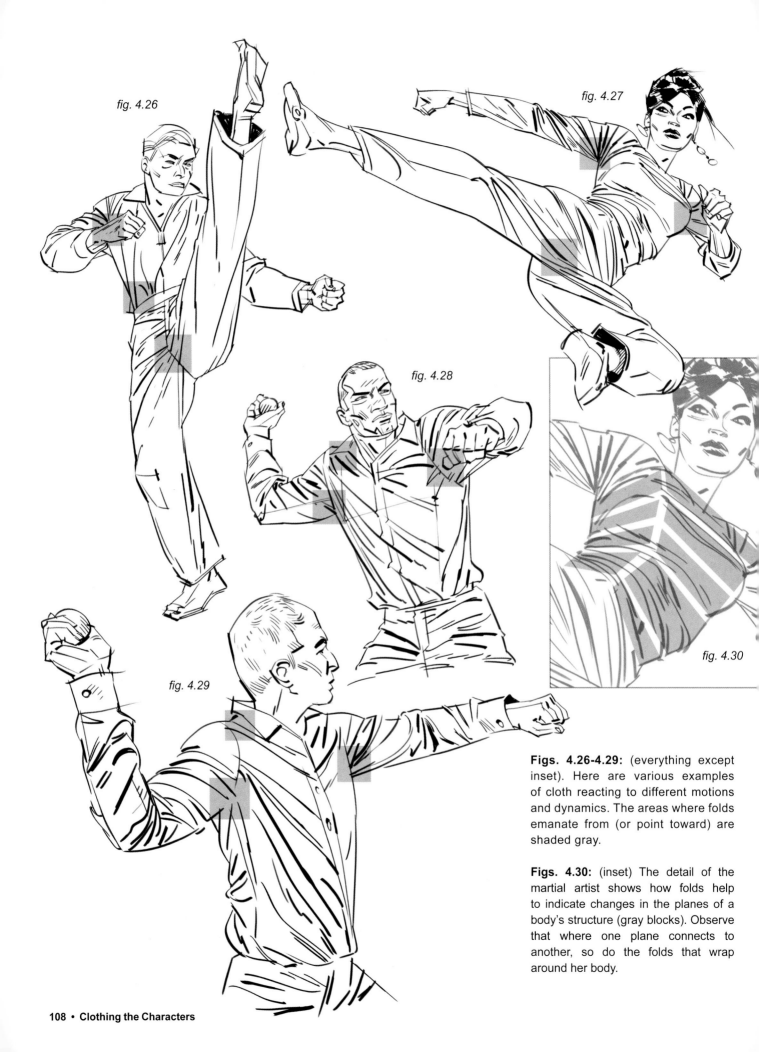

fig. 4.26

fig. 4.27

fig. 4.28

fig. 4.29

fig. 4.30

Figs. 4.26-4.29: (everything except inset). Here are various examples of cloth reacting to different motions and dynamics. The areas where folds emanate from (or point toward) are shaded gray.

Figs. 4.30: (inset) The detail of the martial artist shows how folds help to indicate changes in the planes of a body's structure (gray blocks). Observe that where one plane connects to another, so do the folds that wrap around her body.

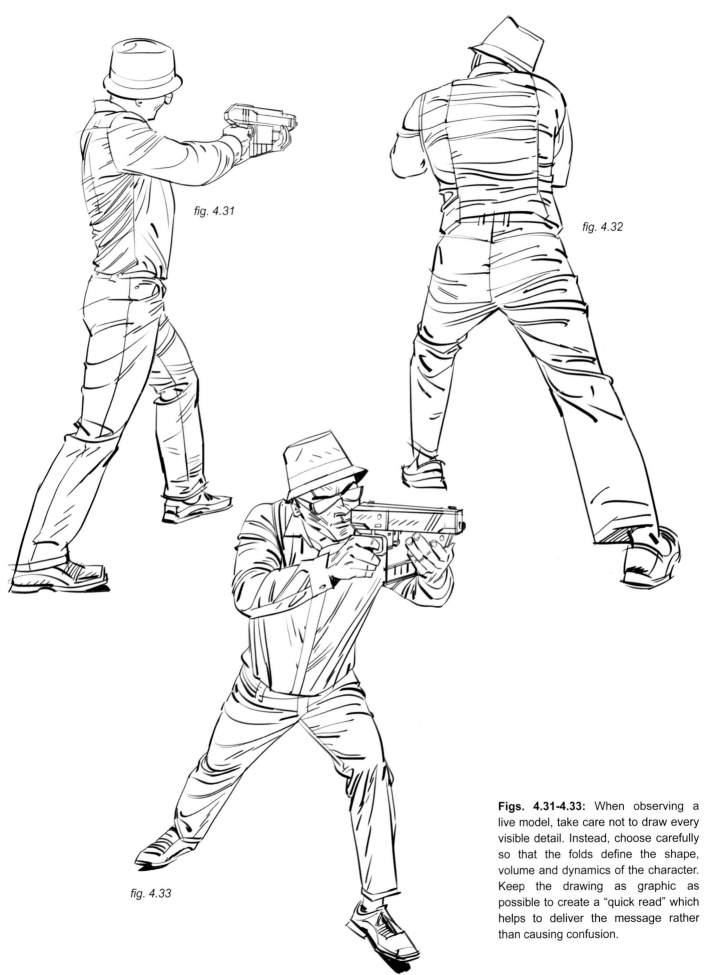

fig. 4.31

fig. 4.32

fig. 4.33

Figs. 4.31-4.33: When observing a live model, take care not to draw every visible detail. Instead, choose carefully so that the folds define the shape, volume and dynamics of the character. Keep the drawing as graphic as possible to create a "quick read" which helps to deliver the message rather than causing confusion.

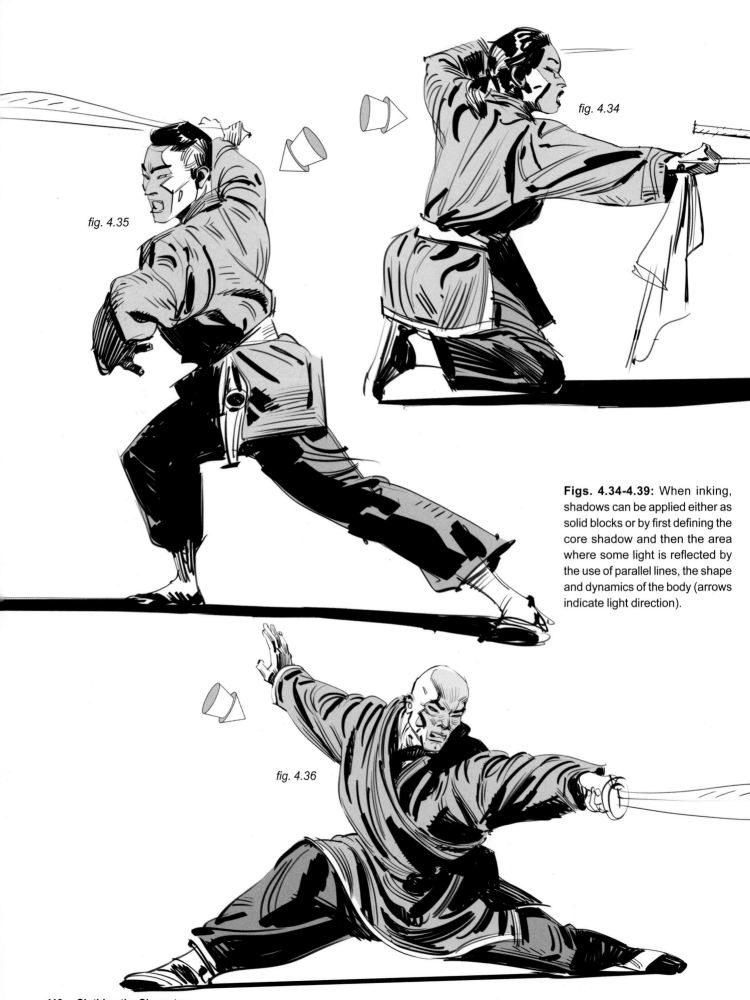

fig. 4.34

fig. 4.35

fig. 4.36

Figs. 4.34-4.39: When inking, shadows can be applied either as solid blocks or by first defining the core shadow and then the area where some light is reflected by the use of parallel lines, the shape and dynamics of the body (arrows indicate light direction).

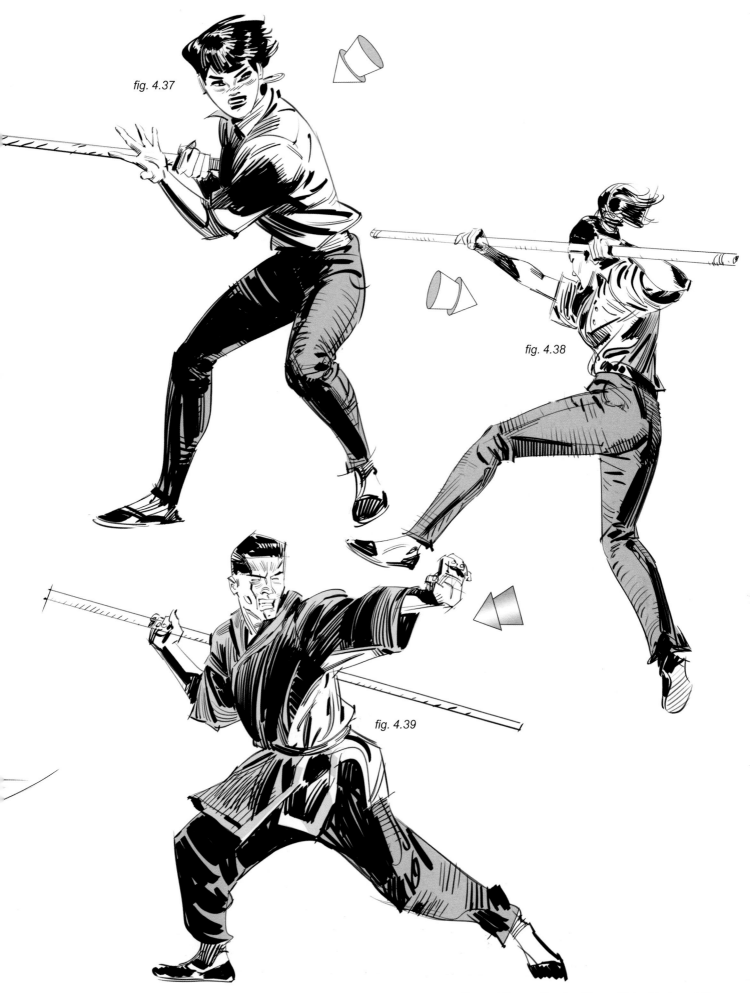

fig. 4.37

fig. 4.38

fig. 4.39

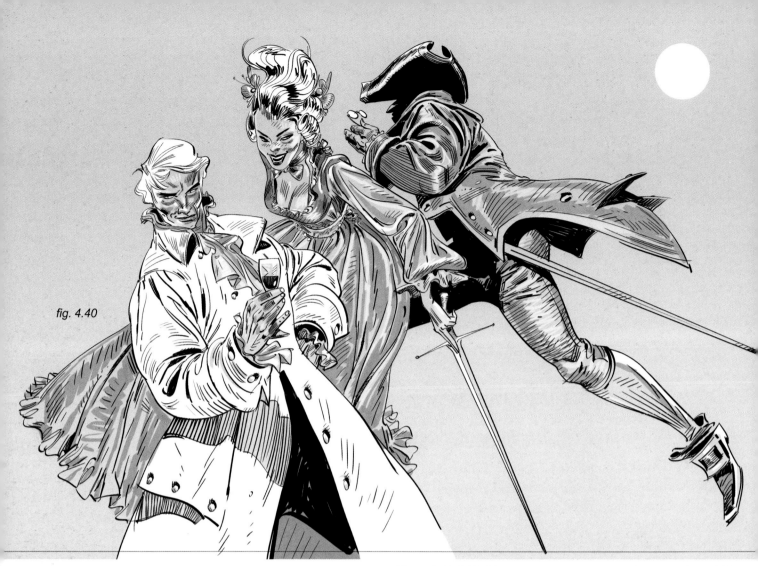

fig. 4.40

Figs. 4.40-4.42: Here are some examples of how clothing folds help to emphasize the sense of volume of the subjects in a finished illustration. The direction of the brush strokes follows the direction of the folds and helps to establish the shape of the volume (arm, leg, etc.) that the clothing is wrapped around.

fig. 4.41

fig. 4.42

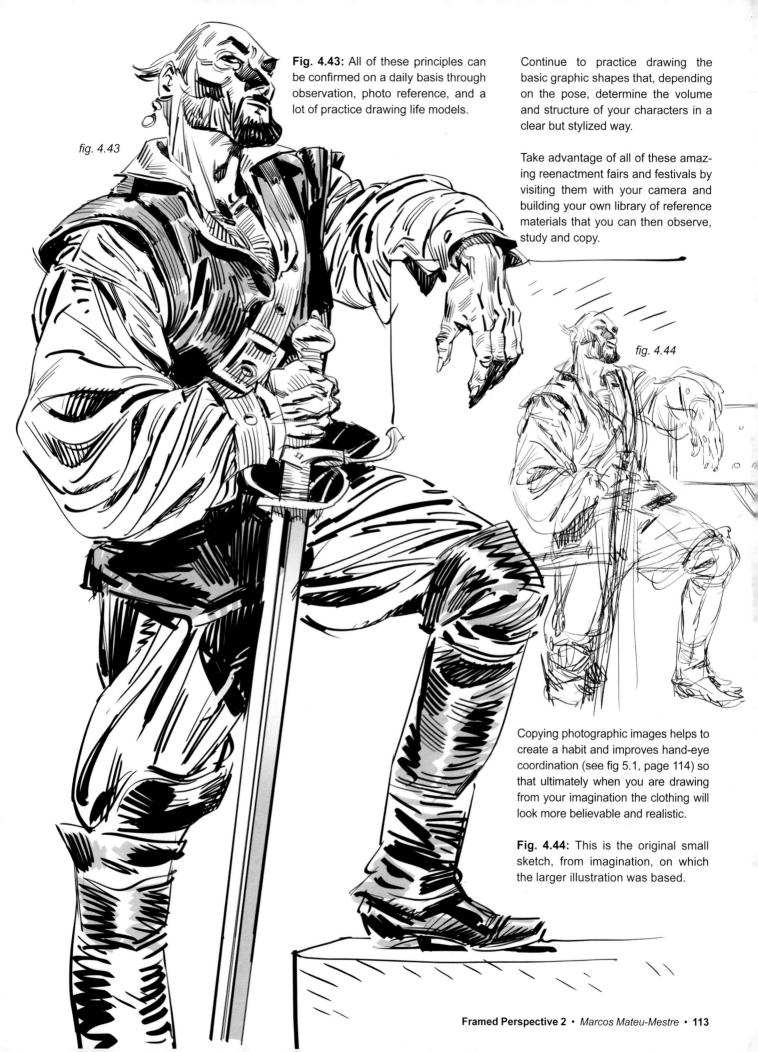

Fig. 4.43: All of these principles can be confirmed on a daily basis through observation, photo reference, and a lot of practice drawing life models.

fig. 4.43

Continue to practice drawing the basic graphic shapes that, depending on the pose, determine the volume and structure of your characters in a clear but stylized way.

Take advantage of all of these amazing reenactment fairs and festivals by visiting them with your camera and building your own library of reference materials that you can then observe, study and copy.

fig. 4.44

Copying photographic images helps to create a habit and improves hand-eye coordination (see fig 5.1, page 114) so that ultimately when you are drawing from your imagination the clothing will look more believable and realistic.

Fig. 4.44: This is the original small sketch, from imagination, on which the larger illustration was based.

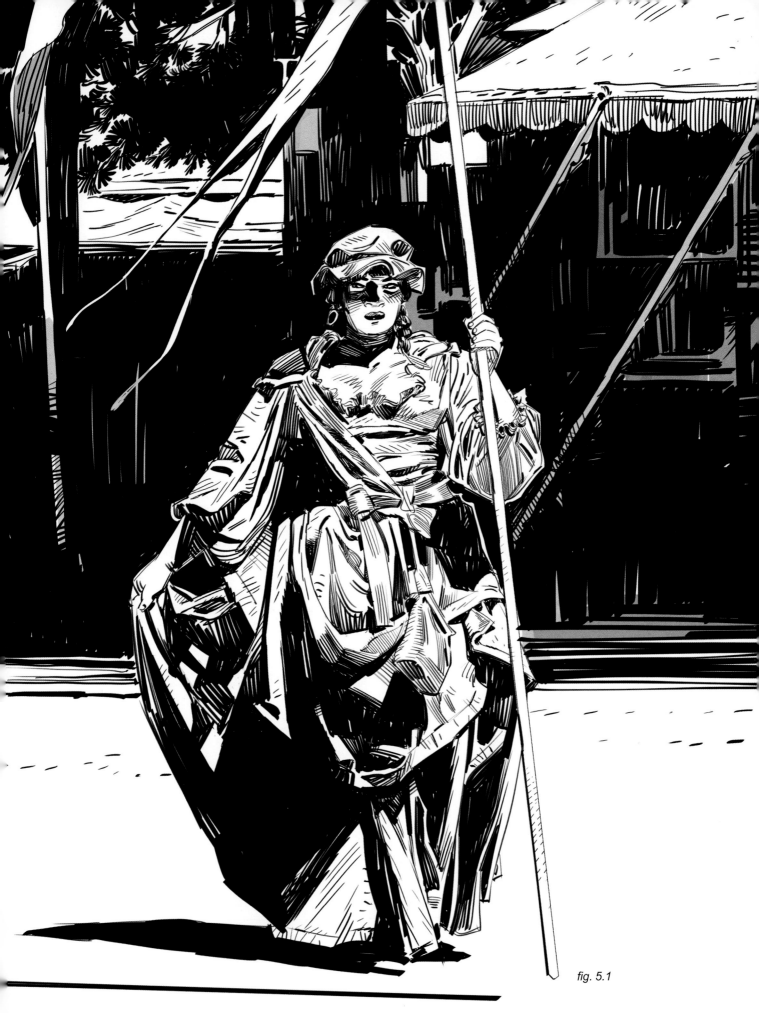

fig. 5.1

RENDERING: THOUGHT PROCESS & EXECUTION

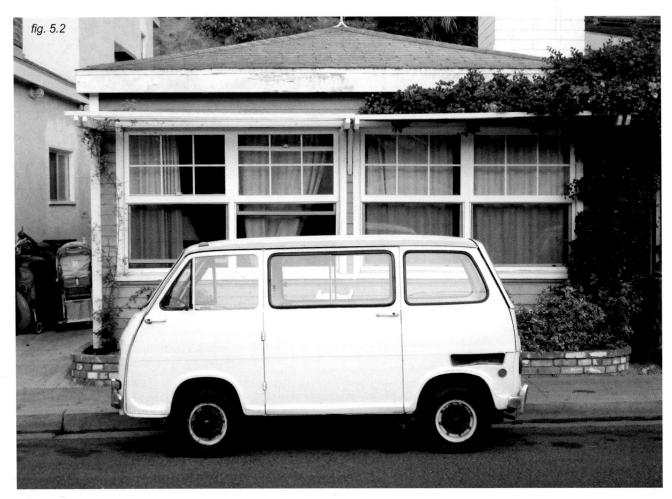

fig. 5.2

The artwork in this chapter was created directly from photographs to show how my mental process works in real-time and how I see and translate real-life elements into hand-drawn graphic statements. In order to keep an organic yet properly structured feel, I drew most lines freehand but used a ruler for a few essential lines to anchor the whole look in a more solid place within a general sense of spontaneity.

Although details like the baby strollers on the left can add a lot of potential character to a scene, in this case they became visually confusing and did not help to define the corner of the alley.

Emphasizing the blacks in the trees behind the house (at top) made the whole house pop a lot more, framing the roof's silhouette especially well.

fig. 5.3

Fig. 5.3: Adding textural lines on the left wall helps to establish a better sense of perspective, structure and depth. Make sure to work from a good perspective grid, otherwise the final result will be disorganized and contrary to what is needed.

fig. 5.4

Fig. 5.4: The shadows of the window frames on the curtains help define the volumes of the folds in a quick, effective and graphic manner.

fig. 5.5

Fig. 5.5: The windows on the right side of the façade have been simplified, the curtains eliminated, to take advantage of the sharp contrast between the white frames and the dark interior.

Similar to the dark mass of trees behind the rooftop, always look for opportunities to use ink in a daring manner.

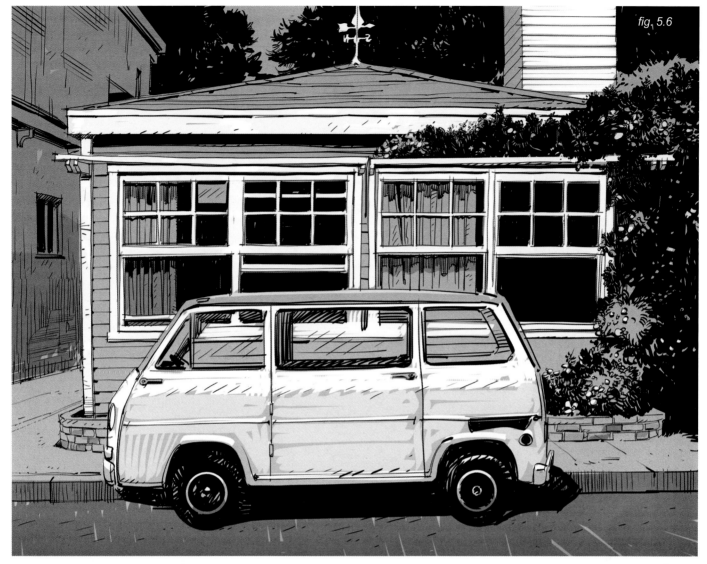

fig. 5.6

fig. 5.7

fig. 5.8

Figs. 5.8: Taking care to throw a bit of light at the top of the tire helps to establish a sense of volume that a solid black tire would not explain so well.

Fig. 5.7: As seen through the windows of the van, the dark interiors of the house and the van seem foggier and somehow lighter. Using a quick line shadow of that interior— as opposed to solid black—does a better job at describing that.

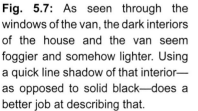

fig. 5.9

Figs. 5.9: The same applies to the hedges and ivy at the right. Using an overall black ink frames the image well, but leaving lighter areas helps to describe the volume, and a proper textural use of the pen or brush describes the shapes of leaves and flowers in a somehow abstract but effective way.

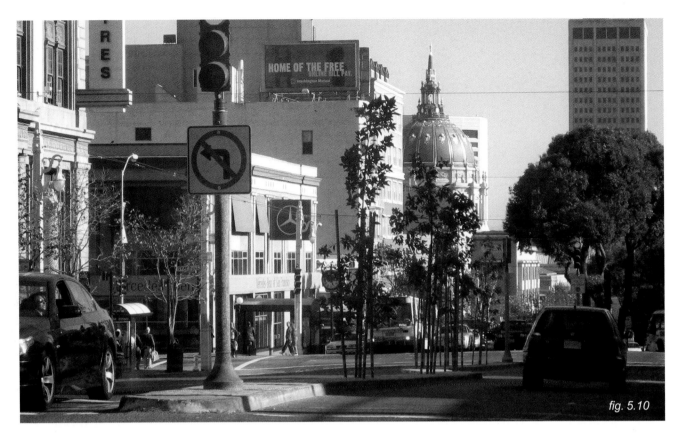

fig. 5.10

Compositionally, I changed a few things from the live reference. Mainly, I removed some of the trees that were partially covering the city hall's dome, to make a more clear image overall, especially since those trees are pretty close to the center of the drawing. Plus, it feels good to celebrate such a beautiful building. For added clarity I eliminated some signage and the canopy at the entrance of the medium-sized building center-left. Lastly, the skyscraper was moved further right so as not to be perfectly centered behind a tree.

For the inking I threw some (nearly) solid blacks on the shadow sides of the main buildings for a graphic approach, making sure to keep some brief areas of white to break the severity and coldness of a purely solid black shape (a matter of style really).

fig. 5.11

fig. 5.12

fig. 5.13

Fig. 5.11: The tree branches and leaves in front of these windows (street level, left) have been eliminated from the original image to clarify the area and give it a more graphic look.

Fig. 5.12: When drawing parallel lines in Photoshop I prefer to give them a freehand feel. To do this, draw several short freehand parallels, select them all as a group and transform/stretch them. This eliminates most of their potentially wobbly quality, as any shake in the line gets stretched out and therefore watered down.

Fig. 5.13: When a detailed drawing needs to be rendered white-on-black, it is better to draw white on a black background then to try to ink the dark background around the white areas.

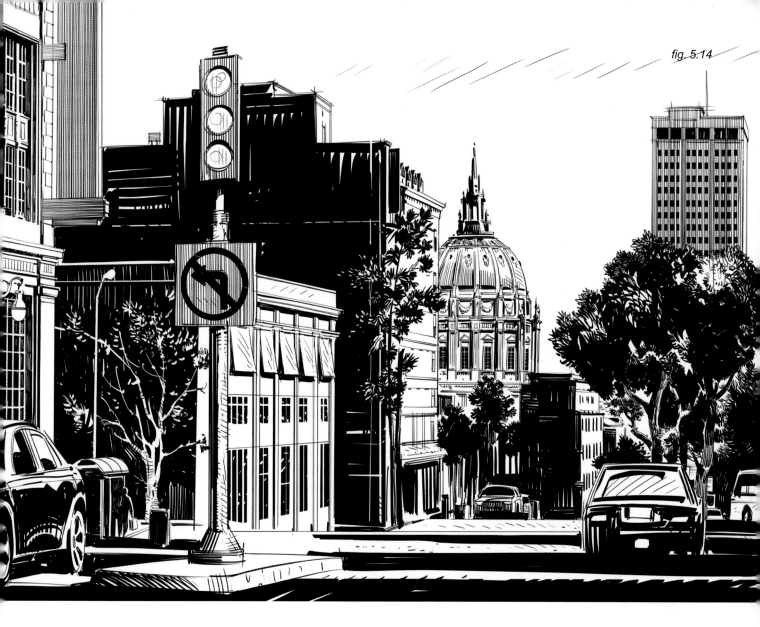

fig. 5.14

fig. 5.15

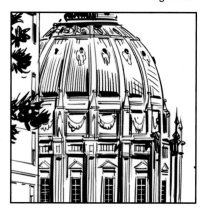

fig. 5.16

fig. 5.17

Fig. 5.15: Solid black is rendered here with thick black brushstrokes while leaving a few gaps to avoid a cold, uninspiring look.

Fig. 5.16: Sometimes an interesting, preciously ornate building such as this one is better rendered accordingly, while staying within the general style of the rest of the panel.

Fig. 5.17: To render the mass of a treetop, it is generally advisable to go at it by roughly describing the shapes of the leaves in a loose, abstract way rather than just applying a black mass.

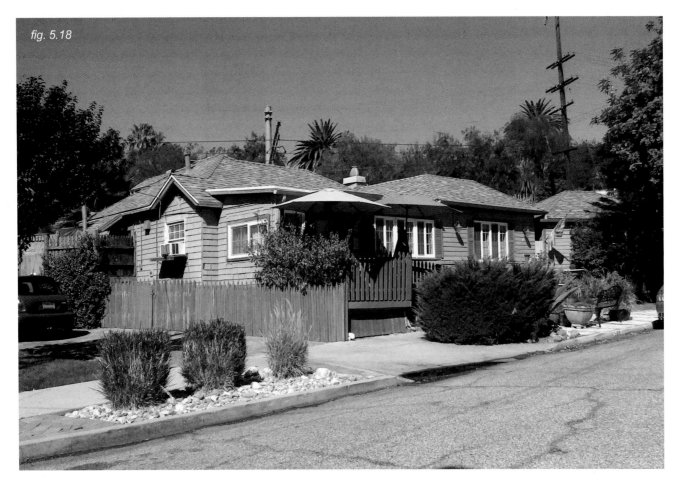

fig. 5.18

Fig. 5.18: Here is an opportunity to frame a nice structure with the darker shapes of the trees around it, with the light source shining at an angle that helps define the volume of the rooftops and the details on both sides of the façade. As part of the overall look I reduced the angle of the sidewalk in the foreground, making it more horizontal. Otherwise it might give the feeling of a somewhat distorted perspective of the road.

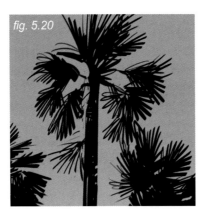

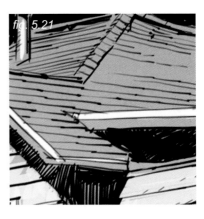

Fig. 5.19: Creating new bushes in the foreground (left) helps focus the view more on the house and makes that corner of the image more visually interesting.

Some of the white details were added afterward to break the monotony of a simple, solid, dark shape.

Fig. 5.20: This tall palm tree helps emphasize the general sense of perspective, creating an arrow-shaped overall structure for the panel (with its widest side on the left, pointing to the right) that balances things out nicely.

Note how this tree is still connected to the rest of the bushes. If it had been drawn as an isolated element it would get too much attention.

Fig. 5.21: Sketchy but organized lines on the rooftop define the texture of the tiles and the general perspective of the house.

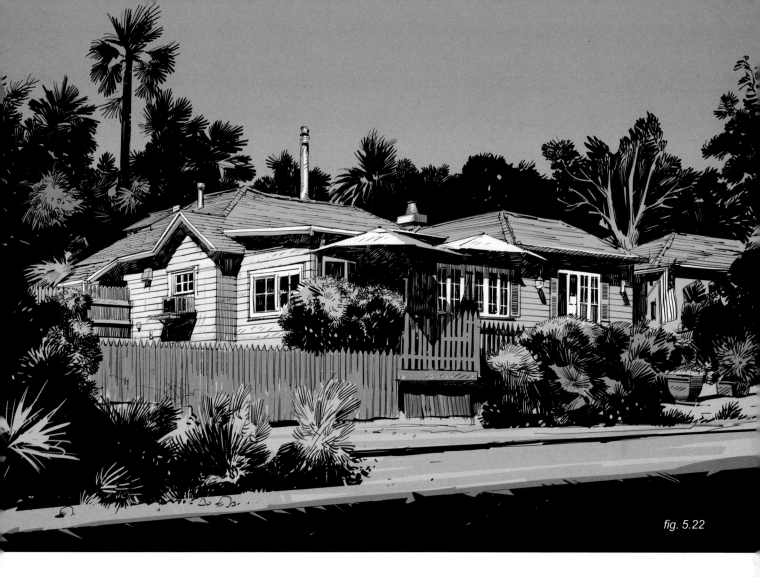

fig. 5.22

fig. 5.23

fig. 5.24

fig. 5.25

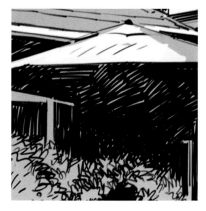

Fig. 5.23: Although the shadow areas underneath the eaves and the umbrellas could have been rendered solid black, using a thinner brush and leaving scattered areas of white in a fresh, organic way brings an interesting sense of bounced or reflected light that gives the feel of a hot day in town.

Fig. 5.24: I decided to give the big hedge at the right more variety of patterns and texture, still keeping within the generally graphic, blocky shape, so that it would look more interesting.

Fig. 5.25: Adding this tree to the very right brings home the arrowhead shape. It was not rendered white on black but the other way around, as it was defined with a thin-tipped brush.

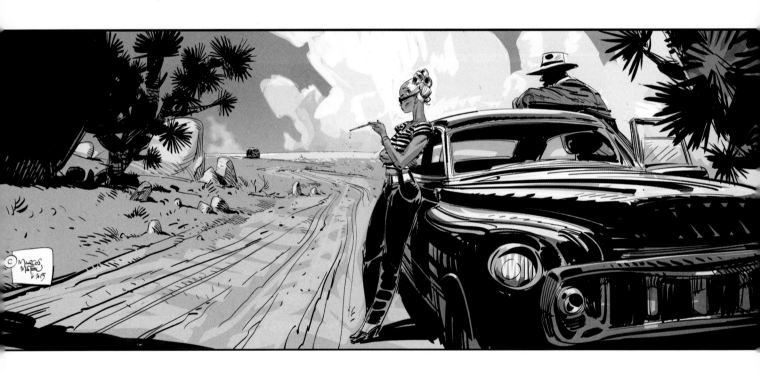

6

NOTES ON COMPOSITION

—This chapter briefly analyzes the illustrations in this book based on the compositional, chiaroscuro and inking techniques explained in depth in the previous book "FRAMED INK"—

ILLUSTRATION	DARK / LIGHT	DYNAMICS	PAGE NUMBER / COMMENTS

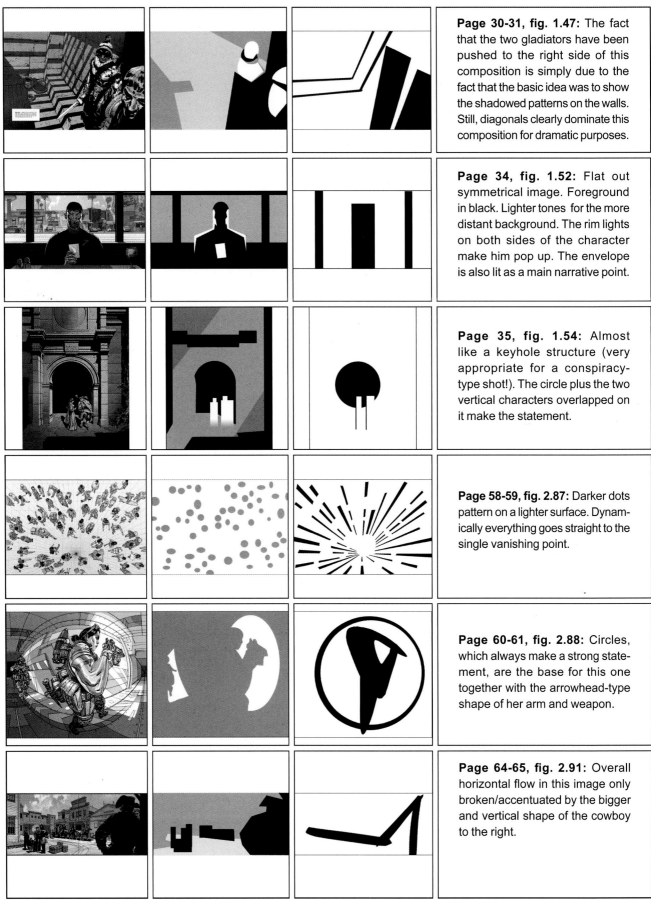

Page 30-31, fig. 1.47: The fact that the two gladiators have been pushed to the right side of this composition is simply due to the fact that the basic idea was to show the shadowed patterns on the walls. Still, diagonals clearly dominate this composition for dramatic purposes.

Page 34, fig. 1.52: Flat out symmetrical image. Foreground in black. Lighter tones for the more distant background. The rim lights on both sides of the character make him pop up. The envelope is also lit as a main narrative point.

Page 35, fig. 1.54: Almost like a keyhole structure (very appropriate for a conspiracy-type shot!). The circle plus the two vertical characters overlapped on it make the statement.

Page 58-59, fig. 2.87: Darker dots pattern on a lighter surface. Dynamically everything goes straight to the single vanishing point.

Page 60-61, fig. 2.88: Circles, which always make a strong statement, are the base for this one together with the arrowhead-type shape of her arm and weapon.

Page 64-65, fig. 2.91: Overall horizontal flow in this image only broken/accentuated by the bigger and vertical shape of the cowboy to the right.

ILLUSTRATION	DARK / LIGHT	DYNAMICS	PAGE NUMBER / COMMENTS

Page 114, fig. 5.1: A light on dark statement for the lady in costume to make an entrance. We establish the basic value structure, then elaborate the details within the lights and darks making the image richer. Her shadowed side brings her above the lower, bright ground plane.

Page 117, fig. 5.6: Basically one small rectangle overlapping a bigger one. The big rectangle (the house) includes two other minor rectangles in it, the windows.

Page 119, fig. 5.14: An abstract dance of squares, rectangles and circles for this one.

Page 121, fig. 5.22: Mild perspective is dominant, with mostly straight lines, topped by a soft curve emphasizing the more organic side of the image.

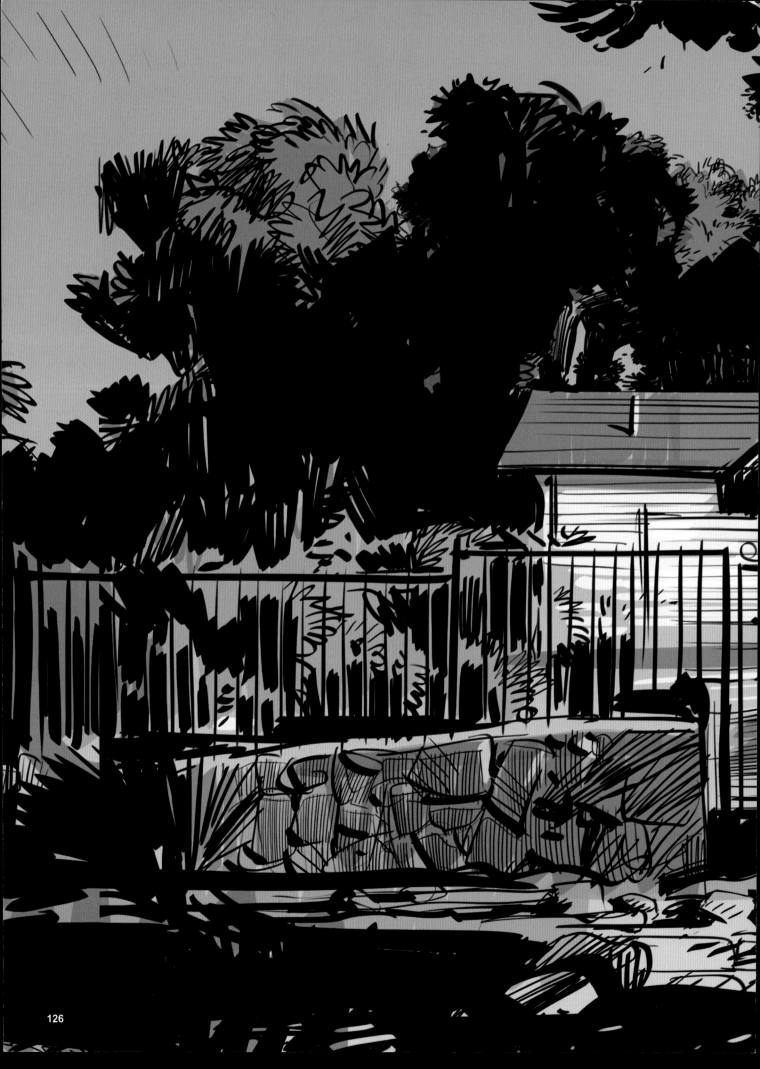

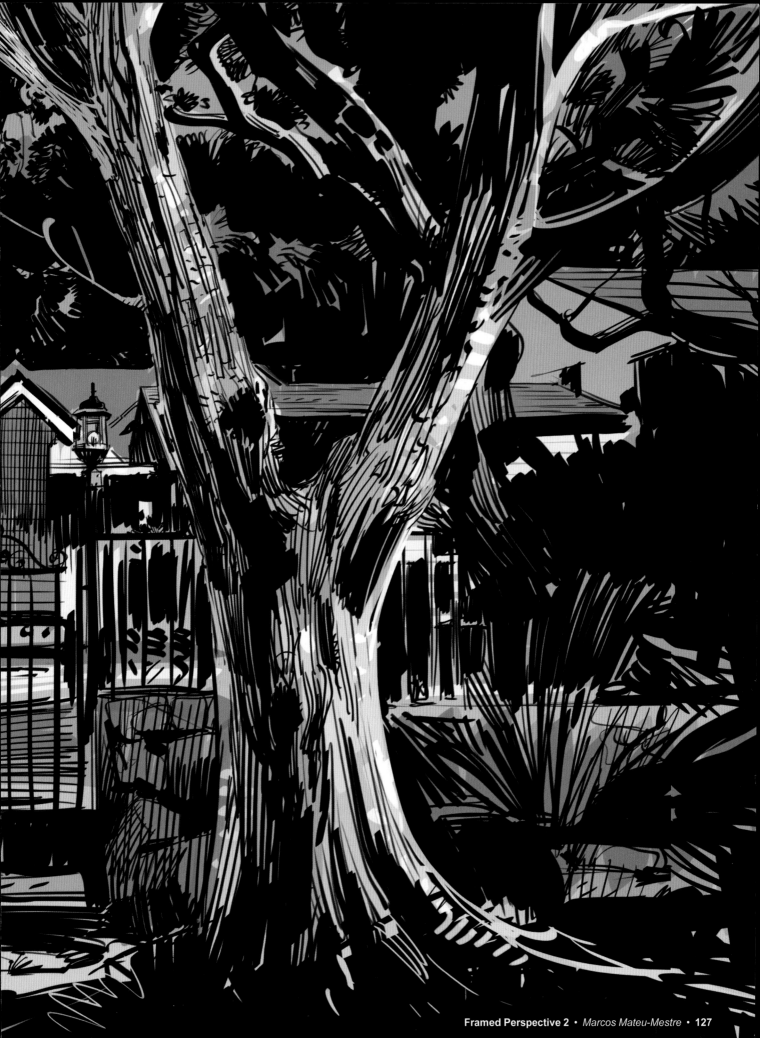

GLOSSARY

A

angle of inclination - The angle between a line and the x-axis. This angle is always between 0 and 180 degrees and is measured counterclockwise from the part of the x-axis to the right of the line.

auxiliary vanishing point - That point toward which receding parallel lines appear to converge for secondary elements of an object or a scene, such as a ramp or a pitched roof.

B

background - The part of a scene or picture that is farthest from the viewer. All background elements are there to offer information about the environment and frame the character.

baluster - An object or vertical member having a vaselike or turned outline.

bird's eye view - A view from a high angle as if seen by a bird in flight, often used in the making of blueprints, floor plans, and maps.

blueprint - A design plan or other technical drawing that shows how something will be made.

C

cantilever - A long projecting beam or girder that sticks out from a wall or other structure to support something above it.

center of vision - The precise point on which the eyes of the observer are focused. This point is at the end of the line of sight.

centered composition - The centered way in which something is put together or arranged.

centerline - A real or imaginary line that is equidistant from the surface or sides of something.

central vanishing point - A point in the picture plane that is the intersection of the projections of a set of parallel lines in space onto the picture plane.

chiaroscuro - The distribution of light and shadow in an image.

concentric - Pertaining to the relationship between two different-sized circular, cylindrical, or spherical shapes when the smaller one is exactly centered within the larger one, therefore having the same center.

cone of vision - The cone of vision is the visual region displayed by a drawing that relates to a person's normal vision without his/her peripheral vision.

converge - As parallel lines recede into the distance, they appear to merge at a single point at a person's eye level (also known as the horizon line).

D

diagonal - A straight line that connects two nonconsecutive vertices of a polygon.

diagonal vanishing point - A diagonal point where parallel lines appear to meet in the distance.

down shot - An elevated view from a high angle.

drawing through - Drawing through the form. Thinking about the 3D volume of the object and keeping the form in mind.

Dutch angle - A type of camera shot where the camera is tilted off to one side so that the shot is composed with vertical lines at an angle to the side of the frame.

E

ellipse - A circle in perspective.

eye level - Located exactly at the height of sight (or eyes) at any given time; therefore it follows wherever the viewer goes.

F

façade - The front of a building.

focal length - The distance from the surface of a lens to the point of focus.

foreground - The part of a scene or picture that is nearest to and in front of the viewer.

foreshortening - To shorten the lines of an object in a drawing or other representation to produce an illusion of projection or extension in space.

G

grid of squares - Evenly spaced verticals and horizontals.

ground plane - The theoretical horizontal plane receding from the picture plane to the horizon line.

H

horizon line - A horizontal line across a picture. Its placement defines the viewer's eye level.

horizon plane - A plane that, going through the viewer's eyes, contains the line of sight.

L

left vanishing point - The spot on the horizon line to which the receding parallel lines diminish. In two-point perspective, the left side has its own vanishing point.

line of sight - An imaginary line that represents the straight direction in which the observer's eyes are looking.

long lens - A lens with a long focal length.

M

mid-ground - The part of the picture that is between the foreground and background.

N

nadir - The point located at the opposite end of a zenith, basically the center of the Earth.

O

observer - The character through whose eyes the scene is viewed.

one-point perspective - A rendition of an object with a principal face parallel to the picture plane. All horizontal lines parallel to the picture plane remain as is, and all other horizontal lines converge to a preselected vanishing point.

opacity - The quality of a material that does not allow light to pass through it.

P

parallel - Lines or planes that extend in the same direction, everywhere equidistant.

pencil/thumb - Simply stretch an arm in the direction of the object being viewed and hold the pencil (usually vertically or horizontally) to measure the distance between two key points. Hold the pencil in such a way that its tip precisely overlaps one of the key points and then slide a thumb along the pencil, stopping right at the position of another key point. Still holding the pencil just so, move it until it is positioned over the other part of the model that is being compared to the first measurement. It will become obvious which one is relatively longer or shorter and by how much, providing a way to better estimate the proper proportions of the model/scene.

peripheral vision - The act of seeing images that fall upon parts of the retina outside the macula lutea. Also known as indirect vision.

perpendicular - Lines that are right angles (90-degree angles) to each other.

perspective - A technique of depicting volumes and spatial relationships on a flat surface.

perspective grid - A network of lines drawn to represent the perspective of a systematic network of lines on the ground or on X-Y-Z planes.

Photoshop - 2D Digital rendering software designed by Adobe Systems (www.adobe.com).

picture plane - The plane of a drawing that is in the extreme foreground of a picture, is coextensive with but not the same as the material surface of the work, is the point of visual contact between the viewer and the picture.

point of view - A position from which someone or something is observed.

polyhedron - A solid formed by plane faces.

R

ramparts - A protective barrier.

right vanishing point - The spot on the horizon line to which the receding parallel lines diminish. In two-point perspective, the right side has its own vanishing point.

rise - The total height from the floor to the top of the last step.

run - The total length of all the steps projected on the ground plane.

S

spiral composition - Piecing your elements together and eliminating unwanted elements and chaos to create a spiral flow for the viewer to follow.

station point - The position of an observer that determines the perspective rendering of the objects or scene being represented in a drawing.

T

tangents - Meeting a curve or surface in a single point if a sufficiently small interval is considered.

three-point perspective - Often used for buildings seen from above (or below). In addition to the two vanishing points from each wall, there is now one for how the vertical lines of the walls recede.

tonal - Relating to color tones. The lightness or darkness of a color.

tread - The upper horizontal part of a step.

two-point perspective - Linear perspective in which parallel lines along the width and depth of an object are represented as meeting at two separate points on the horizon that are 90 degrees apart as measured from the common intersection of the lines of projection.

U

upshot - Seen from ground level or from the lowest level upwards.

V

vanishing point - That point toward which receding parallel lines appear to converge.

vision - The perception of light, reflected off objects, that comes straight toward the eyes.

W

wide-angle lens - Literally includes a wider view, from left to right and top to bottom, of the subject it points at.

wind rose - Another "pretend" contact lens looked through at all times. It consists of four lines at different angles (vertical, horizontal, diagonal-right and diagonal-left) that help identify the angle of inclination for any given line being drawn, although the drawn line usually does not coincide exactly with any of the wind rose's lines.

Z

zenith - A point located at the top end of an imaginary line that is perpendicular to the ground plane, as if such a line were coming straight out from the center of the Earth, past its surface, and up.

INDEX

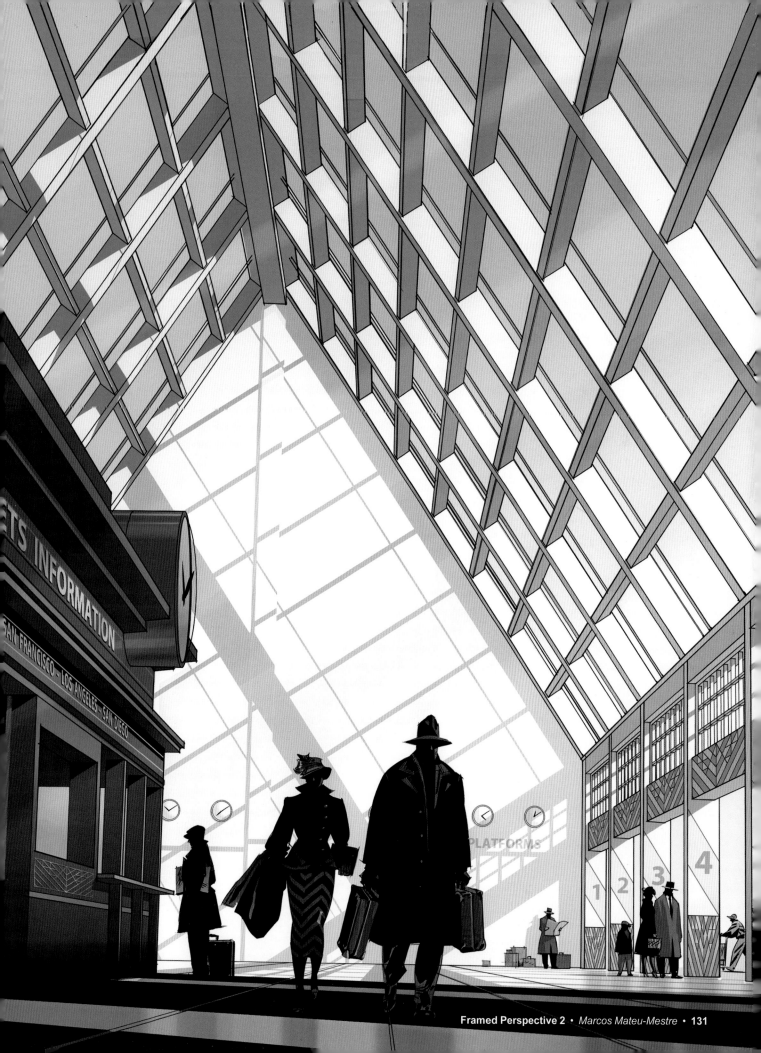

ALSO FROM MARCOS MATEU-MESTRE

Hardcover: 978-1-624650-31-4
Paperback: 978-1-624650-30-7

Paperback: 978-1-933492-15-5

Hardcover: 978-1-933492-82-7
Paperback: 978-1933492-78-0

OTHER TITLES BY DESIGN STUDIO PRESS

Hardcover: 978-1-933492-75-9
Paperback: 978-1-933492-73-5

Hardcover: 978-1-933492-83-4
Paperback: 978-1-933492-96-4

Hardcover: 978-1-624650-11-6
Paperback: 978-1-624650-12-3

Hardcover: 978-1-933492-66-7
Paperback: 978-1-933492-65-0

Hardcover: 978-1-933492-26-1
Paperback: 978-1-933492-25-4

Hardcover: 978-1-933492-91-9
Paperback: 978-1-933492-92-6

Hardcover: 978-1-624650-29-1
Paperback: 978-1-933492-56-8

Hardcover: 978-1-624650-28-4
Paperback: 978-1-624650-21-5

To order additional copies of this book, and to view other books we offer, please visit:
www.designstudiopress.com

For volume purchases and resale inquiries, please email: **info@designstudiopress.com**
tel 310.836.3116

To be notified of new releases, special discounts, and events, please sign up for our mailing list on our website, like our Facebook page, and follow us on Twitter:

designstudiopress.com

facebook.com/designstudiopress

twitter.com/DStudioPress